POPULAR PHOTOGRAPHY

The World's Most Iconic
Photographs

KATHLEEN PERRICONE

CENTENNIAL BOOKS

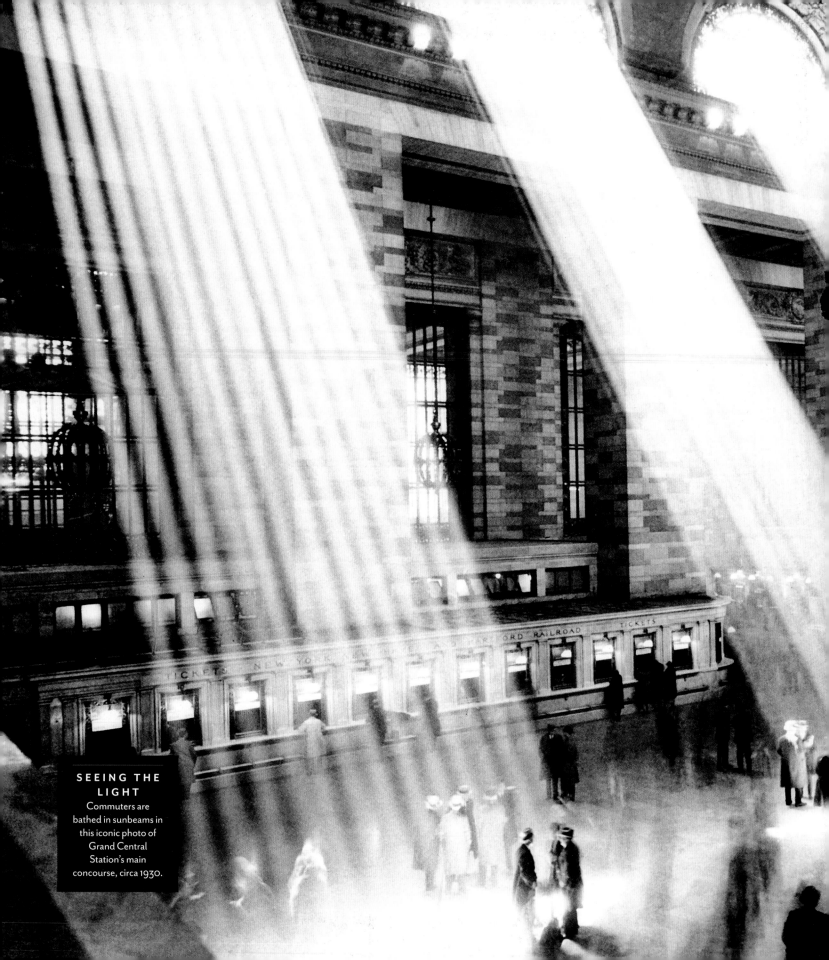

SEEING THE LIGHT
Commuters are bathed in sunbeams in this iconic photo of Grand Central Station's main concourse, circa 1930.

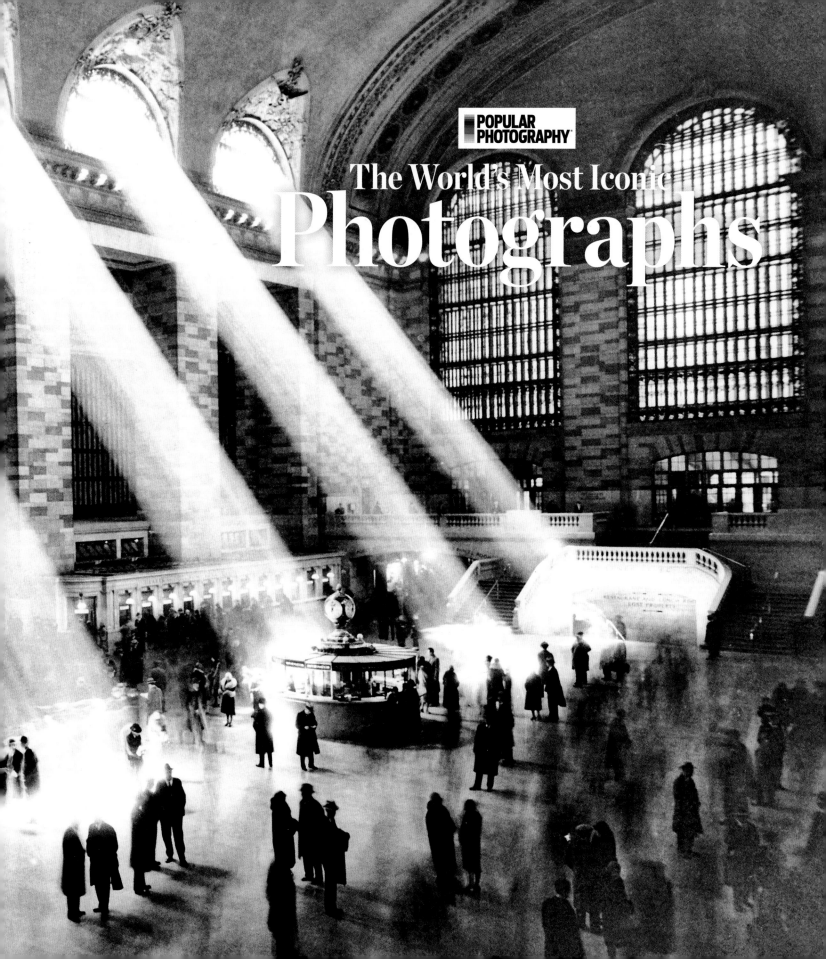

POPULAR PHOTOGRAPHY

The World's Most Iconic
Photographs

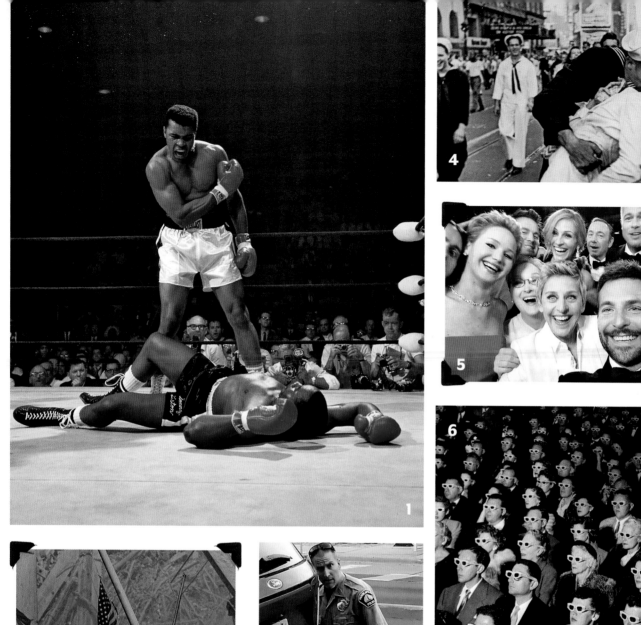

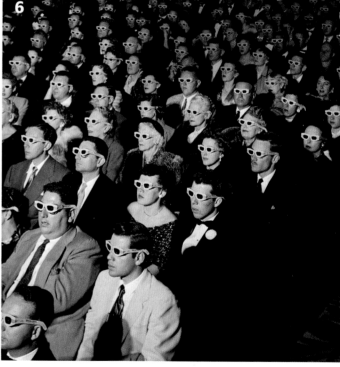

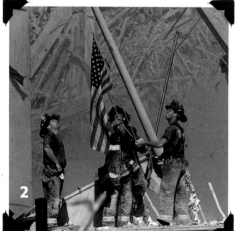

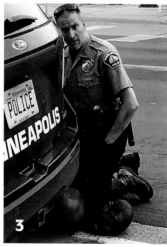

1 *Muhammad Ali triumphantly stands over Sonny Liston on May 25, 1965, in this photo by Neil Leifer.* **2** *Just before sunset on Sept. 11, 2001, three New York City firefighters hoist the American flag over the rubble at ground zero.* **3** *Racism and police brutality are exposed in real time on May 25, 2020, with the death of George Floyd in Minneapolis.* **4** *A sailor and a nurse famously lock lips to celebrate the end of World War II.* **5** *2014 Oscar host Ellen DeGeneres enlists A-list stars to join her for a selfie, taken by Bradley Cooper.* **6** *The audience at a Hollywood screening of Bwana Devil, the first color 3D movie, on Nov. 26, 1952.* **7** *A mushroom cloud forms over Nagasaki, Japan, on Aug. 9, 1945, after the U.S. dropped its second atomic bomb.* **8** *James Dean in the Porsche 550 Spyder he'd bought just days before he was killed in a high-speed crash in 1955.* **9** *American soldiers disembark from a landing craft under fire on D-Day on June 6, 1944.* **10** *Richard M. Nixon gives his famous double-V sign as he departs the White House for the final time on Aug. 9, 1974.*

PICTURE THIS

A PHOTO CAN CAPTURE SO MUCH MORE
THAN A SINGLE MOMENT IN TIME.

Try to imagine life without photography: No captured evidence of historical events, social revolutions, thrilling victories, heartbreaking losses, nature scenes, pop culture nostalgia or personal memories—the good, the bad, the embarrassing. Since the first photo was taken nearly 200 years ago (after hours of exposure just to capture a single image) advancements in technology have optimized cameras, both digital and 35 mm. Nowadays, anyone with a smartphone can feel like a skilled shutterbug with just the push of a button (and an array of flattering filters).

Still, the old adage remains true: Every picture tells a story. And it's up to the beholder to listen, albeit with their eyes. This book showcases 139 of the most iconic images ever taken, along with their incredible accounts, from the very first selfie snapped in 1839 to the 2014 Oscars selfie that went viral thanks to the star power of Ellen DeGeneres, Brad Pitt, Meryl Streep, Jennifer Lawrence and Bradley Cooper.

Begin your journey by taking a look back at how far America has come since 1776, with a celebration of its greatest achievements and darkest hours. Inside, you'll find Neil Armstrong's historic walk on the moon and the devastating *Challenger* shuttle explosion; Martin Luther King Jr.'s "I Have a Dream" speech and the Bloody Sunday attack two years later; the release of American hostages in Iran after 444 days and the deadliest terrorist attack on U.S. soil on Sept. 11, 2001; the assassination of John F. Kennedy and the election of the first Black president, Barack Obama.

Around the world, an audience of billions has witnessed global war, the "Wedding of the Century," famine, political expression, natural disaster and, most recently, the coronavirus pandemic that has killed more than 4.3 million people and forever changed the face of the planet. There are also plenty of lighthearted moments to relive: Disneyland's opening day, Woodstock, Michael Jordan's game-winning shot at the 1998 NBA Finals and the 2007 introduction of Apple's iPhone—the invention that revolutionized modern photography.

Where will the art form go next? Perhaps the answer can be found in the pages ahead. As photographer Sally Mann once said, "Photographs open doors into the past, but they also allow a look into the future."

—*Kathleen Perricone*

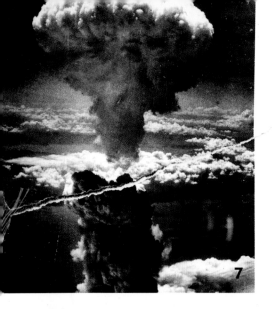

7

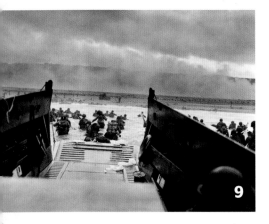

8

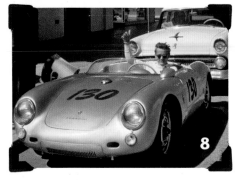

9

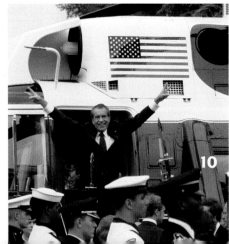

10

CONTENTS

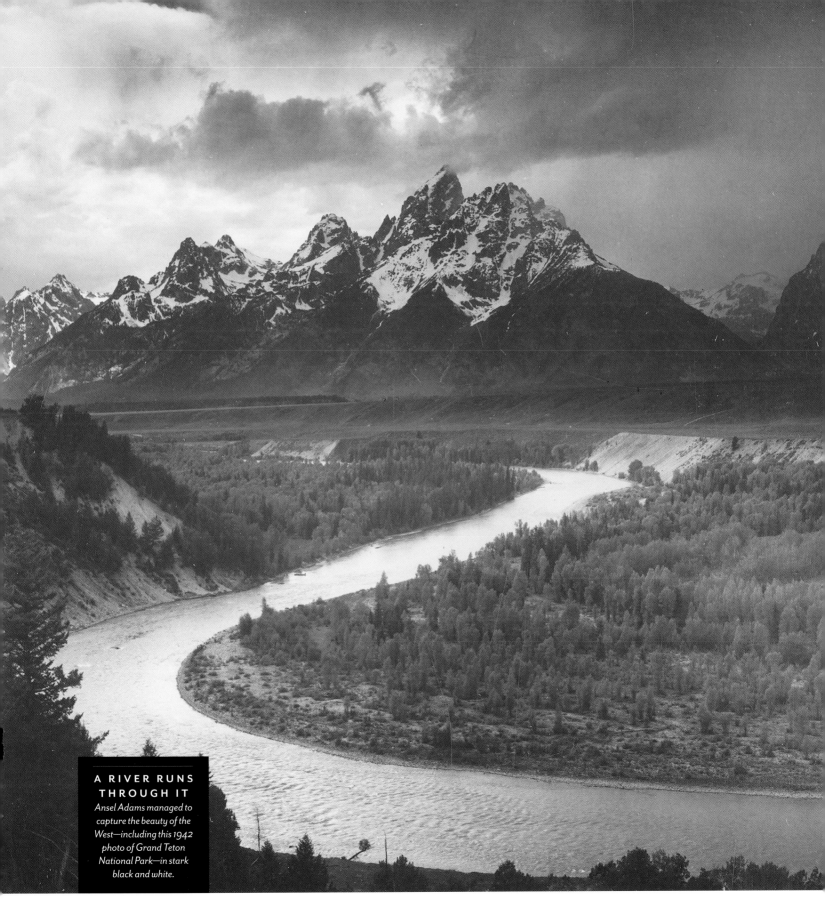

A RIVER RUNS THROUGH IT
Ansel Adams managed to capture the beauty of the West—including this 1942 photo of Grand Teton National Park—in stark black and white.

FIRSTS
IN
PHOTOGRAPHY

IN THE 1830s, DURING THE PRIMITIVE DAYS OF PHOTOGRAPHY, IT TOOK HOURS OF EXPOSURE TO CAPTURE A SINGLE IMAGE. EVEN AS EARLY INVENTORS PERFECTED THE PHOTOGRAPHIC PROCESS, IT REQUIRED INCREDIBLE PATIENCE AND DEDICATION FROM THE EYE BEHIND THE LENS. IN THE NEARLY 200 YEARS SINCE THE FIRST PHOTOGRAPH WAS TAKEN, TECHNOLOGICAL ADVANCEMENTS ONCE UNIMAGINABLE HAVE ENABLED A DIGITAL IMAGE TO CROSS THE EARTH—AND EVEN SPACE—QUICKER THAN A BLINK OF THE EYE. AND AS AN ART FORM, CONSIDER THESE NOTABLE PIONEERING DEVELOPMENTS.

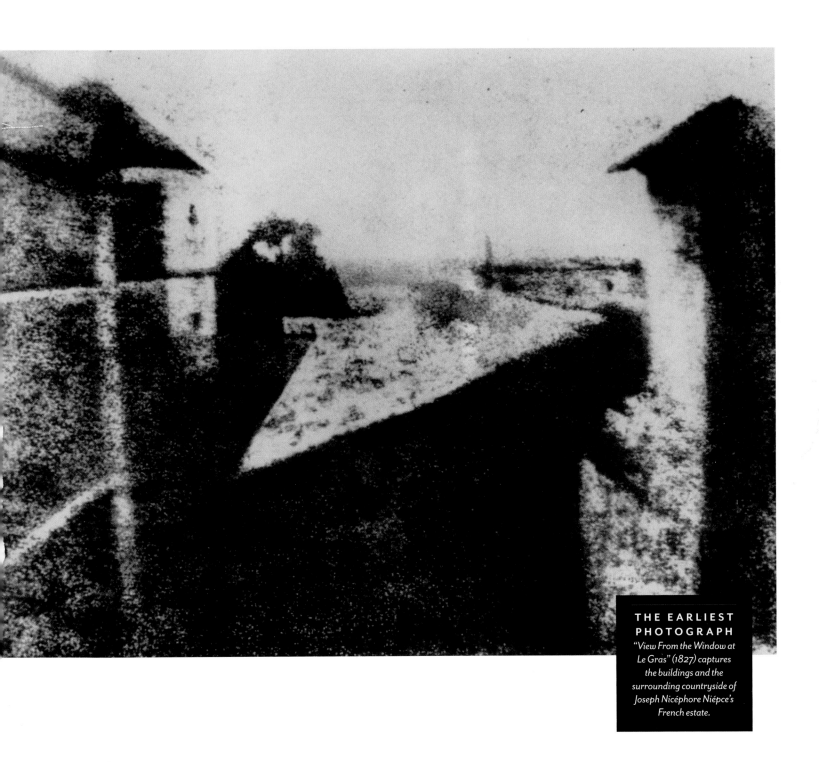

1827 >> FIRST PHOTO *(previous page)*

After serving in the French military, Joseph Nicéphore Niépce returned to his family's estate, Le Gras, France, in 1801. While there, he focused on a number of experiments, including how to use light to reproduce images, which led to heliography, a process that focused a camera obscura (an ancestor of an early photographic camera) onto a coated pewter plate. He then set up his contraption to look out on the countryside, and after an eight-hour exposure, Niépce captured a photo he titled "View From the Window at Le Gras."

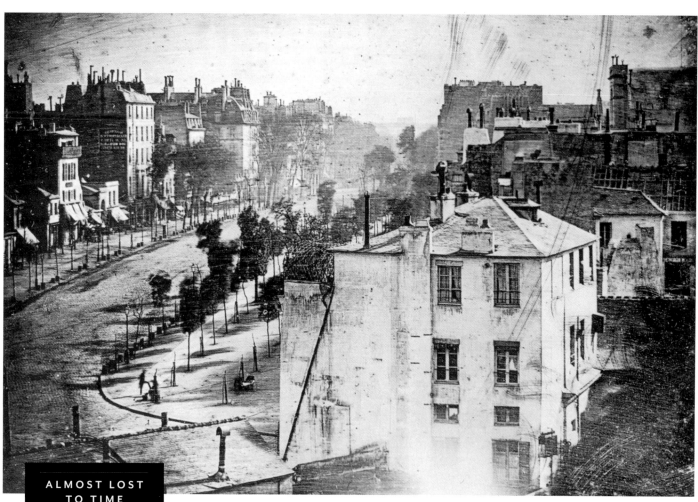

ALMOST LOST TO TIME
Louis-Jacques-Mandé Daguerre's early images were deteriorating until discovered in 1936 and reproduced for display.

1839 >> FIRST HUMANS CAPTURED IN A PHOTO

Twelve years after the first photograph came the next big advancement, when French artist Louis-Jacques-Mandé Daguerre invented a process—later called daguerreotype—in which a sheet of silver-plated copper was treated with fumes to make it sensitive to light. One morning, Daguerre pointed his camera out his Paris window at Boulevard du Temple. Pedestrians traveled in and out of frame during the 10-minute exposure, making it impossible to capture them, but two people—a shoe shiner and his customer—remained in place, thus appearing on film. (See the lower left area of the image above.)

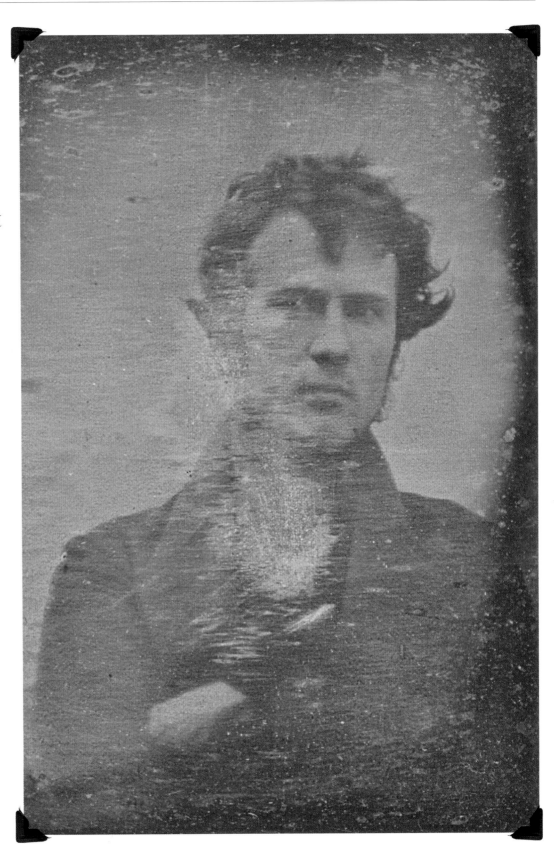

"I have seized the fleeting light and imprisoned it. I have forced the sun to paint pictures for me!"

LOUIS-JACQUES-MANDÉ DAGUERRE

1839 >> FIRST SELFIE

Nearly two centuries before smartphones made selfies a trend, amateur chemist Robert Cornelius snapped his own photo the old-fashioned way. In a back room at his family's store in Philadelphia, the 30-year-old set up his camera, removed the lens cap, ran back into frame and remained still. Cornelius repeated the process a few times until successfully capturing what is considered the first selfie. At the time, however, it had a different meaning to its subject. On the back of the image, Cornelius wrote: "The first light picture ever taken. 1839."

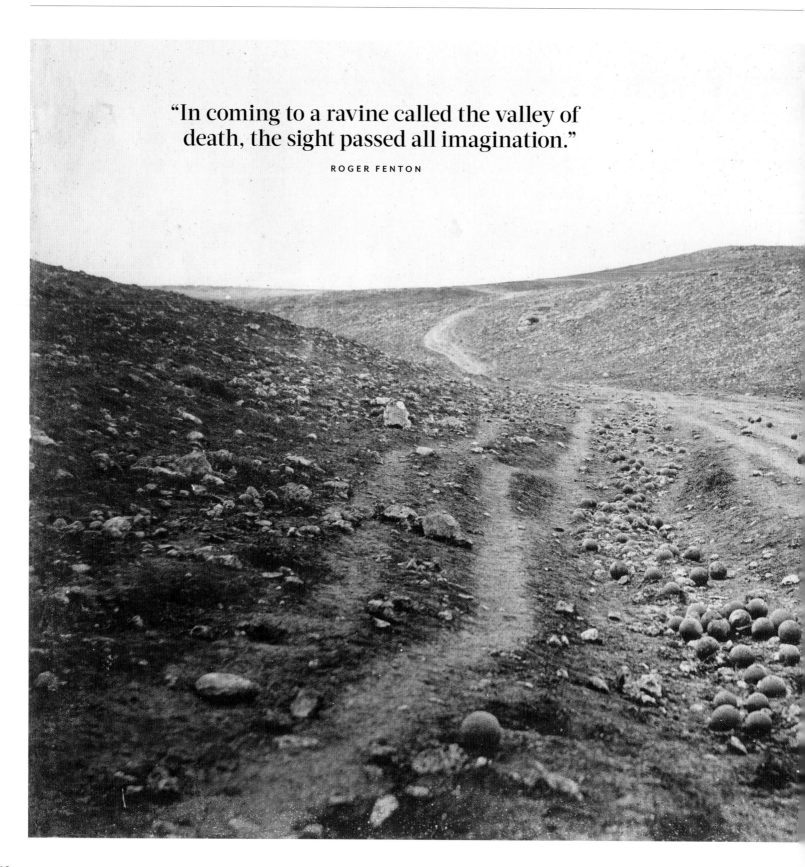

"In coming to a ravine called the valley of death, the sight passed all imagination."

ROGER FENTON

1855 >> FIRST IMAGES BY AN (OFFICIAL) WAR PHOTOGRAPHER

Nearly 30 years after photography was invented, it was used to document conflict. In 1853, war erupted between Russia and the alliance of Great Britain, France and the Ottoman Empire over the rights of Christian minorities in the Holy Land, which was part of the Ottoman Empire. Two years in, the British government hired photographer Roger Fenton to cover the unpopular combat in Crimea and portray the country's success in the war for the *Illustrated London News.* Over the course of his three-month tenure from March to June 1855, Fenton captured soldiers and military leaders and their camps—but did not turn his lens on any of the death or destruction.

Of Fenton's 350 images, his most famous of the Crimean War is "The Valley of the Shadow of Death," taken on April 23, 1855. In the photo, cannonballs shot by the Russians are strewn all over the road. As Fenton described it: "Round shot and shell lay like a stream at the bottom of the hollow all the way down, you could not walk without treading upon them." But in another photo of the same scene, there are no cannonballs on the road, leading some to believe that Fenton had staged the gripping photo.

Although amateur photographers had taken photographs in previous conflicts, Fenton was the first person who was hired by the government and whose pictures were taken specifically for public viewing.

FEAR NO EVIL
The name of Roger Fenton's photo comes from Psalm 23, "The Lord Is My Shepherd," which depicts God as a protector.

1861 >> FIRST COLOR PHOTO

As inventors experimented with different photographic processes, Scottish physicist James Clerk Maxwell was focused on adding color without hand-painting. He theorized that overlapping red, green and blue filters would create a more complex color. In 1861, he presented his photo of a tricolor tartan ribbon at the Royal Institution, but it didn't impress; it was noted that the red and green didn't photograph as well as the blue. It was another 40 years until color photography was perfected.

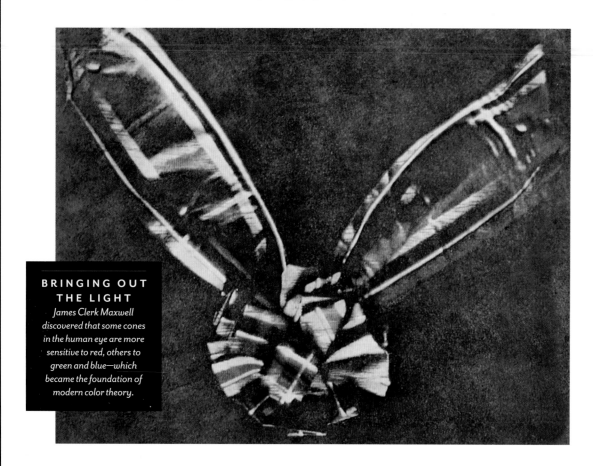

BRINGING OUT THE LIGHT
James Clerk Maxwell discovered that some cones in the human eye are more sensitive to red, others to green and blue—which became the foundation of modern color theory.

"Color is everything, black and white is more."

DOMINIC ROUSE, BRITISH PHOTOGRAPHER

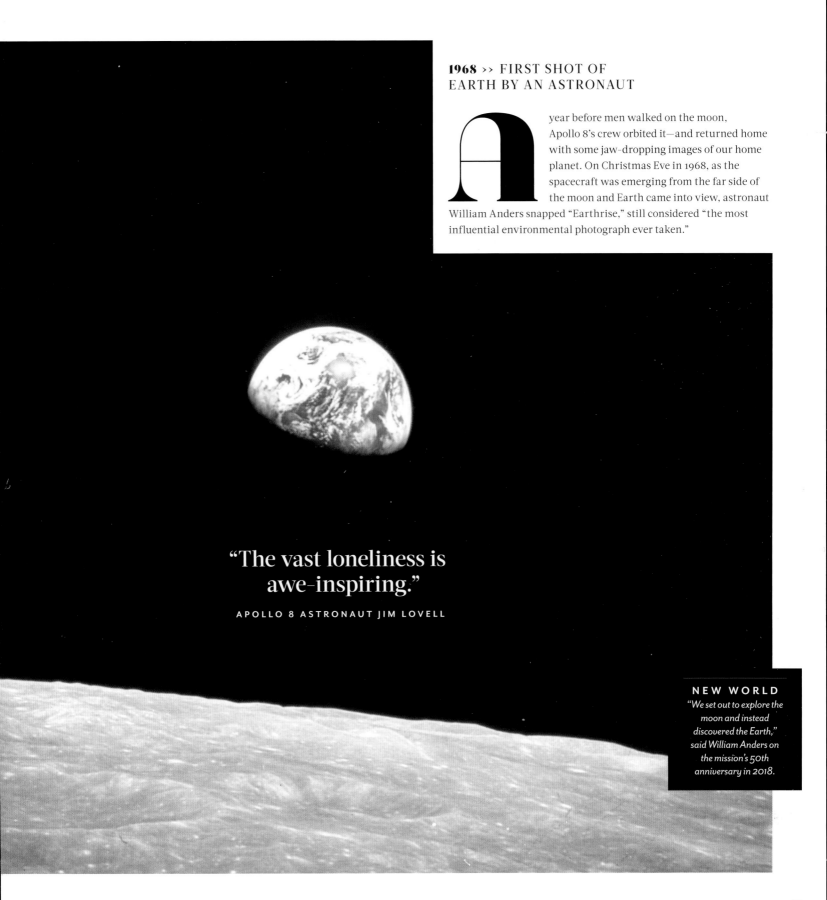

A year before men walked on the moon, Apollo 8's crew orbited it—and returned home with some jaw-dropping images of our home planet. On Christmas Eve in 1968, as the spacecraft was emerging from the far side of the moon and Earth came into view, astronaut William Anders snapped "Earthrise," still considered "the most influential environmental photograph ever taken."

"The vast loneliness is awe-inspiring."

APOLLO 8 ASTRONAUT JIM LOVELL

NEW WORLD
"We set out to explore the moon and instead discovered the Earth," said William Anders on the mission's 50th anniversary in 2018.

1976 >> FIRST PHOTOGRAPH TAKEN ON MARS' SURFACE

On July 20, 1976—after 11 months and half a billion miles in space—Viking 1 became the first craft to successfully land on Mars. Part of a two-part mission to study the Red Planet and search for evidence of extraterrestrial life, the Viking rovers together took more than 14,000 photos and mapped 97% of the Martian surface.

This image from the Viking 1 lander, the first photograph ever taken from the surface of Mars, revealed important clues about the planet's volcanic basalt rock and thin atmosphere that paved the way for future missions. "We couldn't have asked for anything better," said James Martin, the former NASA Langley manager of the Viking mission, "That picture was really worth a thousand words."

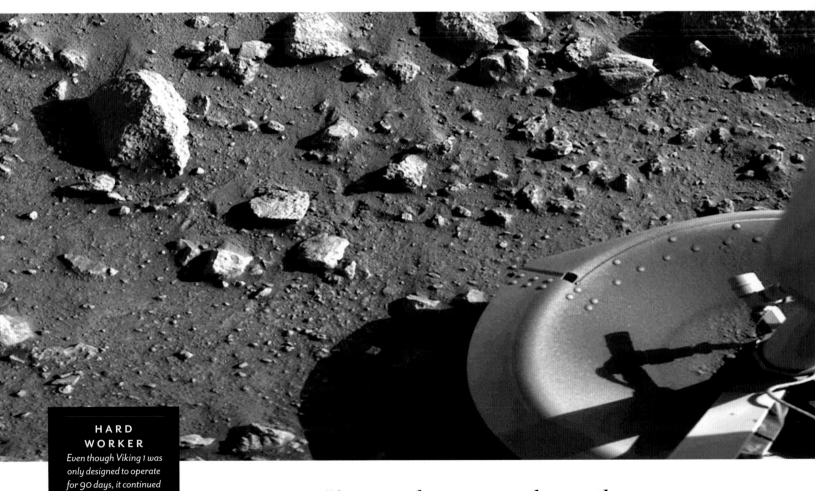

HARD WORKER

Even though Viking 1 was only designed to operate for 90 days, it continued to collect and send data back to Earth for more than six years.

"Are we alone or are there other living things out there?"

VIKING MISSION DIRECTOR TOM YOUNG

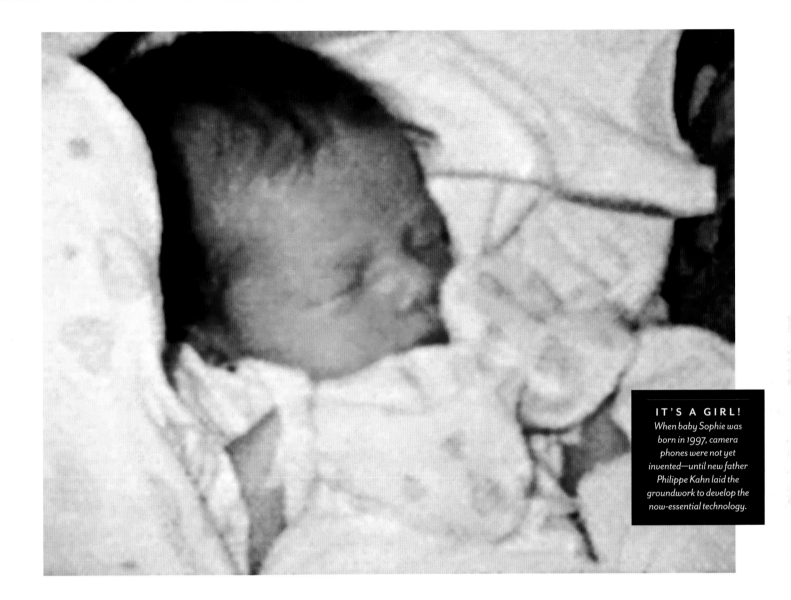

1997 >> FIRST DIGITAL PHOTO SENT VIA CELLPHONE

Cellphone cameras have allowed parents to easily transmit photos to friends and family. So it only makes sense that the first picture ever shared via a cellphone was of a baby. Software entrepreneur Philippe Kahn had been tinkering with technology to instantly share digital images when the birth of his daughter gave him the chance to test it. As his wife was in labor, Kahn wrote code on his laptop, then hooked up a digital camera to his Motorola flip phone. The idea was, the system would dial up his web server, which would upload the image and send an email alert to recipients who could log on and view it. Sounds complicated—but it worked. Within minutes of Sophie's birth, her photo was blasted to 2,000 loved ones.

PHOTOGRAPHY & SCIENCE

THE ART FORM HAS INSPIRED INCREDIBLE ADVANCEMENTS IN MEDICINE AND TECHNOLOGY.

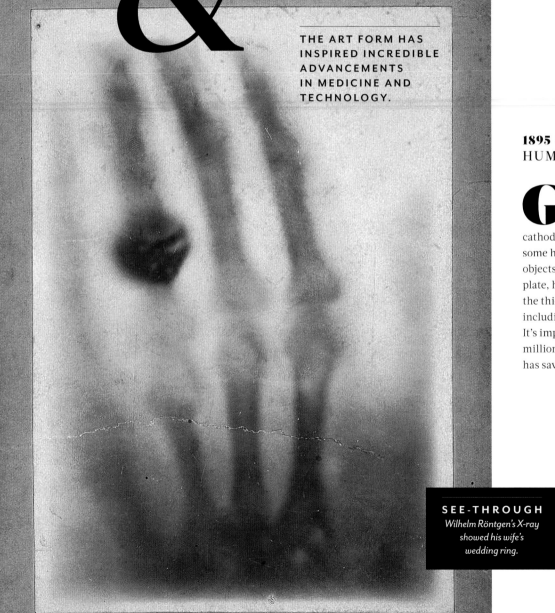

1895 >> FIRST HUMAN X-RAY

German physicist Wilhelm Röntgen was studying the effects of cathode rays when he discovered some had penetrated solid objects. Using a photographic plate, he experimented capturing the thickness of various items, including his wife Anna's hand. It's impossible to say how many millions of lives his invention has saved.

SEE-THROUGH
Wilhelm Röntgen's X-ray showed his wife's wedding ring.

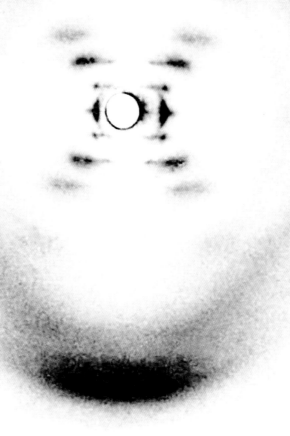

> ## "The instant I saw the picture, my mouth fell open and my pulse began to race."
>
> SCIENTIST JAMES WATSON,
> ON "PHOTO 51"

PHOTO 51
*The first image of
DNA revealed
double-helix strands.*

1952 >> FIRST IMAGE OF DNA

I t was believed all living things carried DNA, the nucleic acid that contained genetic information, but it couldn't be proven—that is, until scientist Rosalind Franklin and PhD student Raymond Gosling were able to capture it on film in London. The two mounted a tiny sample of hydrated DNA inside a camera and then an X-ray beam shone on it for 60 hours until it crystallized.

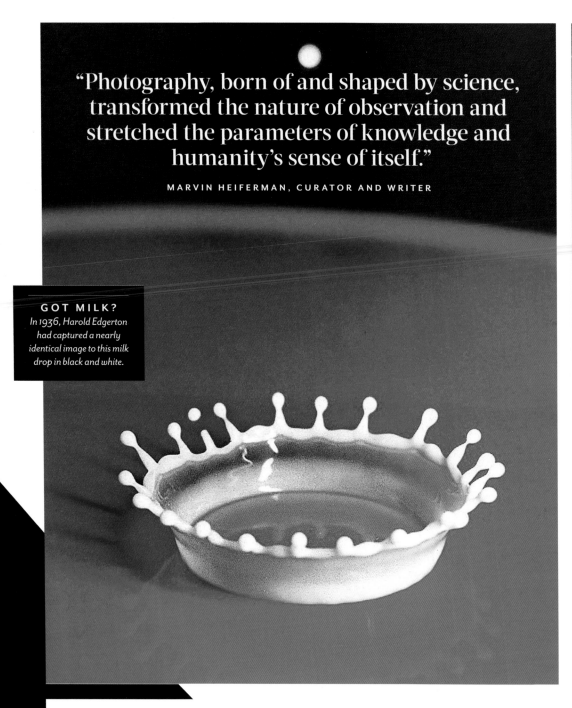

"Photography, born of and shaped by science, transformed the nature of observation and stretched the parameters of knowledge and humanity's sense of itself."

MARVIN HEIFERMAN, CURATOR AND WRITER

GOT MILK?
In 1936, Harold Edgerton had captured a nearly identical image to this milk drop in black and white.

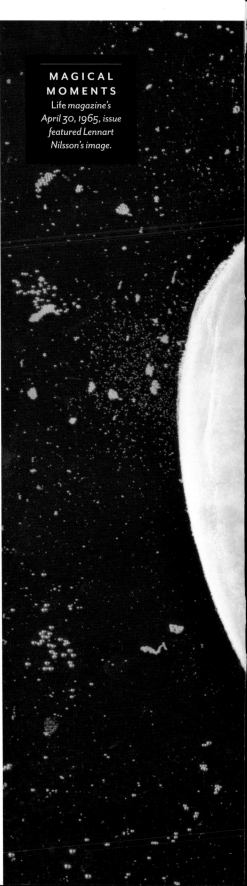

MAGICAL MOMENTS
Life magazine's April 30, 1965, issue featured Lennart Nilsson's image.

1957 >> FIRST STOP MOTION RECORDED

Thanks to Harold Edgerton, there are no longer blink-and-you-missed-it moments. In 1957, he discovered how to capture millisecond motion by using high-tech strobe lights with camera-shutter motors. Edgerton's work, most famously when he froze the moment a drop of milk landed on a table, led to the electric flash.

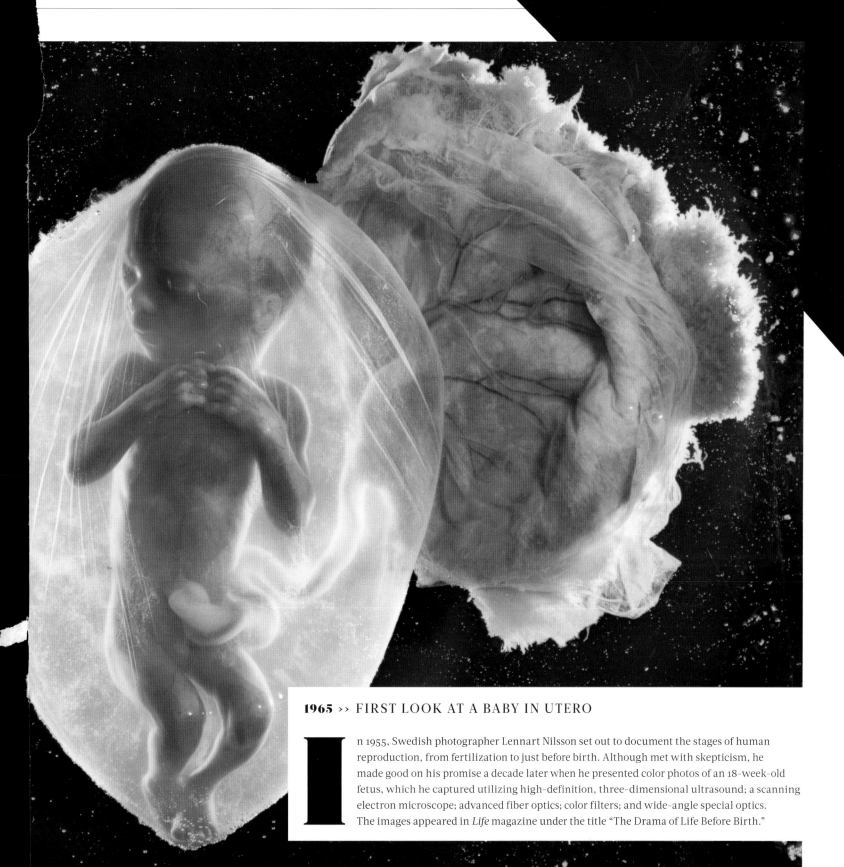

1965 >> FIRST LOOK AT A BABY IN UTERO

In 1955, Swedish photographer Lennart Nilsson set out to document the stages of human reproduction, from fertilization to just before birth. Although met with skepticism, he made good on his promise a decade later when he presented color photos of an 18-week-old fetus, which he captured utilizing high-definition, three-dimensional ultrasound; a scanning electron microscope; advanced fiber optics; color filters; and wide-angle special optics. The images appeared in *Life* magazine under the title "The Drama of Life Before Birth."

AMERICA *THROUGH* THE AGES

IN THE COUNTRY'S RICH HISTORY OVER THE CENTURIES, PIVOTAL EVENTS HAVE INSPIRED AND DEVASTATED US, AND CAMERAS WERE THERE TO BEAR WITNESS. THESE ARE THE TEACHABLE MOMENTS THAT DEFINED OUR NATION'S PAST—AND HAVE HELPED SHAPE ITS FUTURE.

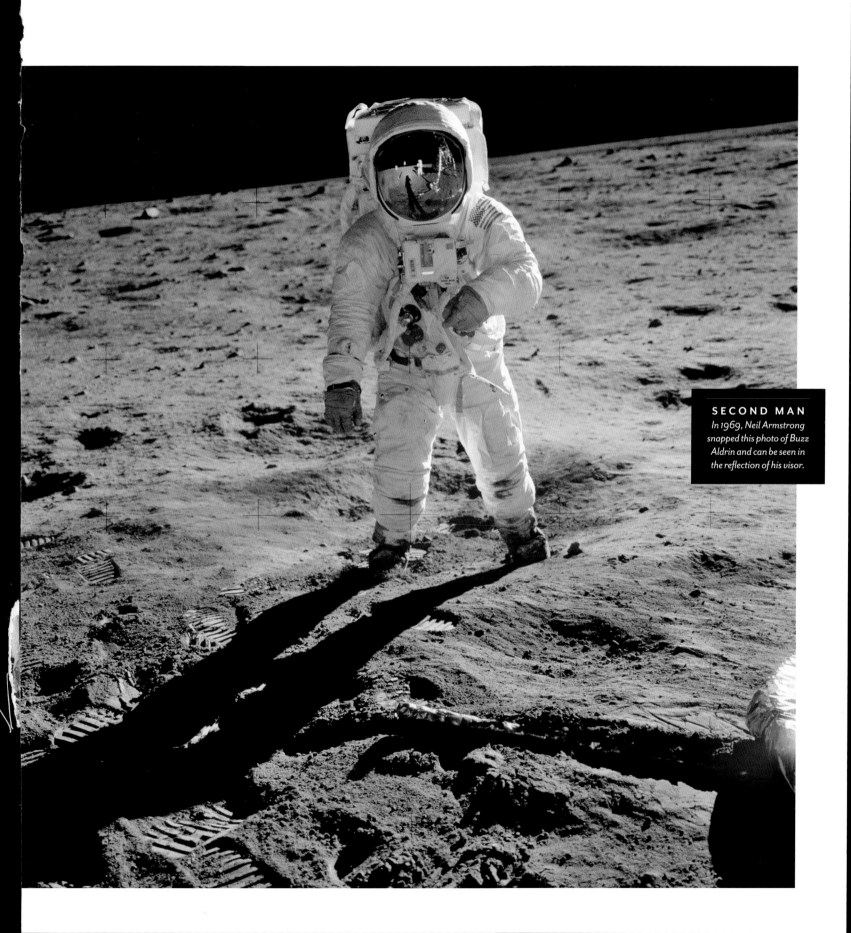

SECOND MAN
In 1969, Neil Armstrong snapped this photo of Buzz Aldrin and can be seen in the reflection of his visor.

1969 » MAN WALKS ON THE MOON
(previous page)

It was one small step for man and one giant leap for mankind when Neil Armstrong walked on the moon on July 20, 1969. As commander of Apollo 11, his objective, along with crewmates Buzz Aldrin and Michael Collins, was to complete a lunar landing. As a half-billion people watched live on TV, Armstrong departed the lunar module Eagle, climbed down its ladder and cautiously placed his left foot onto the powdery, gray surface. Nineteen minutes later, Aldrin joined him on the Sea of Tranquility, a relatively smooth and level area. Over their two-hour exploration, the astronauts photographed the terrain, collected samples, spoke with President Richard M. Nixon and planted a U.S. flag. That night, they slept inside the Eagle on the moon's surface before returning to Earth four days later.

1863 » AMERICA'S CIVIL WAR

A decade after war was first documented in Crimea, America got to see carnage on its own soil during the Civil War. One battle in particular, at Antietam in Sharpsburg, Maryland, on Sept. 17, 1862, claimed more lives in a single day than ever before—and Alexander Gardner was there to capture it all. The Scottish-born photographer used his wet-plate camera to snap dozens of images of dead soldiers and mass burials. Gardner's work later went on display at a New York City gallery, and it haunted all who took in the unfiltered glimpse at war.

One of the most iconic images of the Civil War is "A Harvest of Death," taken after the Battle of Gettysburg on July 4, 1863, by Gardner's associate Timothy H. O'Sullivan. The photograph shows dozens of the thousands of fallen soldiers on the Pennsylvania battlefield and is included in Gardner's two-volume *Photographic Sketch Book of the War* (1866). "The haze of the morning has obscured the details of horses and men in the background," he wrote. "Perhaps their souls are being harvested as well by the reaper on horseback shrouded in the mist of 'A Harvest of Death.'"

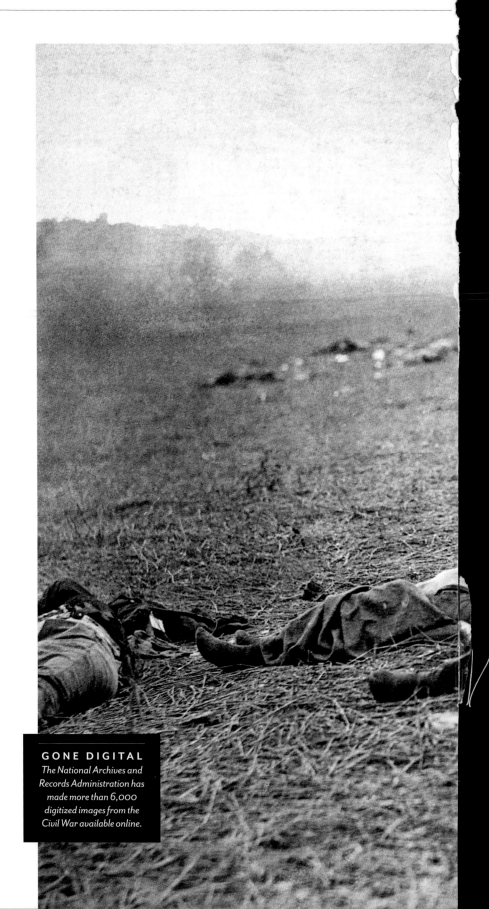

GONE DIGITAL
The National Archives and Records Administration has made more than 6,000 digitized images from the Civil War available online.

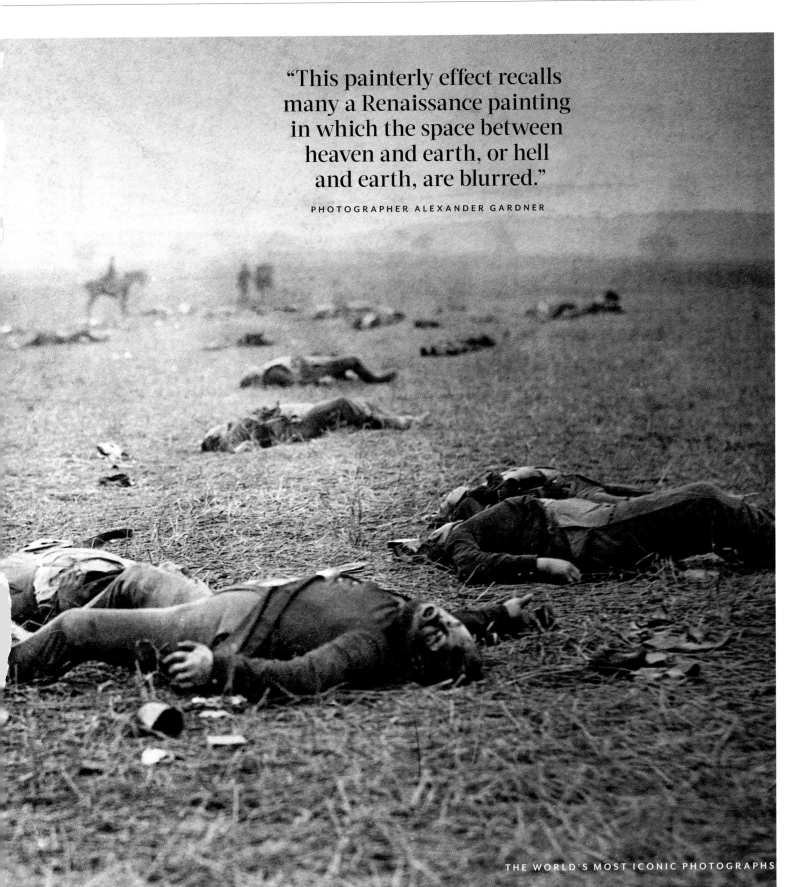

"This painterly effect recalls many a Renaissance painting in which the space between heaven and earth, or hell and earth, are blurred."

PHOTOGRAPHER ALEXANDER GARDNER

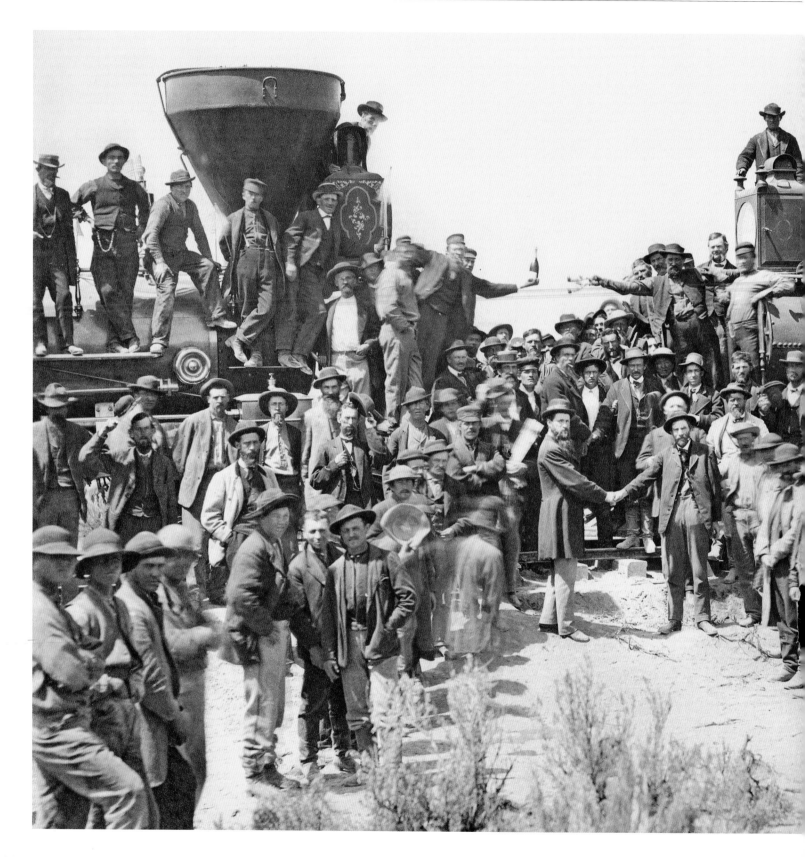

THE FIRST TRANSCONTINENTAL RAILROAD

Traveling in America got a whole lot easier in 1869, when a new railroad in the West was connected to the East's existing railroad, creating the country's first transcontinental rail system. After more than 30 years of discussions, in 1862 Congress finally passed the Pacific Railroad Act, which guaranteed land grants and loans to the Union Pacific and Central Pacific railroad companies. In January 1863, work began to lay the 2,000 miles of track: Central Pacific started in Sacramento, California, and moved east, while Union Pacific broke ground in Omaha, Nebraska, and headed west—until the two teams met six years later in Promontory Point, Utah, on May 10. In a photo from the ceremony, workers from both teams can be seen sharing handshakes and toasting with Champagne.

With the transcontinental railroad, journeys that once lasted weeks by boat or months by wagon now took only days, and the country benefited from a boom in business, population and unity. "The long-looked-for moment has arrived," praised *The New York Times*. "The inhabitants of the Atlantic seaboard and the dwellers on the Pacific slopes are henceforth emphatically one people."

GOLDEN MOMENT

Central Pacific president Leland Stanford drove in the golden Last Spike to connect the two rails. It's now on display at Stanford University.

THE FERRIS WHEEL

For its main attraction at the Chicago World's Fair in 1893, organizers wanted a centerpiece for Paris's world fair, four years earlier. George Ferris Jr., a civil engineer who specialized in bridges, submitted his winning proposal: a 264-foot wheel with 36 suspended carriages, each with 40 revolving chairs, that could carry 2,160 passengers, giving them a bird's-eye view of the fairgrounds.

Each day during the four-month fair, Ferris' wheel wowed 38,000 people. After the exposition ended in October, it was dismantled and rebuilt on Chicago's North Side, where it remained until it was transported to St. Louis for the 1904 World's Fair. Finally, in 1906, it was blown up with 200 pounds of dynamite.

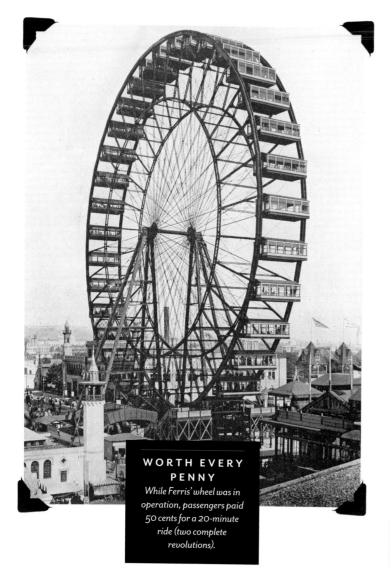

WORTH EVERY PENNY

While Ferris' wheel was in operation, passengers paid 50 cents for a 20-minute ride (two complete revolutions).

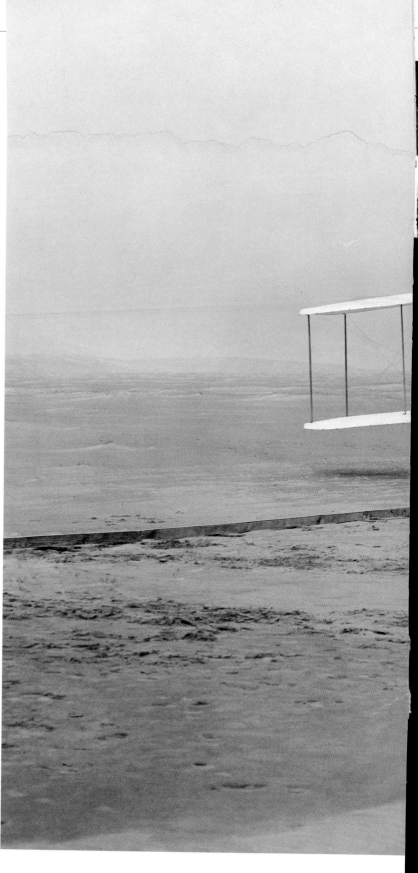

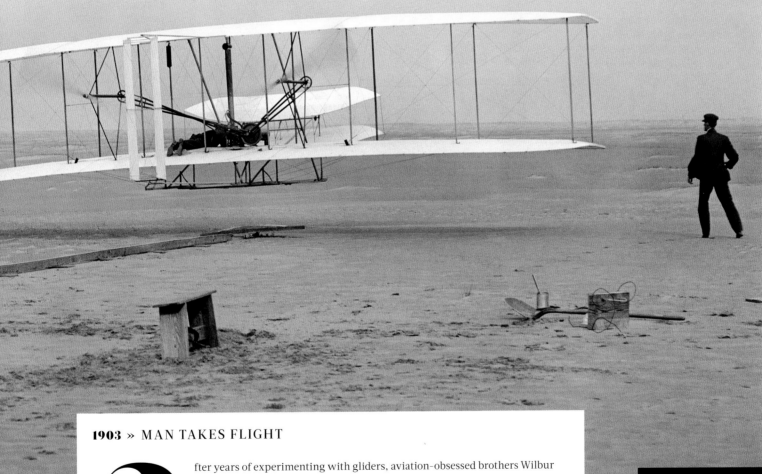

1903 » MAN TAKES FLIGHT

After years of experimenting with gliders, aviation-obsessed brothers Wilbur and Orville Wright added power to their flying machine. On Dec. 17, 1903, they took their *Flyer I* for its inaugural test flight near Kitty Hawk, North Carolina. With Wilbur aboard the aircraft and Orville at the controls, it soared through the air at 6.8 miles per hour for 12 seconds and traveled 120 feet—which was immortalized in a photo that friend John T. Daniels captured using Orville's already positioned camera. Despite the crash landing, three more low-altitude flights followed over the next 90 minutes, each outdoing the previous and culminating with Wilbur's 852 feet journey in 59 seconds—before a gust of wind damaged *Flyer I* beyond repair.

FULL SPEED AHEAD
In 1905, the Wright brothers' Flyer III, the first practical fixed-wing aircraft, completed a 24-mile course in 39 minutes.

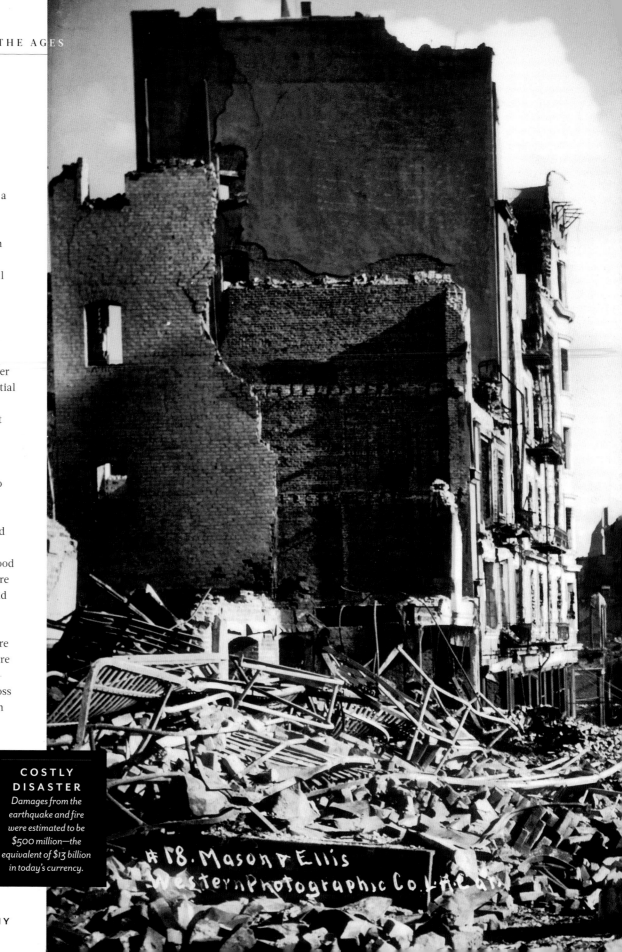

1906 » SAN FRANCISCO EARTHQUAKE

Shortly after 5 a.m. on April 18, 1906, a 7.9 magnitude earthquake rocked the San Francisco Bay area for a solid 60 seconds, sending tremors all the way down to Los Angeles, nearly 400 miles away, and east into central Nevada. But worse than the quake were the subsequent fires that swept through the city. And with water mains destroyed during the initial jolt, firefighters were helpless to battle the roaring blazes that burned for several days.

At the time, San Francisco was the ninth-largest city in the United States, with 410,000 citizens, and the majority of those were left homeless after the devastating earthquake and fire. As temporary shelter, the Army built thousands of redwood and fir relief houses, which were rented out for $2 per month, and they were utilized for the next year as the city was rebuilt. In the end, 28,000 buildings—more than 80% of San Francisco—were destroyed and 3,000 people killed, making it the greatest loss of life from a natural disaster in California history.

COSTLY DISASTER

Damages from the earthquake and fire were estimated to be $500 million—the equivalent of $13 billion in today's currency.

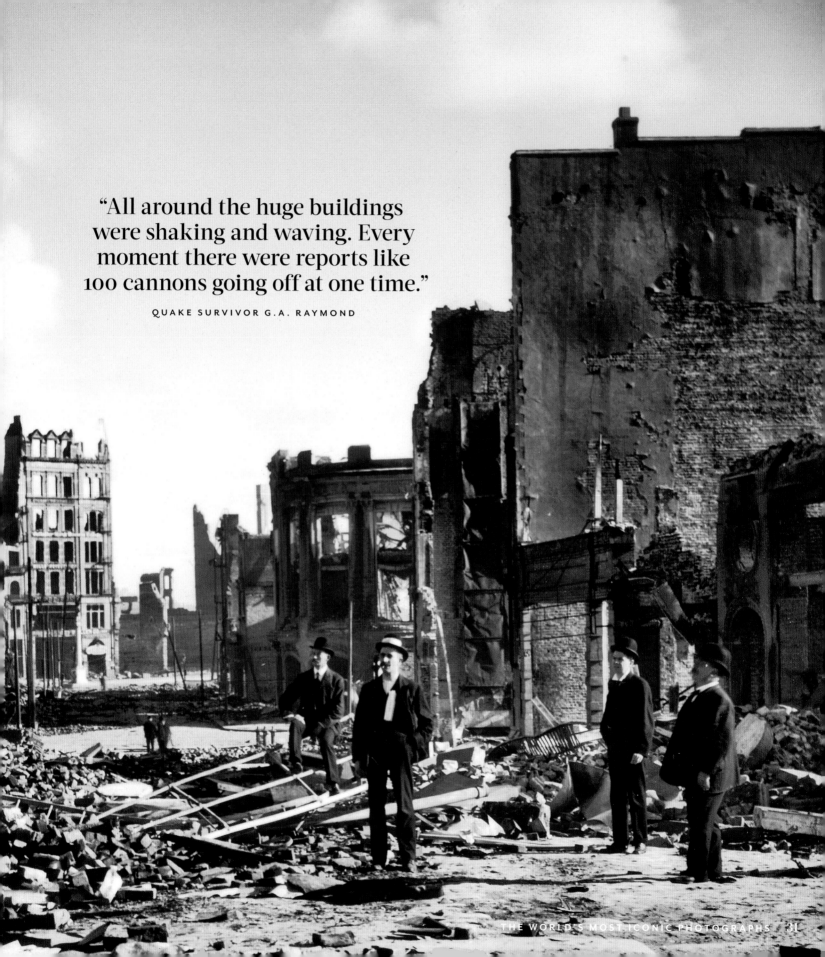

"All around the huge buildings were shaking and waving. Every moment there were reports like 100 cannons going off at one time."

QUAKE SURVIVOR G.A. RAYMOND

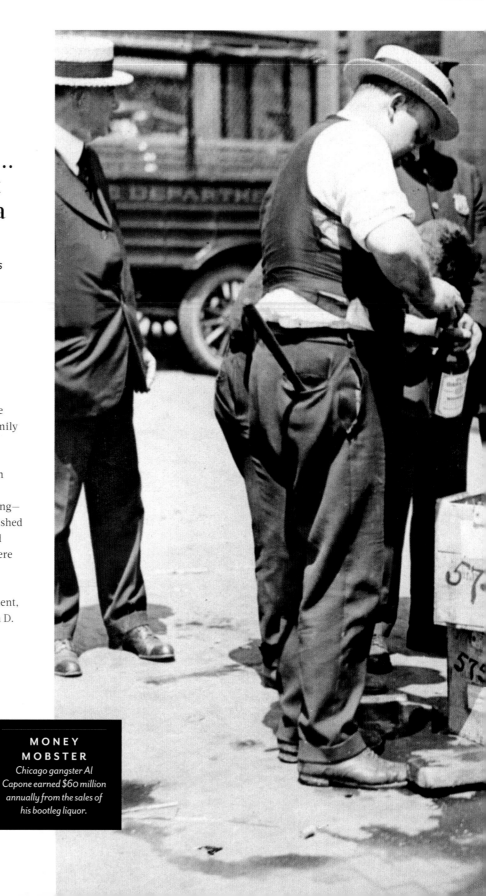

"Five years into Prohibition... it was already evident that the dream of a dry America had crumbled."

THE PROHIBITION ERA IN THE UNITED STATES BY GUSTAVO VÁZQUEZ LOZANO

1926 » PROHIBITION

The roaring twenties were a little less raucous due to Prohibition. Following the 19th century's rise in alcoholism and family violence, the United States government ratified the 18th Amendment, which banned the manufacture, transportation and sale of liquor, in 1920.

But many Americans resisted being "dry," and bootlegging—the illegal act of manufacturing and selling alcohol—flourished during this time. To combat the activity, federal agents and local police would raid private homes and speakeasies, where people would gather to drink illegally, and pour out all the bottles of moonshine.

In 1933, the 21st Amendment repealed the 18th Amendment, and Prohibition came to an end—which President Franklin D. Roosevelt celebrated with a dirty martini.

MONEY MOBSTER
Chicago gangster Al Capone earned $60 million annually from the sales of his bootleg liquor.

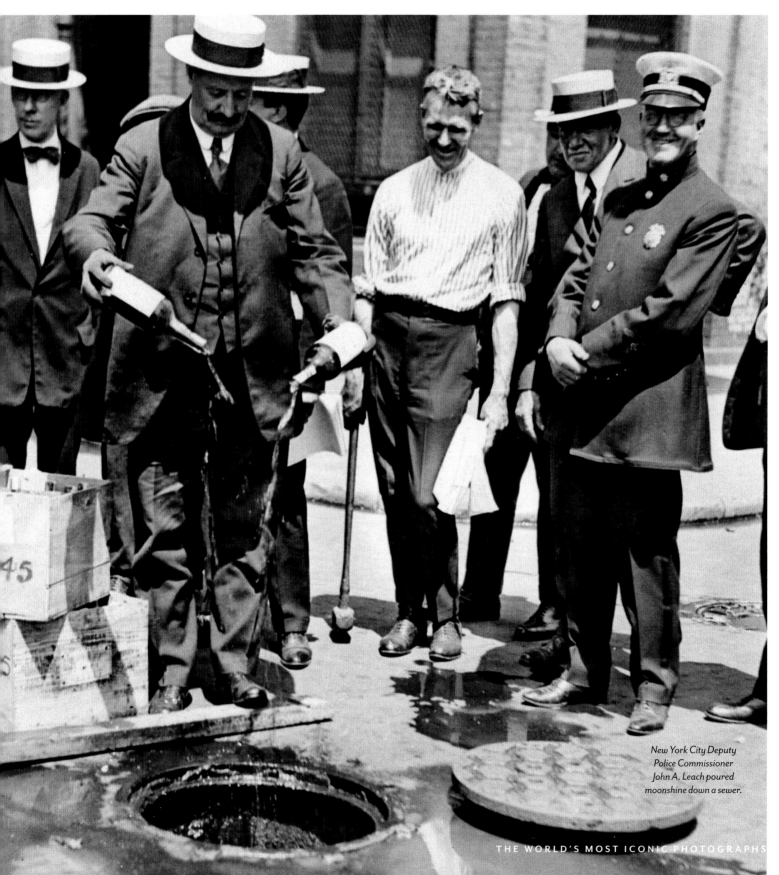

New York City Deputy Police Commissioner John A. Leach poured moonshine down a sewer.

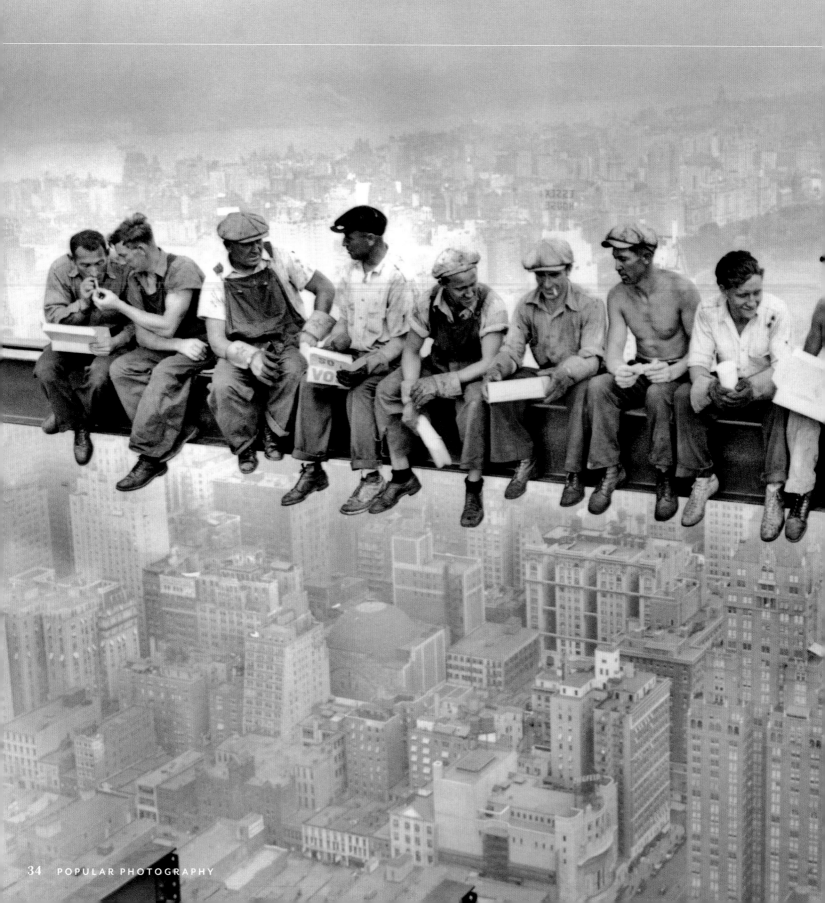

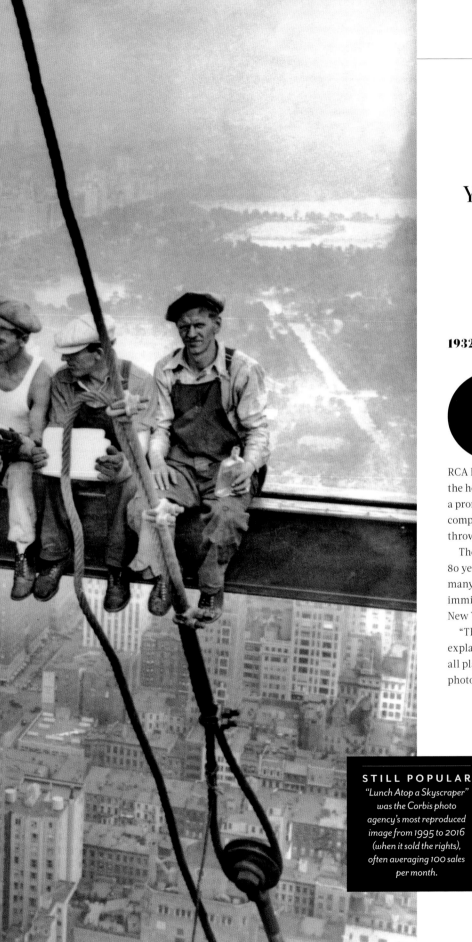

"This is a photograph in which every element of photography and of New York City come together with spectacular panache."

DOCUMENTARY FILMMAKER RIC BURNS

1932 » LUNCH ATOP A SKYSCRAPER

One of the most popular images of 20th-century America is not entirely what it seems. "Lunch Atop a Skyscraper" shows 11 ironworkers, perilously perched on a narrow crane 69 stories above New York City, taking a break from constructing the RCA Building. And while there was no trickery involved in creating the heart-stopping photograph, it was actually staged as part of a promotional campaign for 30 Rockefeller Center's skyscraper complex. In other images from the same day, the men are shown throwing a football and pretending to sleep on a metal girder.

The identities of the workers had remained a mystery for 80 years, until the 2012 documentary *Men at Work*—which traced many of them back to their roots as Irish, Italian and Slovak immigrants who were responsible for constructing much of New York City's skyline in the early 20th century.

"There are so many unknowns," filmmaker Seán Ó Cualáin explained to the Smithsonian. "They could be anybody. We can all place ourselves on that beam. I think that is why the photograph works."

STILL POPULAR
"Lunch Atop a Skyscraper" was the Corbis photo agency's most reproduced image from 1995 to 2016 (when it sold the rights), often averaging 100 sales per month.

1945 » RAISING THE FLAG ON IWO JIMA

On Feb. 23, 1945, a team of U.S. Marines summited Mount Suribachi on the south side of the Japanese island of Iwo Jima. After four brutal days of fighting, they raised a small flag to the cacophonous celebration of Marines on the volcanic island and sailors on the beach below. But the flag was too small to be easily visible from the north side of the island, so top brass ordered that a second, larger flag be raised. Joe Rosenthal, a photographer with the Associated Press, scrambled to the top of the mountain just in time to see six Marines preparing to replace the flag.

Rosenthal sprang into action, stacking rocks and sandbags to construct a makeshift platform where he would have a better vantage point. "I swung my camera around and held it until I could guess that this was the peak of the action, and shot. I couldn't positively say I had the picture. It's something like shooting a football play; you don't brag until it's developed," Rosenthal says in his AP Oral History interview.

Though captured serendipitously, Rosenthal's snapshot of this brief moment became one of the most iconic photographs of World War II—and the 20th century. "Raising the Flag on Iwo Jima" went on to inspire the construction of the Arlington Marine Corps War Memorial in Virginia in 1954, a monument dedicated to all Marines who have given their lives in defense of the United States since 1775.

NOT OVER YET
Though to many Americans the flag raising symbolized triumph in Japan, the Battle of Iwo Jima would rage on for another month. Nearly 7,000 U.S. Marines were killed in action there, and the war itself did not end for another six months.

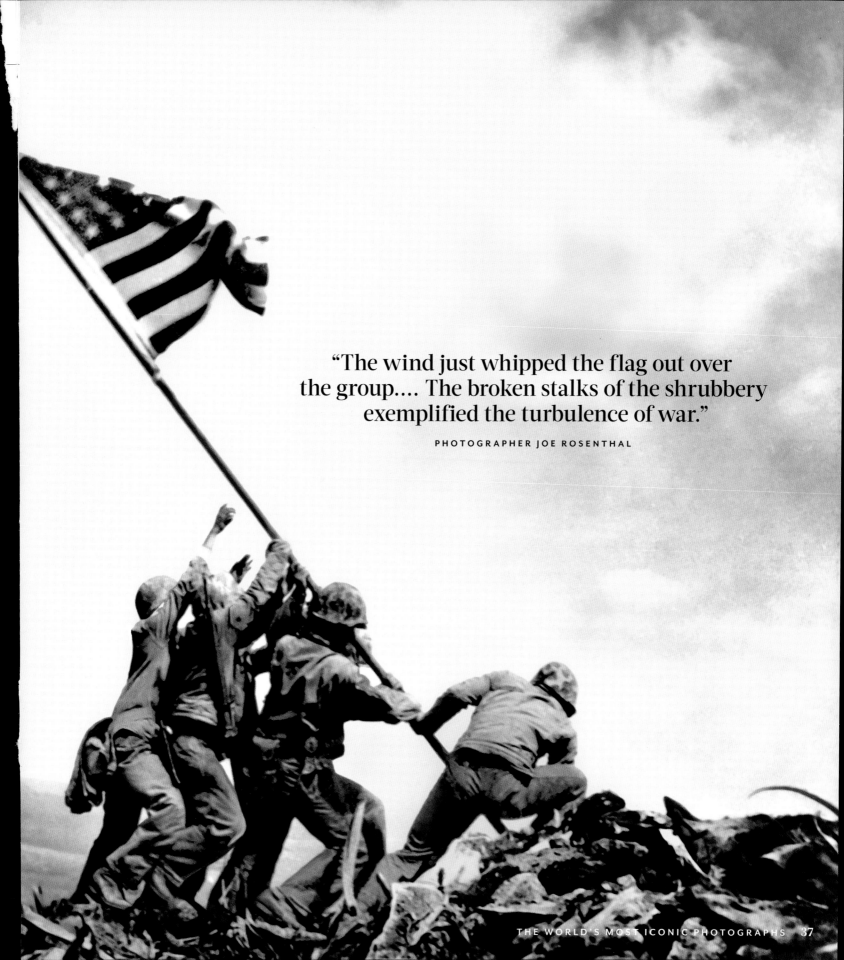

"The wind just whipped the flag out over the group.... The broken stalks of the shrubbery exemplified the turbulence of war."

PHOTOGRAPHER JOE ROSENTHAL

1945 >> V-J DAY IN TIMES SQUARE

When Japan surrendered to the Allies on Aug. 14, 1945, effectively ending World War II, the jubilation was especially strong in America. That day, *Life* magazine photographer Alfred Eisenstaedt took to the streets of New York City, hoping to capture that excitement on film. Little did he know he wouldn't have to do much to find it: As he walked through Times Square with his camera, he noticed an amorous Navy sailor celebrating Victory over Japan Day with his lips.

"He was grabbing every female he could find and kissing them all—young girls and old ladies alike," recalled Eisenstaedt. "Then I noticed the nurse standing in that enormous crowd. I focused on her—and, just as I'd hoped, the sailor came along, grabbed the nurse and bent down to kiss her"—and with that, he snapped what is arguably the most romantic photograph of all time. "People tell me that when I'm in heaven, they will remember this picture."

Over the years, a handful of men and women have claimed to be the famous lip-lockers, but George Mendonsa and Greta Friedman are believed to be the real subjects of this timeless kiss.

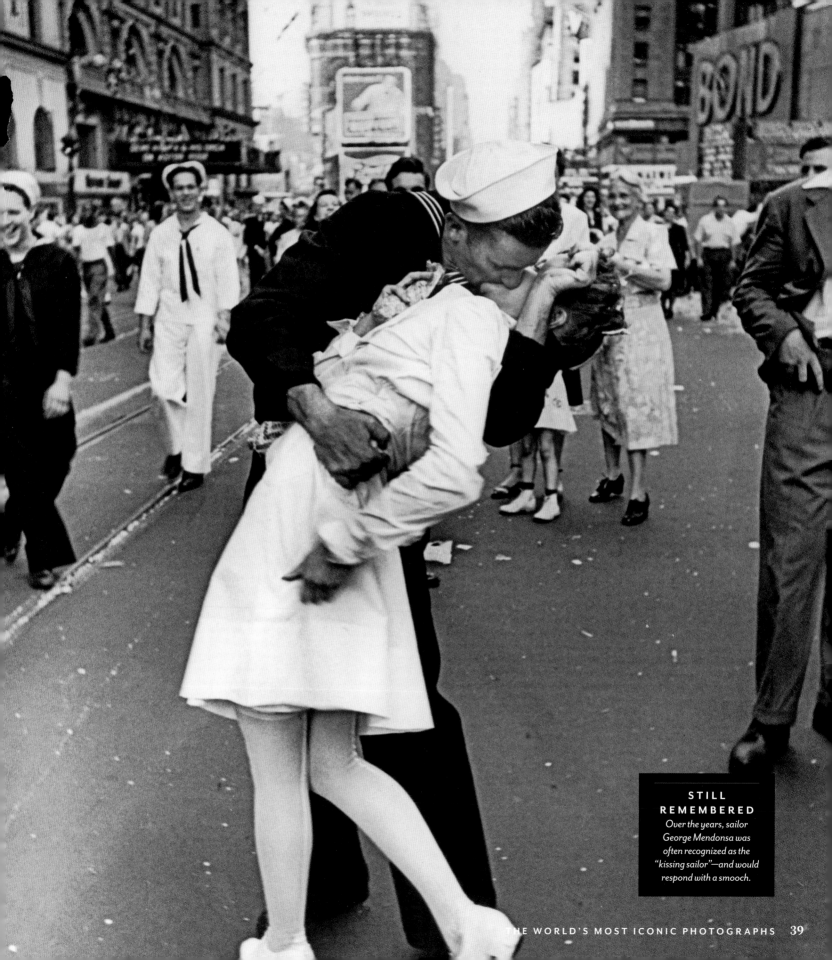

STILL REMEMBERED
Over the years, sailor George Mendonsa was often recognized as the "kissing sailor"—and would respond with a smooch.

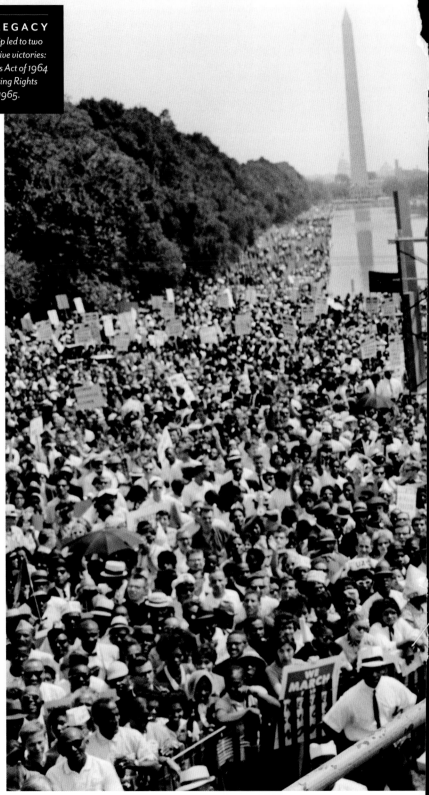

1963 » MARTIN LUTHER KING JR. GIVES "I HAVE A DREAM" SPEECH

The civil rights movement had seen its share of low points in the 1950s and 1960s, with discrimination, segregation and police brutality. But Martin Luther King Jr.'s "I Have a Dream" speech at the March on Washington on Aug. 28, 1963, was a defining moment that finally set change in motion.

Incredibly, the famous phrase almost didn't make it into his speech. King was halfway through it when gospel singer Mahalia Jackson, who had performed "How I Got Over" earlier in the day, called out to him from the side of the stage, "Tell them about the dream, Martin"—and he did just that.

"It is a dream deeply rooted in the American dream," King told the crowd of 250,000 (and millions more watching from home) while standing on the steps of the Lincoln Memorial. "I have a dream that my four little children will one day live in a nation where they will not be judged by the color of their skin but by the content of their character."

Although King's powerful words resonated, it was almost another year before the Senate passed the Civil Rights Act of 1964, which ended segregation in public places and banned employment discrimination on the basis of race, religion or sex.

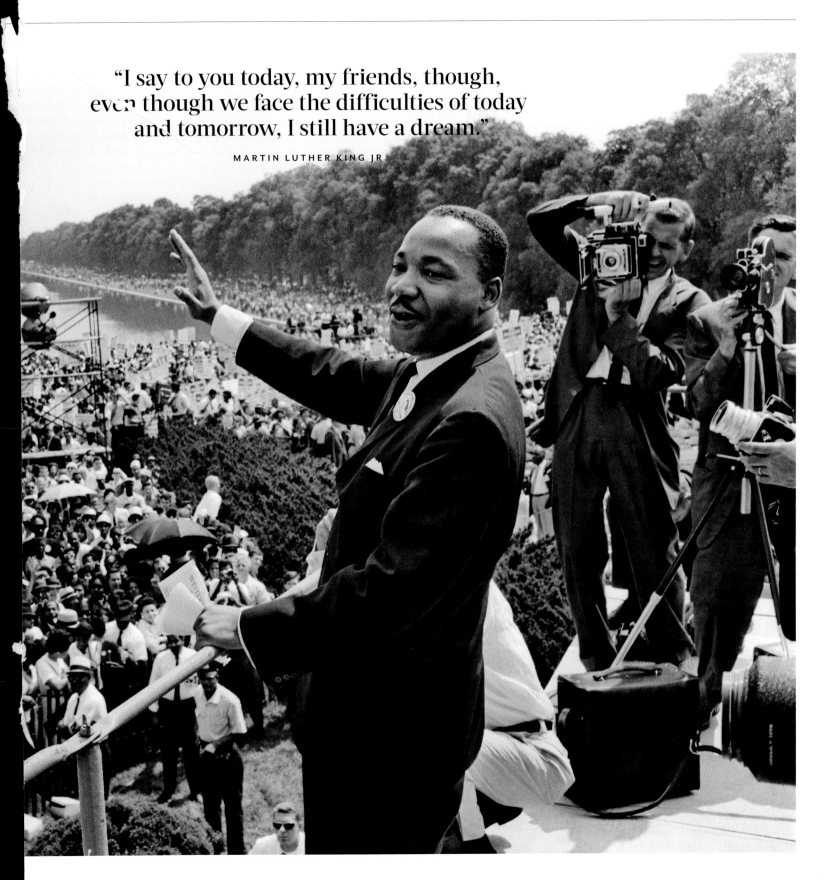

"I say to you today, my friends, though, even though we face the difficulties of today and tomorrow, I still have a dream."

MARTIN LUTHER KING JR.

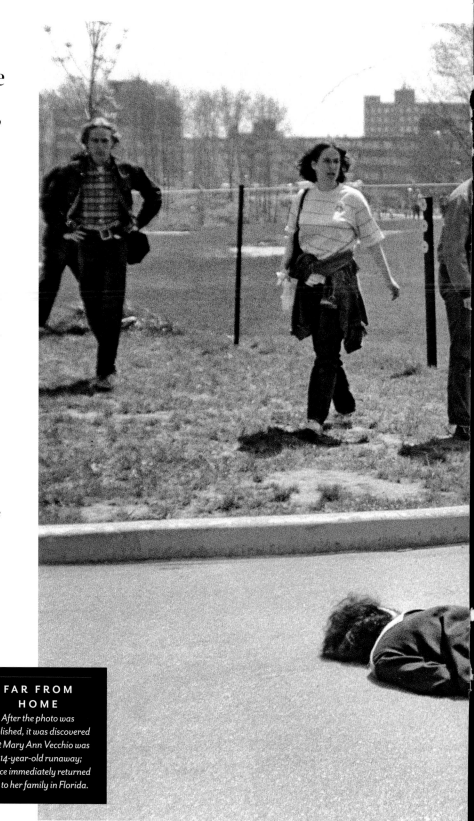

"This should remind us all once again that when dissent turns to violence, it invites tragedy."

PRESIDENT RICHARD M. NIXON

1970 » STUDENTS MASSACRED AT KENT STATE

hen U.S. troops invaded Cambodia during the Vietnam War, 4 million high school and college students expressed their discontent by going on strike. During a demonstration at Kent State University in Ohio, order turned to chaos when National Guard troops opened fire on the protesters, killing four and injuring nine more.

In the days leading up to the massacre, tensions were high in Kent after a night of drunken revelry led to police using tear gas on the unruly crowd. So when 2,000 people gathered at the university's commons on May 4, 1970, the Ohio National Guard were on edge. When the crowd refused to disperse, the soldiers used tear gas, prompting some protesters to lob back the canisters. Shortly afterward, one of the National Guard soldiers inexplicably began firing at the students, which prompted more than two dozen other guardsmen to do the same.

When the 13 seconds of gunfire was over, bodies lay all over Blanket Hill. The horror was captured by student John Filo, who pointed his camera at the body of Jeffrey Miller, who had been walking to class, as Mary Ann Vecchio kneeled over him and wailed in horror.

FAR FROM HOME
After the photo was published, it was discovered that Mary Ann Vecchio was a 14-year-old runaway; police immediately returned her to her family in Florida.

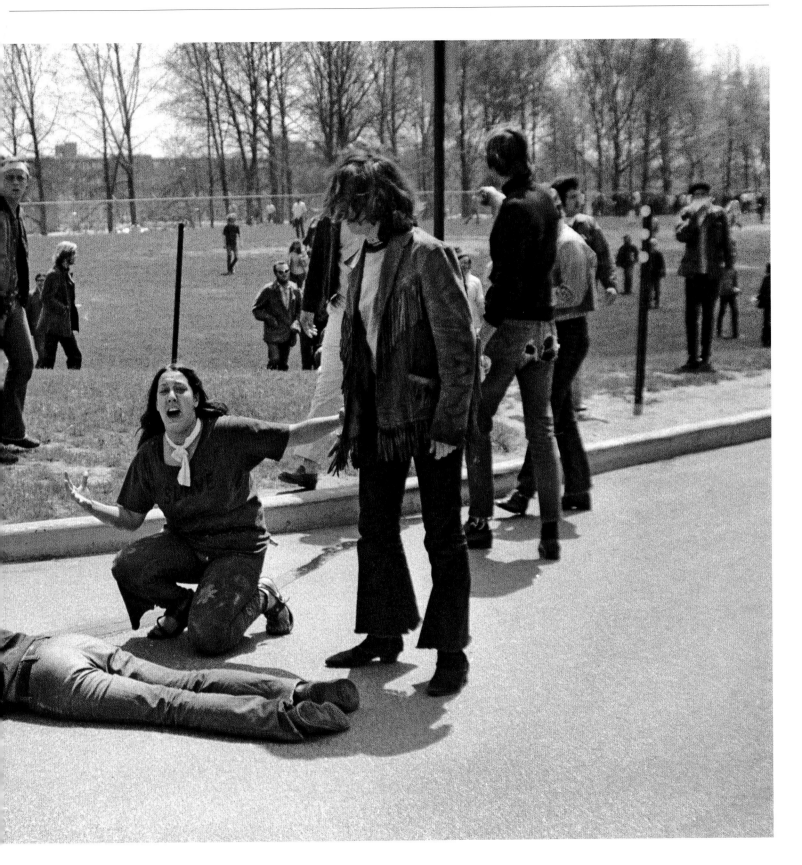

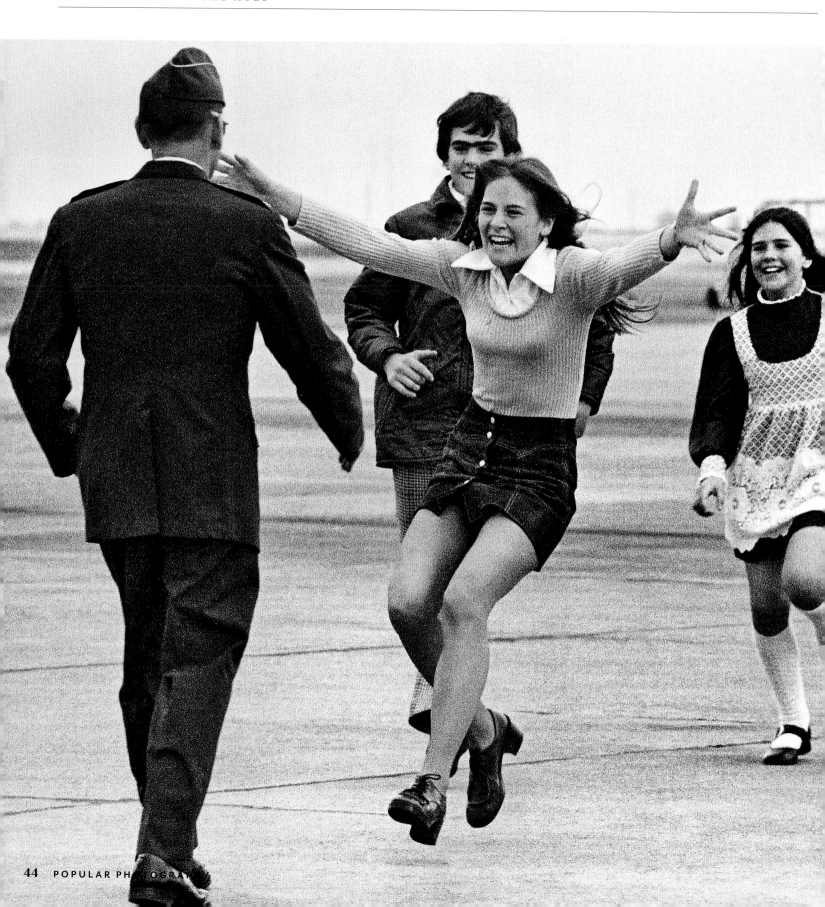

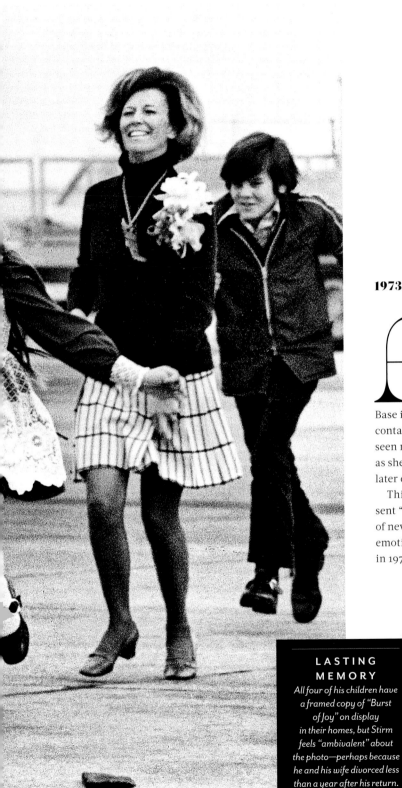

"That moment was all our prayers answered, all our wishes come true."

LORRIE STIRM

1973 » POW COMES HOME

A mid the grim stories coming out of Vietnam, there were a few uplifting moments, such as the return of prisoner of war Lt. Col. Robert L. Stirm, an Air Force fighter pilot who had been shot down over Hanoi in 1967. It had been six years since his wife and four children had seen him, until March 17, 1973, when he landed at Travis Air Force Base in Northern California—and his 15-year-old daughter, Lorrie, could not contain her excitement. In a photograph of their reunion, the young girl is seen running toward her father, arms outstretched, her feet off the ground as she jumps into his arms. "I just wanted to get to Dad as fast as I could," she later explained. "We didn't know if he would ever come home."

Thirty minutes later, Associated Press photographer Slava "Sal" Veder sent "Burst of Joy" out over the wires, and it appeared on the front pages of newspapers all over the country. "You could feel the energy and the raw emotion in the air," described Veder, who won a Pulitzer Prize for the photo in 1974.

LASTING MEMORY
All four of his children have a framed copy of "Burst of Joy" on display in their homes, but Stirm feels "ambivalent" about the photo—perhaps because he and his wife divorced less than a year after his return.

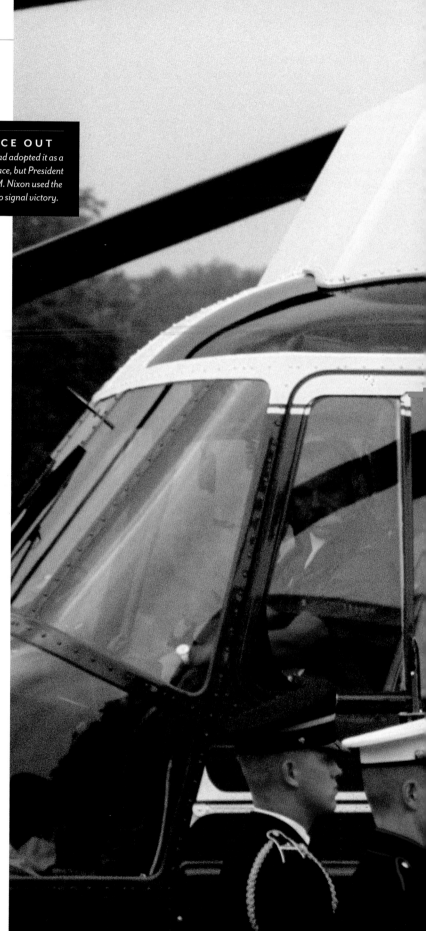

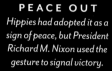

PEACE OUT
Hippies had adopted it as a sign of peace, but President Richard M. Nixon used the gesture to signal victory.

1974 » PRESIDENT RICHARD M. NIXON RESIGNS

During the 1972 presidential election between incumbent Republican Richard M. Nixon and Democratic Sen. George McGovern, five men were caught breaking into the Democratic National Committee headquarters at the Watergate Hotel in Washington, D.C. The subsequent investigation revealed the Nixon administration's attempts at covering up its involvement—and the corruption brought shame upon the president in the eyes of most Americans. Facing impeachment, Nixon chose to resign on Aug. 8, 1974, and allow Vice President Gerald R. Ford to take his place. "I have never been a quitter," he stated in his final speech from the Oval Office, which aired live on television and radio. "To leave office before my term is completed is abhorrent to every instinct in my body. But as president, I must put the interest of America first. America needs a full-time president and a full-time Congress, particularly at this time with problems we face at home and abroad." The next morning, as Nixon left the White House for the last time and boarded the Army One helicopter, he turned to the crowd and bid them goodbye with a hand gesture he had famously made many times over the years: the double-V sign.

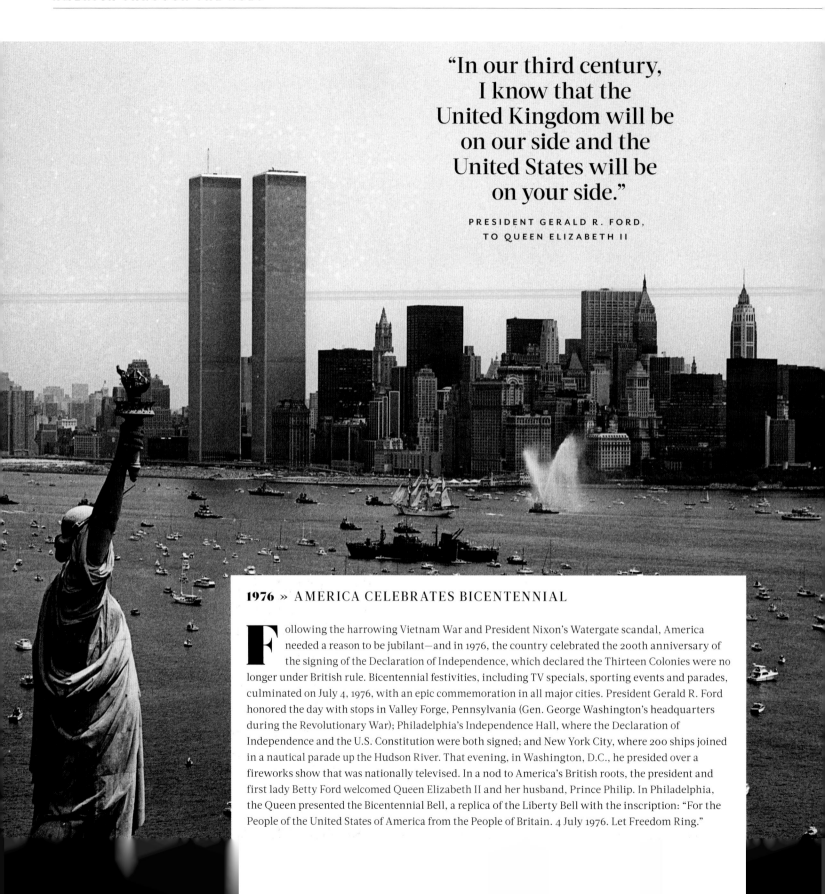

"In our third century,
I know that the
United Kingdom will be
on our side and the
United States will be
on your side."

PRESIDENT GERALD R. FORD,
TO QUEEN ELIZABETH II

1976 » AMERICA CELEBRATES BICENTENNIAL

Following the harrowing Vietnam War and President Nixon's Watergate scandal, America needed a reason to be jubilant—and in 1976, the country celebrated the 200th anniversary of the signing of the Declaration of Independence, which declared the Thirteen Colonies were no longer under British rule. Bicentennial festivities, including TV specials, sporting events and parades, culminated on July 4, 1976, with an epic commemoration in all major cities. President Gerald R. Ford honored the day with stops in Valley Forge, Pennsylvania (Gen. George Washington's headquarters during the Revolutionary War); Philadelphia's Independence Hall, where the Declaration of Independence and the U.S. Constitution were both signed; and New York City, where 200 ships joined in a nautical parade up the Hudson River. That evening, in Washington, D.C., he presided over a fireworks show that was nationally televised. In a nod to America's British roots, the president and first lady Betty Ford welcomed Queen Elizabeth II and her husband, Prince Philip. In Philadelphia, the Queen presented the Bicentennial Bell, a replica of the Liberty Bell with the inscription: "For the People of the United States of America from the People of Britain. 4 July 1976. Let Freedom Ring."

1981 » IRAN HOSTAGES ARE FREED

On Nov. 4, 1979, 66 Americans were taken hostage when a group of Iranian students—furious that the ousted shah of Iran, Mohammad Reza Pahlavi, had received medical treatment in New York City—took over the U.S. Embassy in Tehran. The Ayatollah Khomeini, Iran's political and religious leader, ignored the U.N.'s demand for their release, although he did free female and minority hostages, leaving 52 still in custody. For months, President Jimmy Carter engaged in negotiations that went nowhere; on April 24, 1980, he ordered a military rescue mission, but it failed when two helicopters collided in the desert, killing eight U.S. soldiers. Partly as a result of the mishandling of the crisis, Carter was defeated by Ronald Reagan in the 1980 presidential election.

A month later, in December 1980, Iran agreed to release all hostages as long as the U.S. freed $9 billion of Iranian assets from American banks, which Carter had frozen when the crisis had begun. In a final act of disrespect to the U.S. president, the Iranians waited until the moment Reagan was sworn in on Jan. 20, 1981, to free the hostages after 444 days in captivity. When the Americans landed in West Germany before continuing home to the U.S., Carter was there to greet them—but got the cold shoulder. "Mr. Carter was introduced to us one by one, giving us each a hug," William Daugherty, a former CIA agent, recalled in 1996. "Few embraces were returned with any enthusiasm."

Once back on American soil, the hostages were given a hero's welcome. After reuniting with their families at an air base in upstate New York, they then traveled to Washington and paraded down Pennsylvania Avenue to the White House as 200,000 people cheered and waved flags. "It could not have been any warmer or more memorable," described Daugherty. "I was, and remain so today, immensely grateful for the homecoming our fellow Americans showered on us."

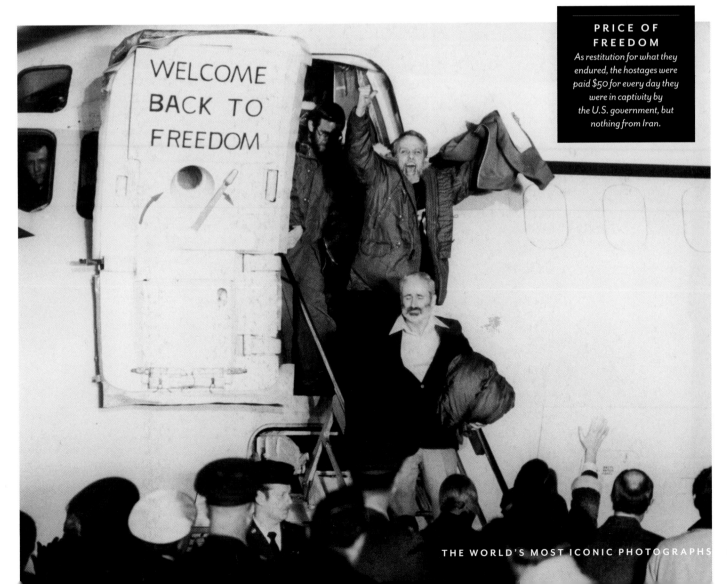

PRICE OF FREEDOM
As restitution for what they endured, the hostages were paid $50 for every day they were in captivity by the U.S. government, but nothing from Iran.

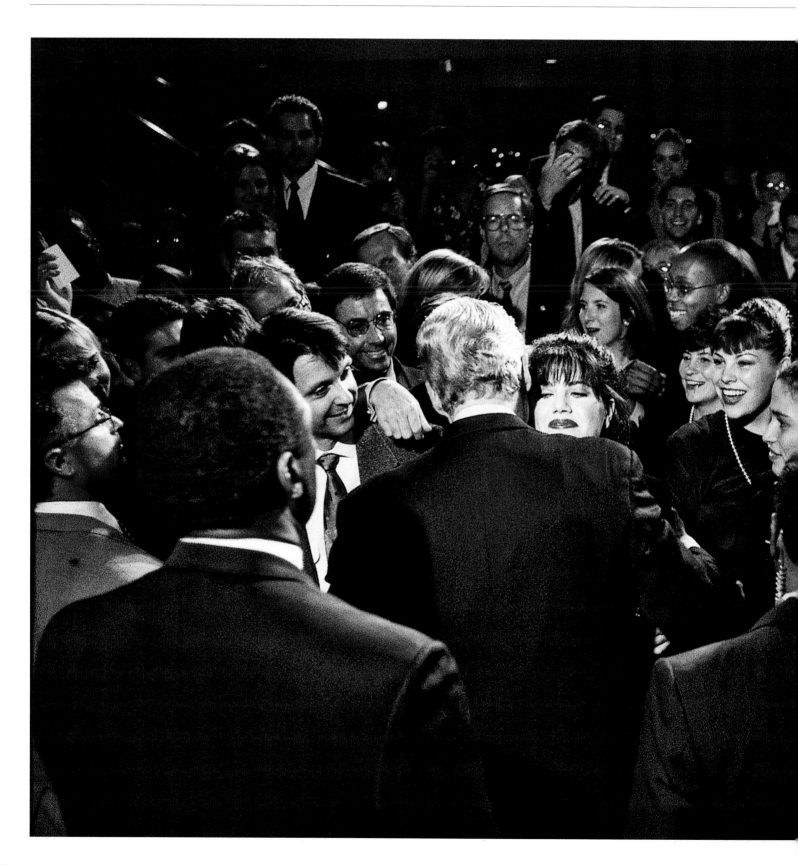

1996 » BILL CLINTON AND MONICA LEWINSKY'S AFFAIR

After it was revealed in 1998 that President Bill Clinton had engaged in a sexual relationship with former White House intern Monica Lewinsky from 1995 to 1997, the media scoured every archive to find footage of the two together. *Time* magazine photographer Dirck Halstead immediately knew the 22-year-old's face but couldn't recall at which Clinton event he had taken her picture. He hired a researcher to comb through 5,000 of his photos until it was discovered four days later: Clinton embracing Lewinsky at a fundraiser for his reelection in Washington, D.C., on Oct. 23, 1996, a year into their affair.

"The circumstances behind that photograph [were] that in the last days of the campaign in 1996, the president was making an appearance before what they called the Saxophone Club, which were young Democrats," Halstead explained.

But *Time* didn't immediately publish the incriminating photo. The magazine waited until Lewinsky decided to go to prosecutors in Paula Jones's sexual harassment suit against Clinton with her testimony about the affair—and then splashed it on the front page of its Aug. 10, 1998, issue.

"They took this kid like a hostage in the nighttime."

DONATO DALRYMPLE, TO *THE WASHINGTON POST*

2000 » ELIÁN GONZÁLEZ DEPORTED TO CUBA

A 6-year-old boy named Elián González was at the center of an international tug-of-war when the boat he and his mother had boarded to flee Cuba sank; his mother drowned, while Elián was saved. After his rescue, the U.S. Immigration and Naturalization Service temporarily placed him with paternal relatives in Miami—who then refused to return him to his father in Cuba.

A U.S. district court ruled that only the father had the right to petition for the boy to receive asylum in America, and since he wanted Elián back in Cuba, Attorney General Janet Reno ordered the Miami relatives to relinquish him. She set a deadline for April 13, 2000, which they ignored.

On April 22, Border Patrol agents knocked on the door but received no response, so they forced entry into the González home. Once inside, they found Elián hiding in a bedroom closet with Donato Dalrymple, one of the fishermen who'd rescued him—and the moment the terrified boy was discovered by an armed agent was instantly captured by Associated Press photographer Alan Diaz.

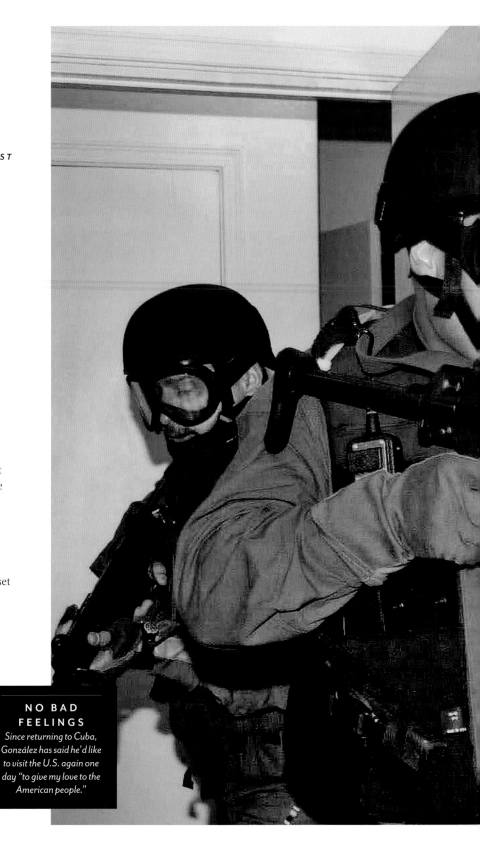

NO BAD FEELINGS
Since returning to Cuba, González has said he'd like to visit the U.S. again one day "to give my love to the American people."

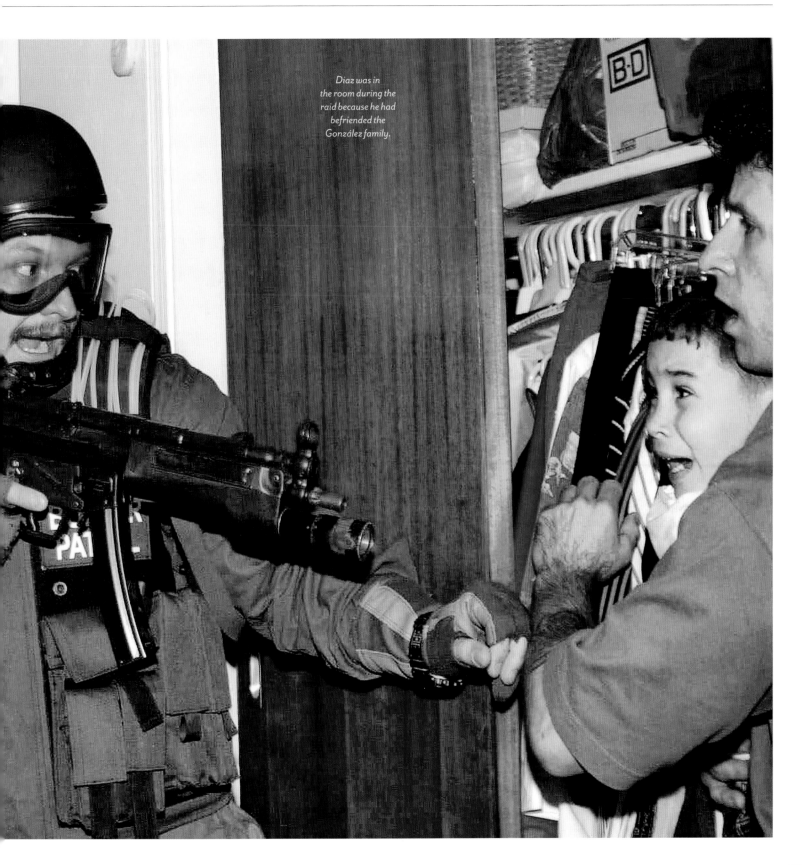

Diaz was in the room during the raid because he had befriended the González family.

2005 » HURRICANE KATRINA AND THE FLOODING OF NEW ORLEANS

Early in the morning of Aug. 29, 2005, Hurricane Katrina made landfall on the Gulf Coast, pummeling Mississippi, Louisiana and Alabama with heavy rains and winds of 100–140 miles per hour. After the initial devastation, the worst was yet to come: In New Orleans alone, the storm surge resulted in 53 levee breaches, which sent floodwaters rushing into the city. Citizens living in low-lying neighborhoods, such as St. Bernard Parish and the Ninth Ward, were forced to scramble to their roofs—some waiting days for rescue.

Despite 80% of New Orleans being under water, relief efforts were astonishingly delayed. More than 700 bodies were later recovered in the flooded areas, in addition to 215 found in nursing homes and hospitals. Six hundred prisoners were abandoned in their locked jail cells at Templeman III— and spent four days without food or power. An investigation resulted in the resignations of FEMA director Michael D. Brown and New Orleans police superintendent Eddie Compass.

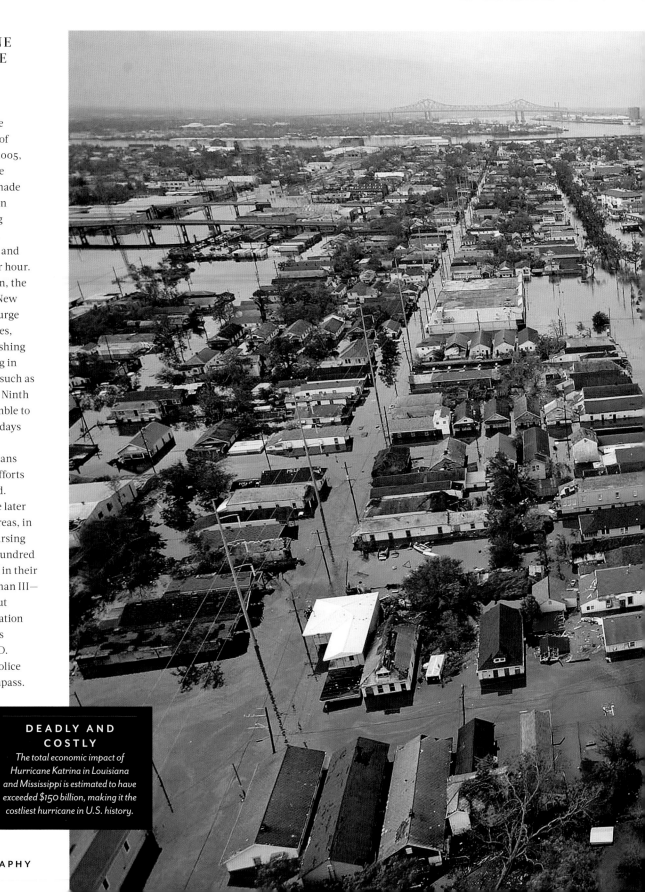

DEADLY AND COSTLY
The total economic impact of Hurricane Katrina in Louisiana and Mississippi is estimated to have exceeded $150 billion, making it the costliest hurricane in U.S. history.

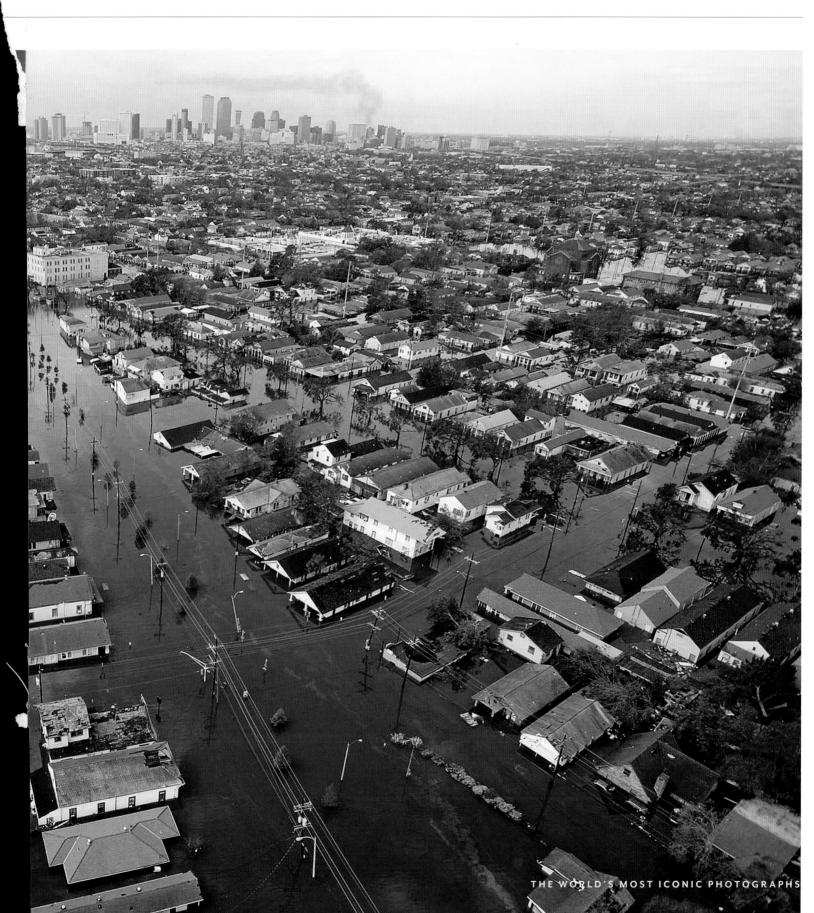

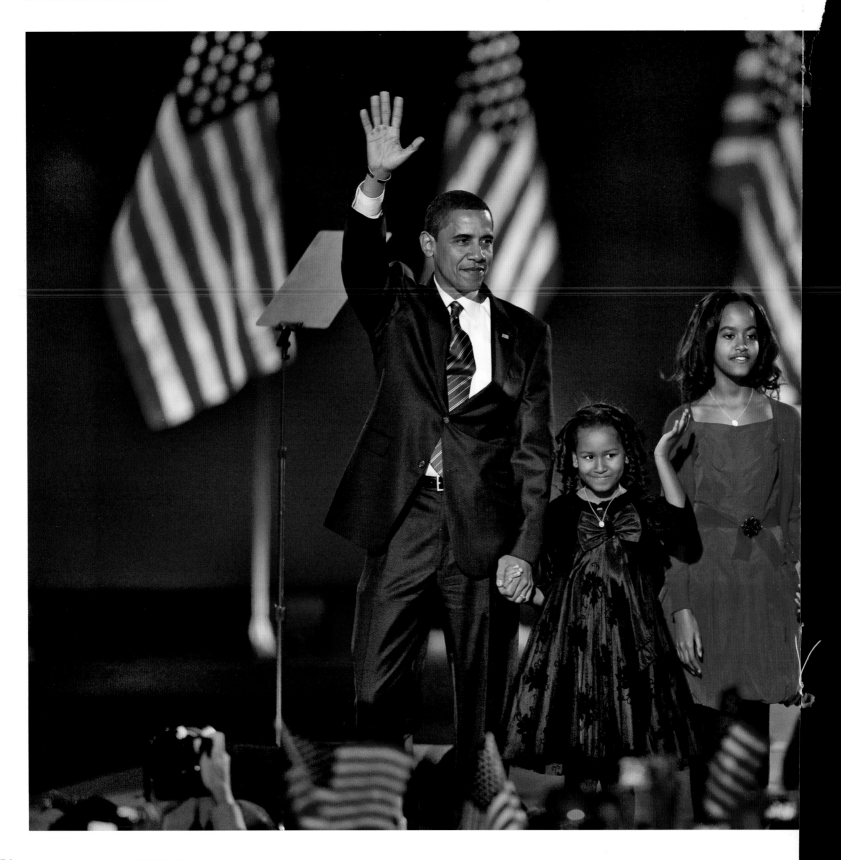

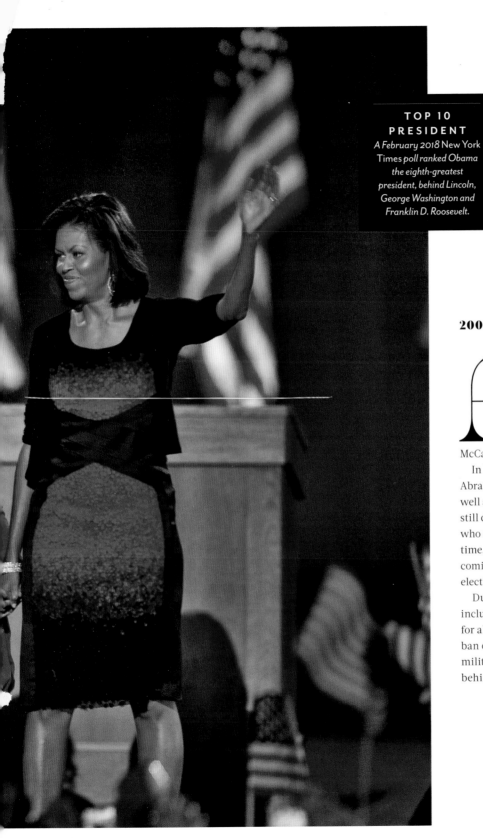

2008 » FIRST BLACK PRESIDENT ELECTED

After 220 years, the U.S. presidency got quite a shake-up on Nov. 4, 2008, when Illinois Sen. Barack Obama was elected, making him the country's first-ever African American commander in chief. The Democrat defeated Arizona Sen. John McCain, 365 electoral votes to 173, with 52.9% of the popular vote.

In his victory speech, Obama cited John F. Kennedy and Abraham Lincoln, two presidents who fought for civil rights, as well as Martin Luther King Jr. "If there is anyone out there who still doubts that America is a place where all things are possible, who still wonders if the dream of our founders is alive in our time…tonight is your answer," he said. "It's been a long time coming, but tonight, because of what we did on this date in this election at this defining moment, change has come to America."

During his two terms, he brought about record reform, including the Affordable Care Act, which provides health care for all citizens, and urged the Supreme Court to strike down the ban on same-sex marriage (see page 58). Obama also ordered the military operation that resulted in the death of the mastermind behind the 9/11 attacks, Osama bin Laden (see page 82).

2015 » LEGALIZATION OF SAME-SEX MARRIAGE

It was a historic ruling 40 years in the making: On June 26, 2015, the Supreme Court ruled 5–4 that states cannot ban same-sex marriage. It's a right that gay Americans had been fighting for since the early 1970s, when Minnesota's *Baker v. Nelson* declared that denying marriage licenses to same-sex couples did not violate the U.S. Constitution. It was another 20 years before a stride was made, when the Hawaii Supreme Court ruled the state's ban to be unconstitutional.

President Obama was the first sitting president to support same-sex marriage (after initially saying during the 2008 election that he believed "marriage is the union between a man and a woman"), and on the evening it finally became legal, the White House was illuminated in rainbow lights. Within two years, Gallup reported that an estimated 10.2% of American same-sex couples were married, compared to 13.6% of heterosexual couples.

"It's a victory for gay and lesbian couples who have fought so long for their basic civil rights."

PRESIDENT BARACK OBAMA

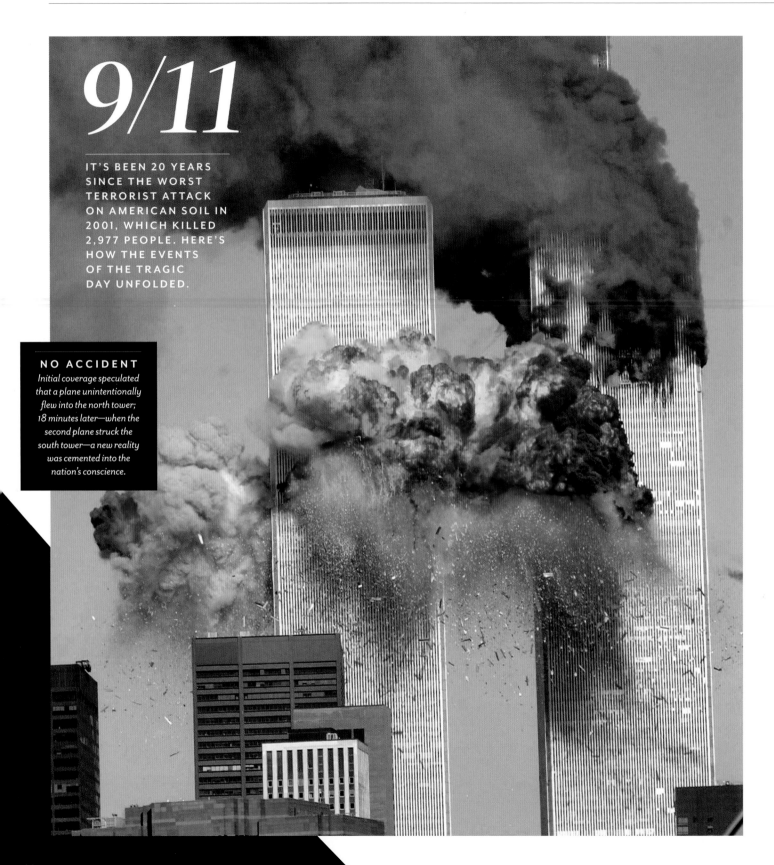

9/11

IT'S BEEN 20 YEARS
SINCE THE WORST
TERRORIST ATTACK
ON AMERICAN SOIL IN
2001, WHICH KILLED
2,977 PEOPLE. HERE'S
HOW THE EVENTS
OF THE TRAGIC
DAY UNFOLDED.

NO ACCIDENT
*Initial coverage speculated
that a plane unintentionally
flew into the north tower;
18 minutes later—when the
second plane struck the
south tower—a new reality
was cemented into the
nation's conscience.*

"AMERICA IS UNDER ATTACK"

President George W. Bush was visiting a school in Sarasota, Florida, when White House Chief of Staff Andrew Card (right) whispered in his ear that a second plane had struck the World Trade Center: "America is under attack." As cameras rolled, Bush's expression turned grave. Thirty minutes later, after two more hijacked planes crashed into the Pentagon and in Pennsylvania, the president went on live TV: "Terrorism in our nation will not stand."

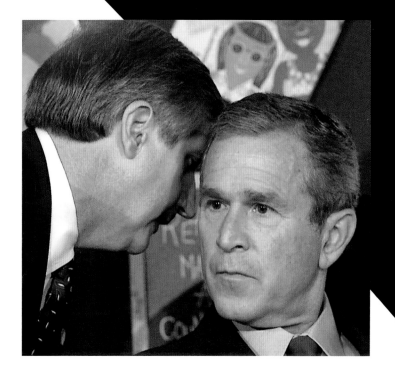

RUNNING FOR THEIR LIVES

This image captured by an Associated Press photographer of pedestrians fleeing from the collapse of the south tower became so widespread, it's featured at the National September 11 Memorial & Museum in New York. Stephen Cooper (far left) was delivering documents near the World Trade Center that morning, unaware of the attack, when a police officer yelled out, "You have to run." The 60-year-old had no idea the photo was taken until he saw it published in a magazine. "'Oh my God. That's me,'" Cooper exclaimed, according to longtime partner Janet Rashes. "He was amazed. Couldn't believe it." Sadly, early on in the coronavirus pandemic, Cooper contracted COVID-19 and died in a Delray Beach, Florida, hospital in March 2020.

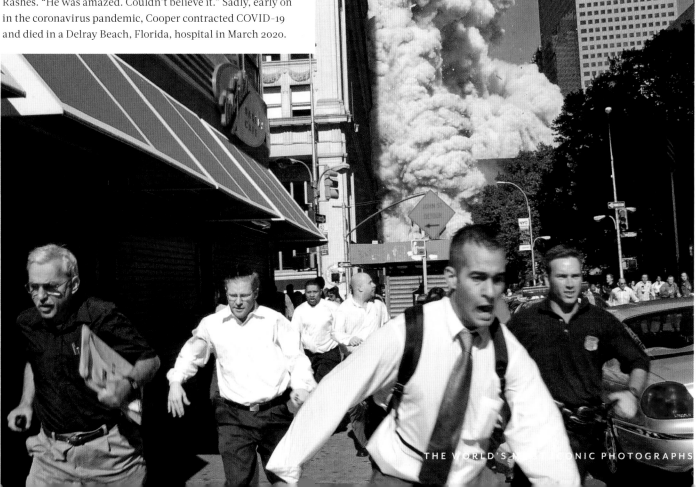

THE FALLING MAN

As many as 200 people jumped or fell as fire and smoke filled the buildings. The final moments of one man plunging from the north tower were captured by Richard Drew. As for why the haunting photo has stood out among the more gruesome ones from that day, Drew has a theory: "There's no blood, there's no violence. It's just this quiet picture of this man falling."

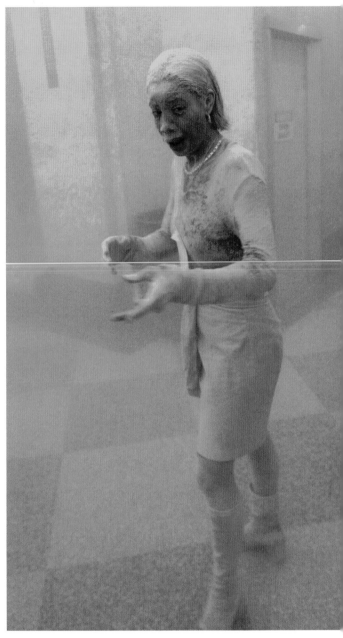

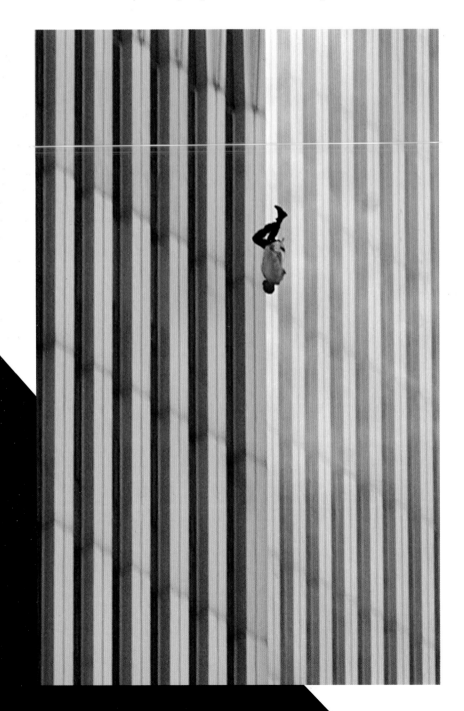

THE DUST LADY

Of all the images of survivors, one of the best remembered is of Marcy Borders, who emerged from the rubble completely covered in debris. Known as "Dust Lady," the Bank of America legal assistant was working on the 81st floor of the north tower, but managed to escape just before it collapsed. Thirteen years later, Borders—who struggled with depression and addiction as a result of 9/11—was diagnosed with stomach cancer, which she blamed on the toxic dust. Unable to afford treatment, the 42-year-old died in 2015.

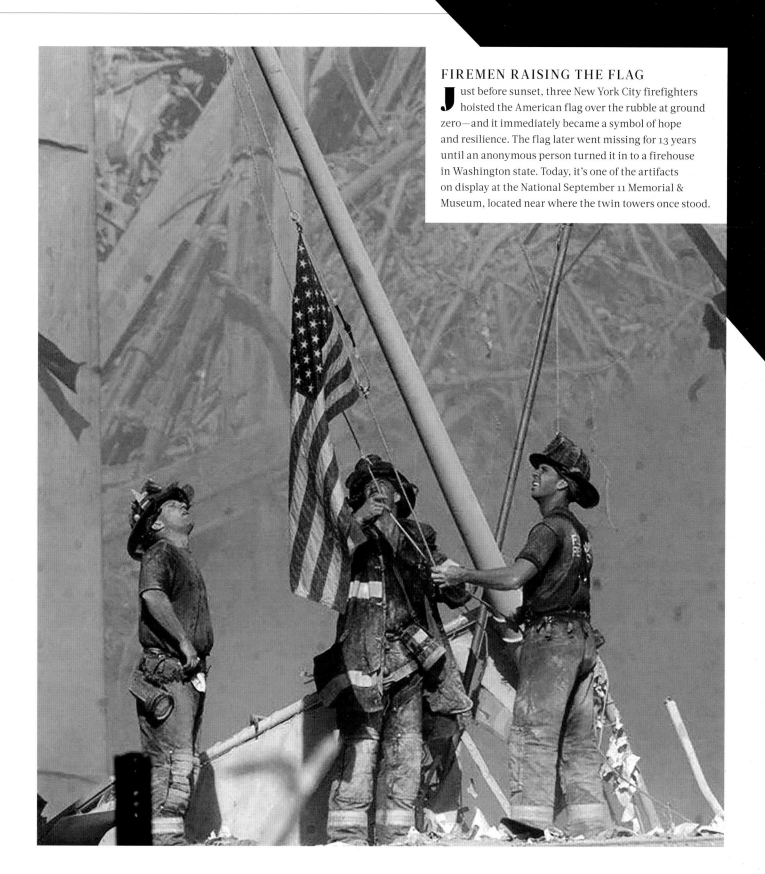

FIREMEN RAISING THE FLAG

Just before sunset, three New York City firefighters hoisted the American flag over the rubble at ground zero—and it immediately became a symbol of hope and resilience. The flag later went missing for 13 years until an anonymous person turned it in to a firehouse in Washington state. Today, it's one of the artifacts on display at the National September 11 Memorial & Museum, located near where the twin towers once stood.

THE
WORLD
IS
WATCHING

WITH AN AUDIENCE OF BILLIONS, THE PLANET HAS WITNESSED THE BEAUTY OF LOVE AND BRAVERY, THE HEARTBREAK OF DESPAIR AND THE FACE OF EVIL. OVER THE PAST CENTURY, DOZENS OF EVENTS HAVE SEEMINGLY BROUGHT EVERYONE ON EARTH TOGETHER, WHILE OTHERS HAVE WIDENED THE GAP.

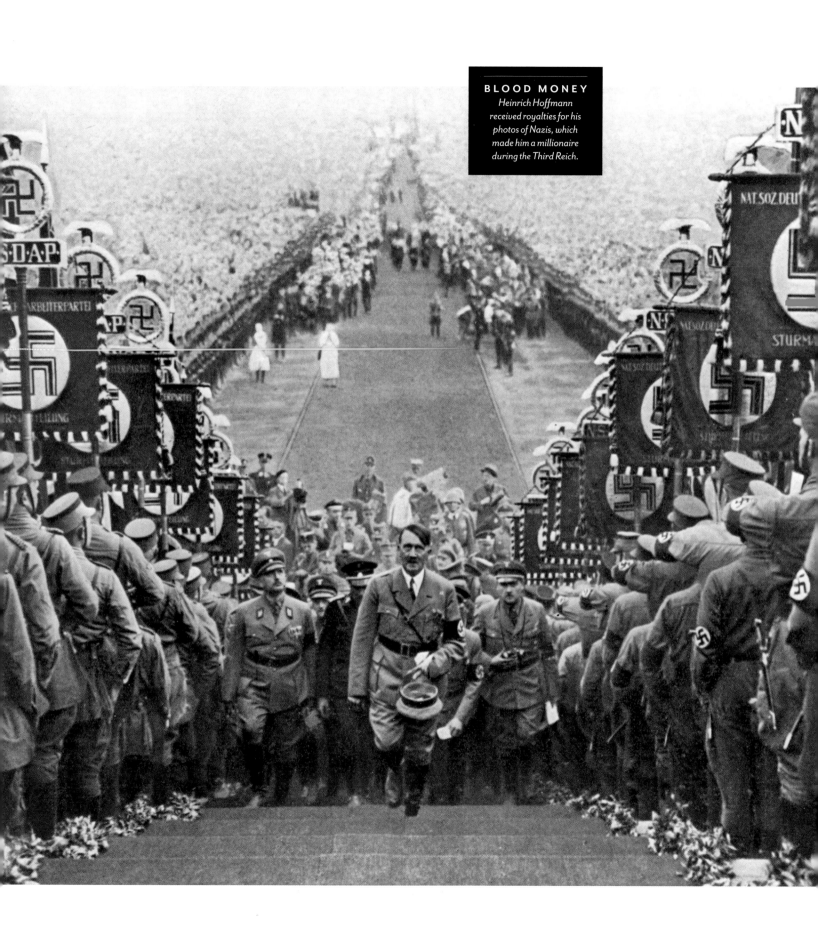

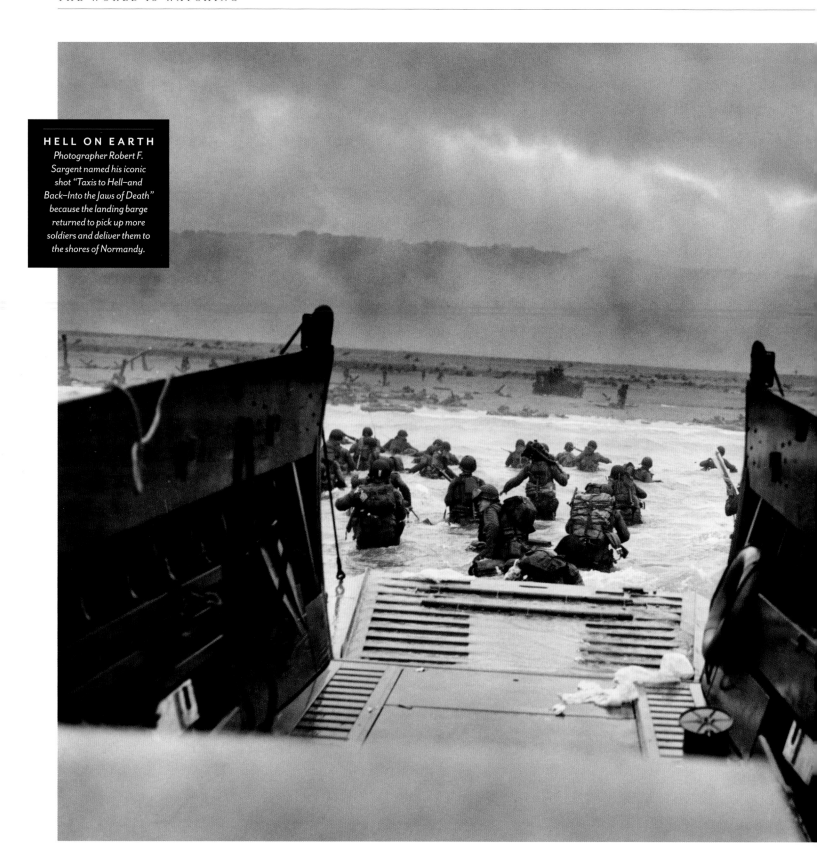

HELL ON EARTH
Photographer Robert F. Sargent named his iconic shot "Taxis to Hell–and Back–Into the Jaws of Death" because the landing barge returned to pick up more soldiers and deliver them to the shores of Normandy.

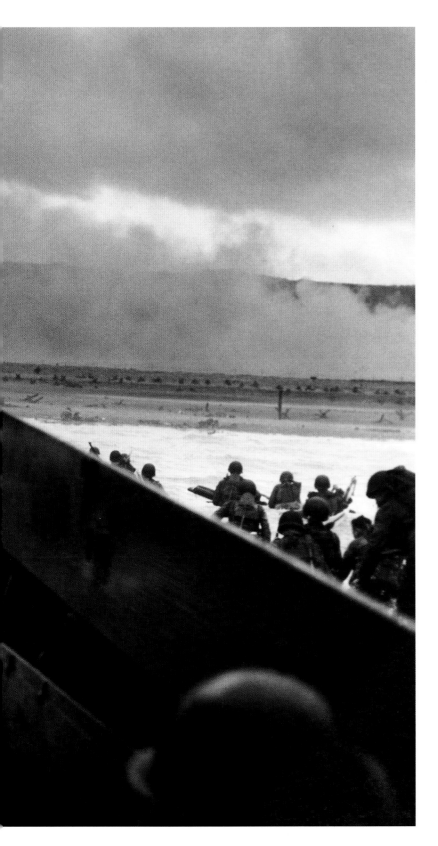

1933 >> THE RISE OF ADOLF HITLER
(page 65)

With the unstable political and economic climate in Germany, Adolf Hitler and his Nazi party easily ascended to power in 1933. But he also had the help of some strategic propaganda: The German dictator employed his own photographer, Heinrich Hoffmann, to document grandiose Nazi events with the purpose of selling the public on the party's ideals. Hoffmann took more than 2 million photos for the Nazis, but one stands out: the Bückeberg Harvest Festival on Sept. 30, 1934. In this image, Hitler is shown climbing a set of steps, flanked by soldiers proudly hoisting banners emblazoned with the swastika. Behind him stands a seemingly endless crowd of supporters. The choreographed photos succeeded: Soon enough, Hitler and the Nazis reigned over German-occupied territories throughout Europe, leading to the Holocaust—which was responsible for the deaths of approximately 17 million people, including 6 million Jews—and World War II.

1944 >> ALLIED TROOPS LAND AT NORMANDY

As Nazi Germany expanded its control of Western Europe during WWII, the Allies launched Operation Neptune to halt Hitler. On June 6, 1944—dubbed D-Day—24,000 American, British and Canadian paratroopers first surprised the German soldiers stationed in occupied France. Then another 156,000 descended on the shores of five Normandy beachheads, making it the largest sea-born invasion in history. At Omaha Beach (pictured), landing craft ran aground on sandbars, forcing the U.S. 1st Infantry to wade ashore through deep water, as heavy enemy fire rained down from the cliffs above. Those who made it to land were met with more obstacles, as it was mined with barbed wire, metal and wood. In the first wave of the invasion, 2,400 Americans were killed. Despite the high number of casualties on D-Day, the operation was successful and the victory turned the tide: Within the year, Hitler had died by suicide and Germany had surrendered.

"The men aboard with me gasped 'My God' and what had been Hiroshima was a mountain of smoke like a giant mushroom."

REAR ADM. WILLIAM S. PARSONS

1945 >> U.S. DROPS ATOMIC BOMBS ON JAPAN

With the war concluded in Western Europe, focus shifted to the most powerful Nazi ally, Japan. On Aug. 6, 1945, Air Force Col. Paul Tibbets led his team on the *Enola Gay* toward the city of Hiroshima, where the plane would drop Little Boy, the nearly 10,000-pound nuclear bomb, on the city. The bomb fell almost 6 miles in 43 seconds before detonating at an altitude of 2,000 feet, engulfing the city in a flash of heat and light. The temperature at ground level reportedly reached 7,000 degrees Fahrenheit in less than a second, vaporizing bystanders half a mile away from ground zero. At least 80,000 people are said to have died instantly.

From the *Enola Gay*, Tibbets and his crew saw "a giant purple mushroom" that "had already risen to a height of 45,000 feet, 3 miles above our altitude, and was still boiling upward like something terribly alive," according to the National World War II Museum. Three days later, on Aug. 9, a second bomb (nicknamed Fat Man, a plutonium implosion-type weapon) was dropped onto Nagasaki (pictured here).

When the atomic dust settled, the loss of life was catastrophic: between 129,000 and 226,000 people, mostly civilians, half of whom died from the aftereffects, such as radiation poisoning. Within days, the Japanese surrendered, and on Sept. 2, WWII was finally over after six years of conflict.

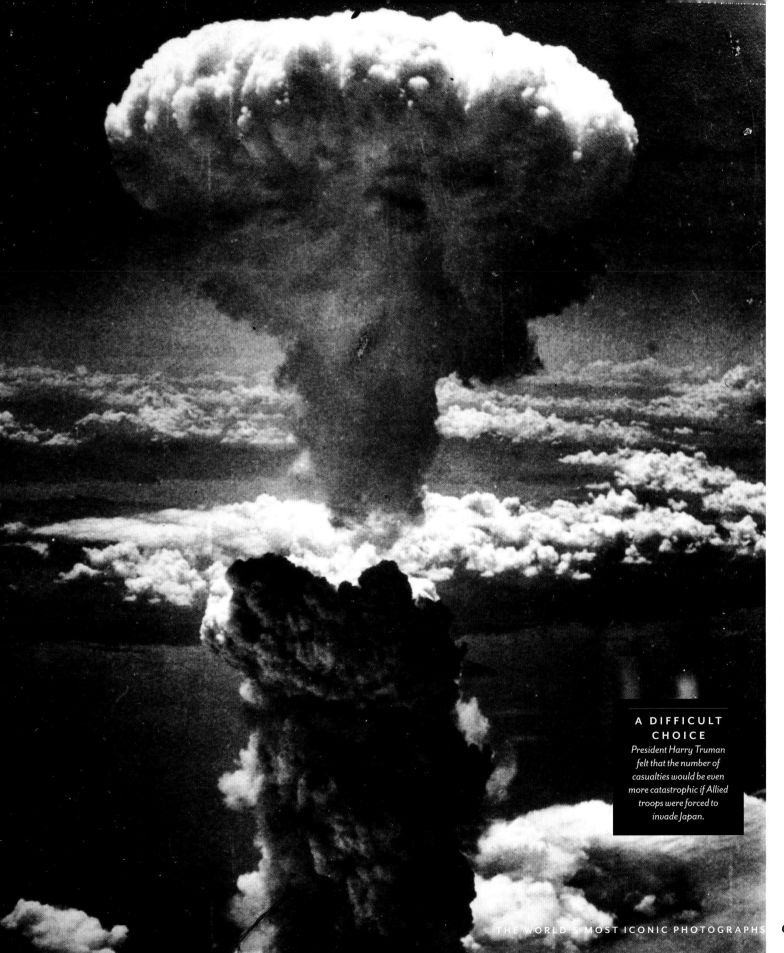

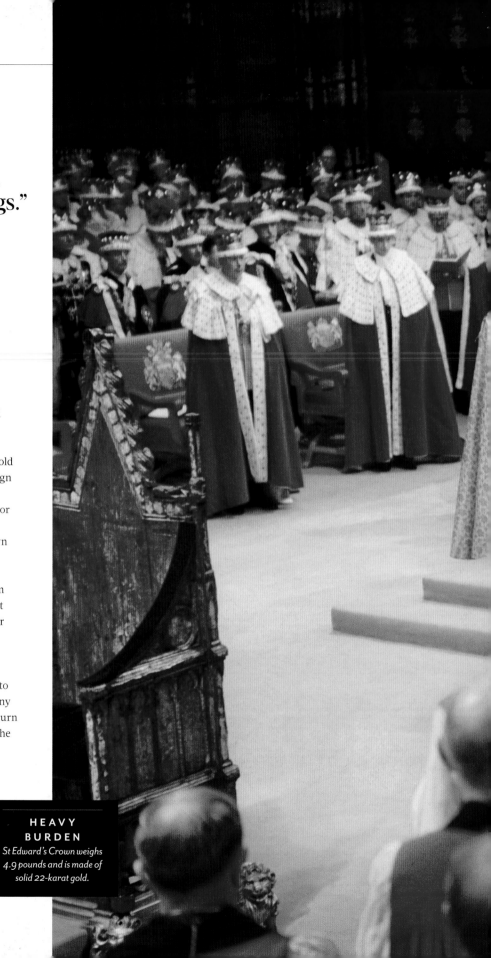

"There are some disadvantages to crowns. But, otherwise, they're quite important things."

QUEEN ELIZABETH II

1953 >> QUEEN ELIZABETH II'S CORONATION

The pomp and circumstance of the coronation of Queen Elizabeth II played out beyond the 8,000 attendees inside Westminster Abbey on June 2, 1953. Millions tuned in to watch the 25-year-old princess become England's new sovereign (her father, King George VI, had died the previous year) during the three-hour ceremony, which was the first major international event to be broadcast on television.

The morning began with Elizabeth, in a white satin gown embroidered with the emblems of the United Kingdom and the Commonwealth in gold and silver thread, and her husband, Philip, the Duke of Edinburgh, being driven from Buckingham Palace in the Gold State Coach pulled by eight gray geldings. Once at the Abbey, the future queen took her seat on St Edward's Chair and was adorned with the solid-gold St Edward's Crown, the Purple Robe of Estate and the Coronation Ring as she took her oath—to which the crowd cheered, "God Save the Queen!" After the procession back to Buckingham Palace, the new queen appeared on the balcony with her family. That evening, she emerged once again to turn on the Lights of London, which illuminated the city from the National Gallery to the Tower of London.

HEAVY BURDEN
St Edward's Crown weighs 4.9 pounds and is made of solid 22-karat gold.

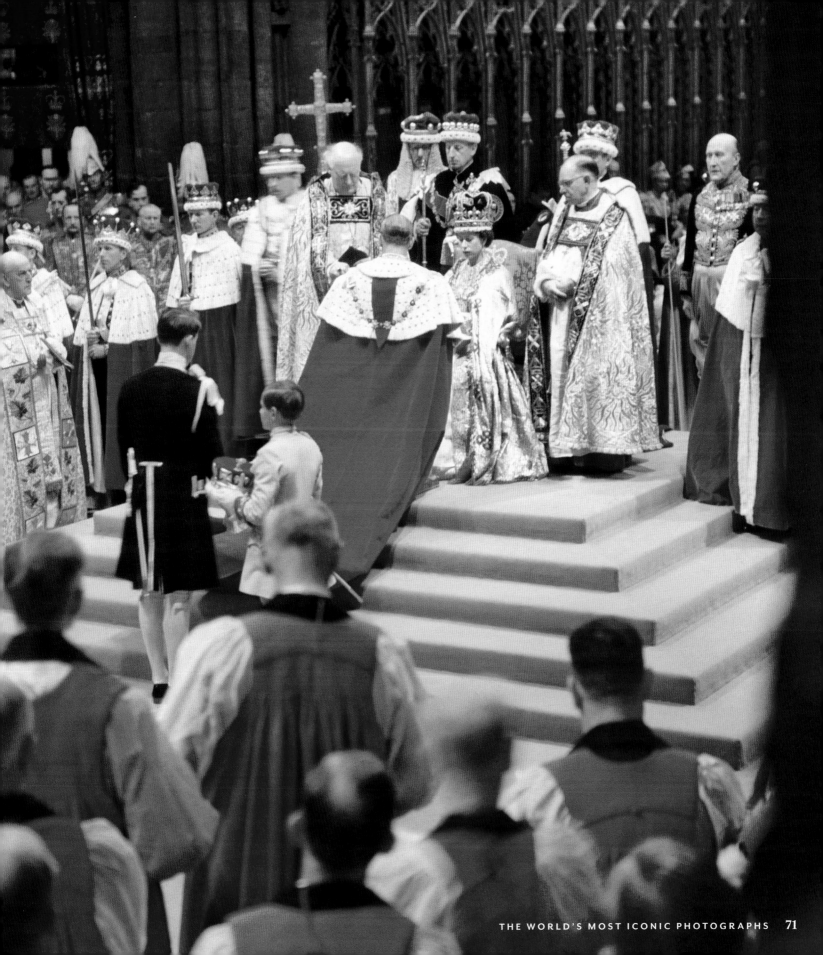

"Do not pray for easy lives,
pray to be stronger men."

PRESIDENT JOHN F. KENNEDY

1963 >> JOHN F. KENNEDY JR.
SALUTES HIS FATHER'S COFFIN

The world mourned with America after the assassination of President John F. Kennedy on Nov. 22, 1963. His grieving widow, Jacqueline, instructed the chief usher to follow the protocol and details of Abraham Lincoln's 1865 state funeral, including lying in state in the White House's East Room as well as in the Capitol rotunda, where more than 250,000 people filed past Kennedy's flag-draped coffin.

On Nov. 25, the day of the funeral, Jacqueline and her children, Caroline, who was almost 6, and John Jr., 3, had been the picture of stoicism until the moment the little boy broke away from his mother's grasp. As the coffin passed the family, John-John took a step forward and honored his father one last time with a tiny salute. The heartbreaking image was snapped by New York's *Daily News* photographer Dan Farrell, and it ran on the paper's front page the next day. "It was the saddest thing I've ever seen in my whole life," he explained in 2013. "I'm just glad my emotions didn't take over when I was trying to take the picture."

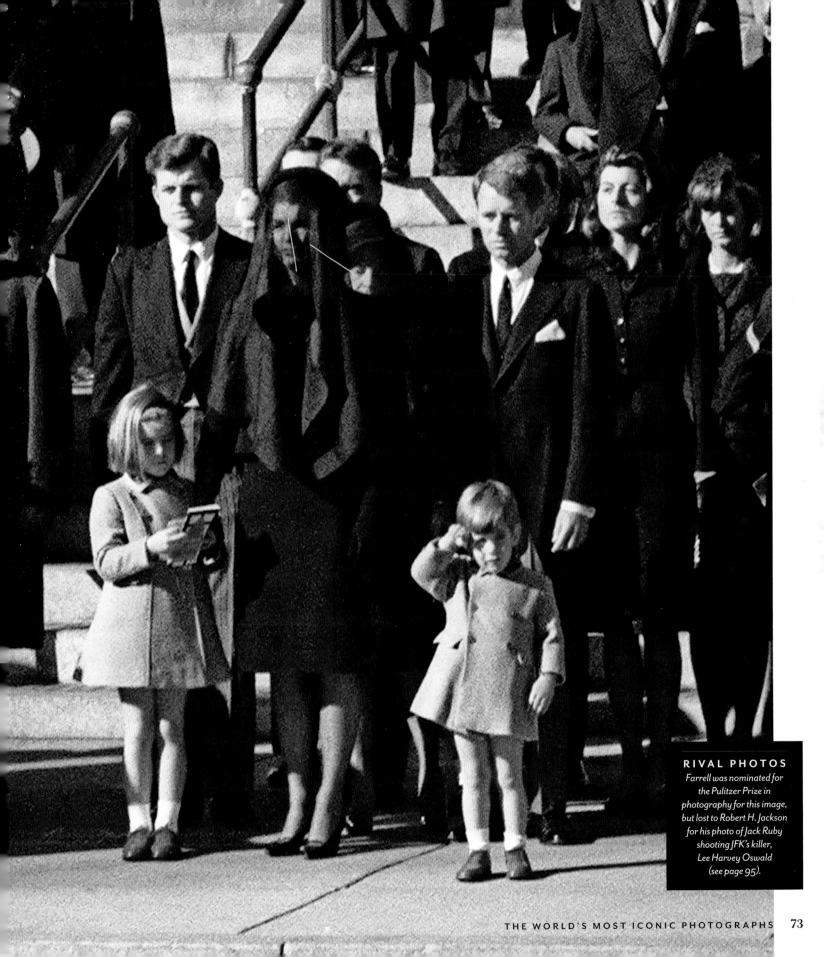

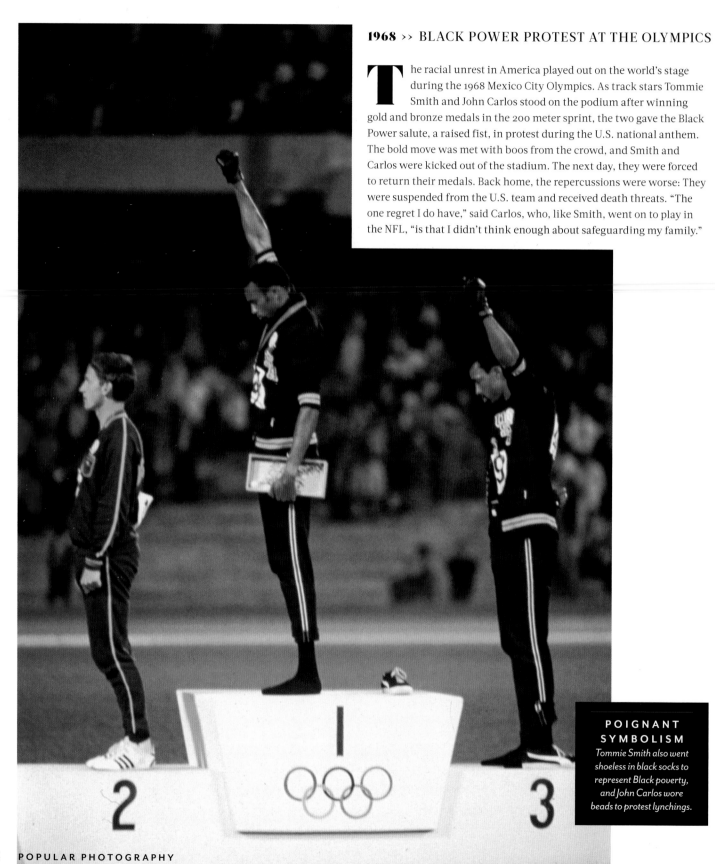

1968 >> BLACK POWER PROTEST AT THE OLYMPICS

The racial unrest in America played out on the world's stage during the 1968 Mexico City Olympics. As track stars Tommie Smith and John Carlos stood on the podium after winning gold and bronze medals in the 200 meter sprint, the two gave the Black Power salute, a raised fist, in protest during the U.S. national anthem. The bold move was met with boos from the crowd, and Smith and Carlos were kicked out of the stadium. The next day, they were forced to return their medals. Back home, the repercussions were worse: They were suspended from the U.S. team and received death threats. "The one regret I do have," said Carlos, who, like Smith, went on to play in the NFL, "is that I didn't think enough about safeguarding my family."

POIGNANT SYMBOLISM
Tommie Smith also went shoeless in black socks to represent Black poverty, and John Carlos wore beads to protest lynchings.

In the late 1960s, after the death of President John F. Kennedy, his remarried widow, Jacqueline Kennedy Onassis, was one of the most famous people in the world—and with that came an insatiable interest in her life. While living in New York City, she was hounded on a nearly daily basis for years by paparazzo Ron Galella. In October 1971, he spotted Onassis walking on the Upper East Side and hopped in a cab before she noticed him. For blocks, Galella snapped away, until his driver honked the horn and caught her attention. As Onassis turned to look, a gust beautifully tousled her hair—and Galella captured his most famous paparazzi photo, "Windblown Jackie." "I call it my 'Mona Lisa,'" he told *Time*, "because the smile was on her eyes and lips."

Onassis was hardly amused: In 1973, she sued Galella for harassment and invasion of privacy and won a restraining order to keep him 25 feet away from her and her children. Undeterred, he continued to follow her—but carried a tape measure to ensure he didn't break the law.

PUBLIC NUISANCE

A year before Onassis sued Galella, he took her to court for ordering her Secret Service agents to destroy his camera.

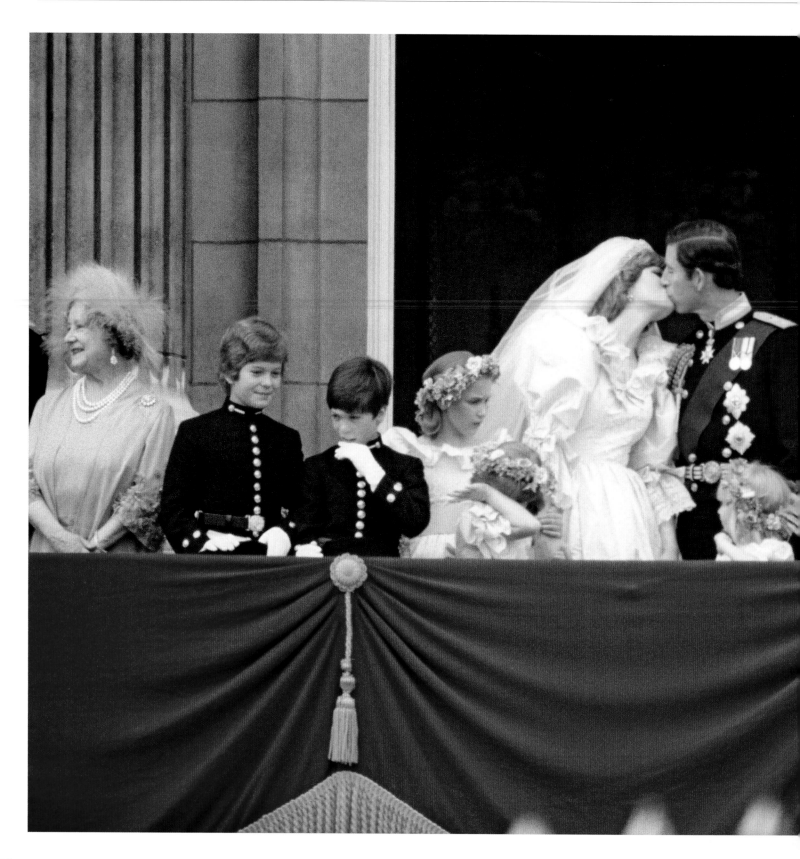

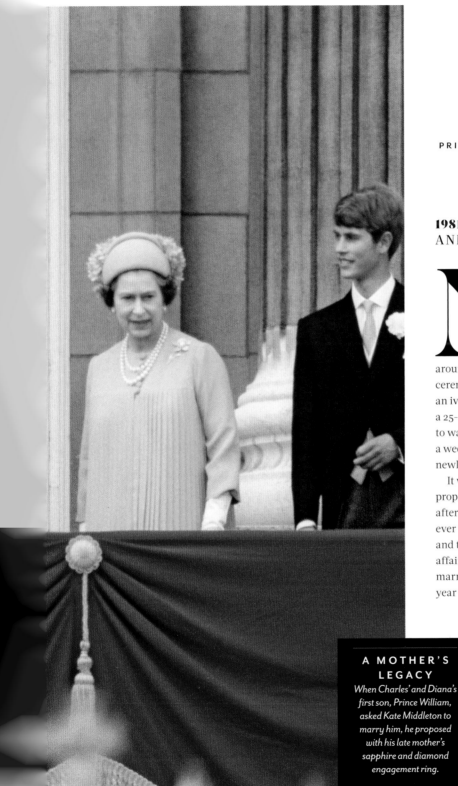

"I never tried to call it off... but I think [it was] the worst day of my life."

PRINCESS DIANA, TO JOURNALIST ANDREW MORTON

1981 >> WEDDING OF PRINCE CHARLES AND DIANA SPENCER

Not since Queen Elizabeth II's coronation had the world been so obsessed with British royalty: During the "Wedding of the Century" between the queen's eldest son, Prince Charles, and Lady Diana Spencer on July 29, 1981, more than 750 million people around the world tuned in as the couple exchanged vows in a lavish ceremony at St Paul's Cathedral in London. The new princess wore an ivory silk-taffeta gown adorned with thousands of pearls and a 25-foot train that was so cumbersome it took her four minutes to walk down the aisle to the church's altar. After the ceremony, a wedding breakfast was held at Buckingham Palace, where the newlyweds kissed on the balcony in front of a cheering crowd.

It was a quick courtship for Charles, 32, and Diana, 20: He proposed after six months of dating, and they wed five months after announcing their engagement. But they did not live happily ever after. The couple separated in 1992 after 11 years of marriage and two sons—William and Harry—amid accusations of Charles' affair with former girlfriend Camilla Parker Bowles, whom he later married. Charles and Diana were officially divorced in 1996, only a year before Diana's tragic death at the age of 36.

A MOTHER'S LEGACY
When Charles' and Diana's first son, Prince William, asked Kate Middleton to marry him, he proposed with his late mother's sapphire and diamond engagement ring.

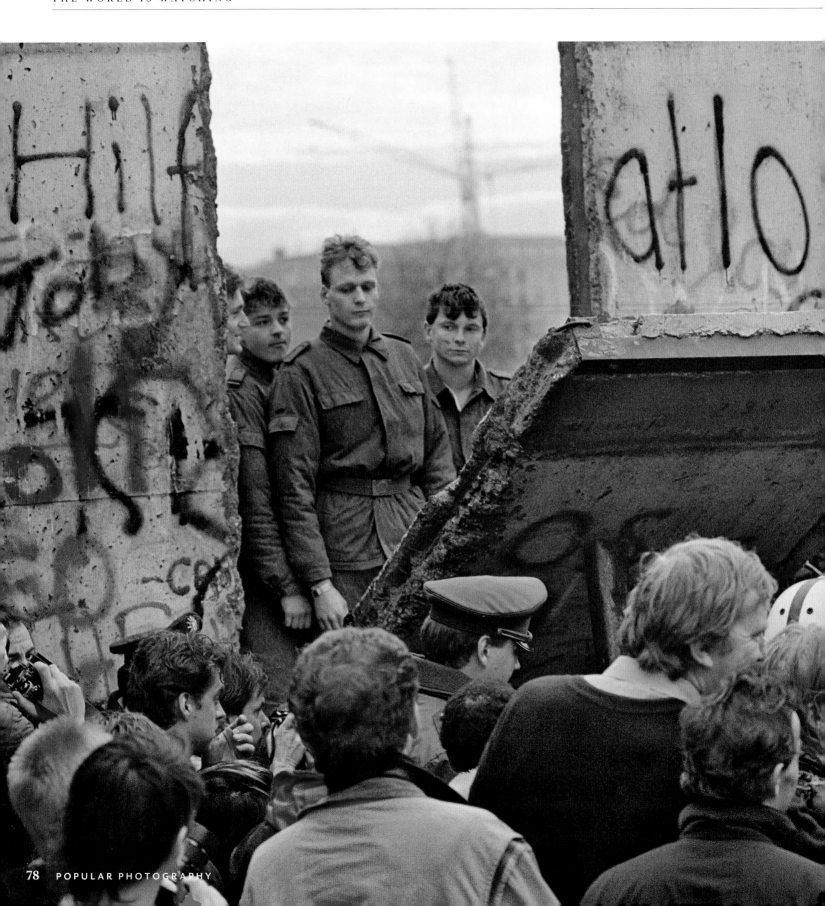

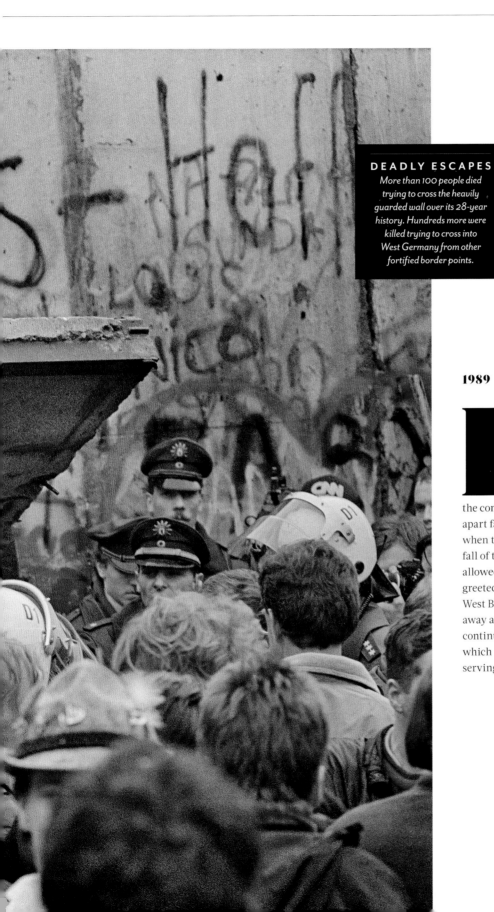

1989 >> BERLIN WALL FALLS

During the Cold War, thousands of people living in Communist East Germany fled to democratic West Germany. To prevent any more defections, Soviet authorities constructed the Berlin Wall practically overnight in August 1961. For 10,316 days, the concrete barrier separated the two territories—and tore apart families trapped on opposing sides—until November 1989, when the collapse of the Soviet empire brought on the physical fall of the Berlin Wall. After 28 years, East Germans were finally allowed to cross over into West Germany, where they were greeted with flowers, Champagne and singing. Both East and West Berliners celebrated by jumping on the wall and chiseling away at its graffiti-covered surface to allow free passage. This continued for weeks until official demolition began on the wall, which concluded in 1992. Today, three long sections remain, serving as a memorial.

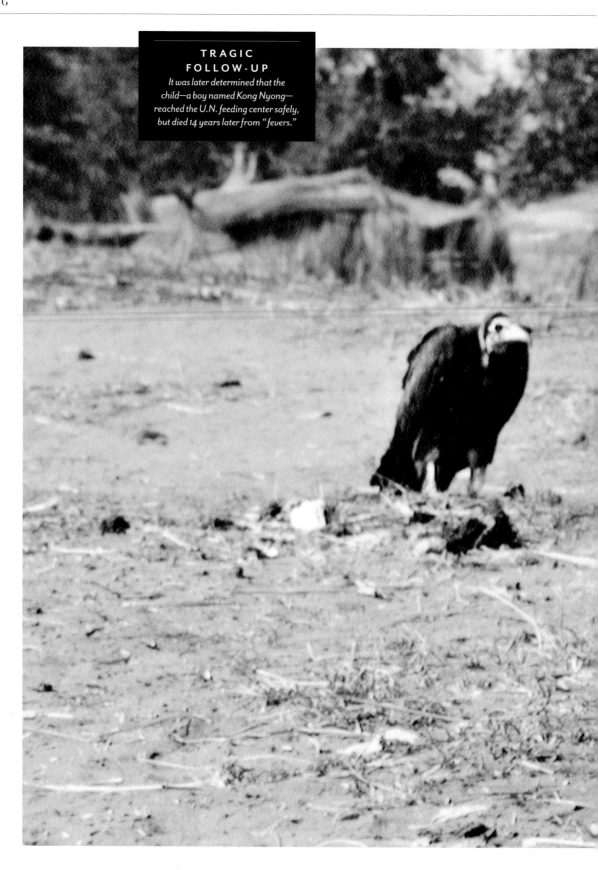

1993 >> STARVING CHILD WITH WAITING VULTURE

In the early 1990s, famine devastated Sudan. While on a mission to call attention to the human suffering, photographer Kevin Carter was taking a break from a long day of shooting in the village of Ayod when he heard a faint whimper. It was the pitiful sound of a starving toddler who had collapsed while trying to get to a United Nations feeding center. Carter picked up his camera. As he clicked away, a vulture ominously landed in his frame, mere feet from the vulnerable child, who lay helpless. Carter watched for 20 minutes, hoping the bird would spread its wings and give him the perfect shot. When it didn't, he scared it away. As Carter watched the child continue to the feeding center, he wept.

After *The New York Times* ran the chilling photo on March 26, 1993, outrage erupted over why Carter hadn't put down his camera to help the child. Although he won a Pulitzer Prize, the accolade didn't relieve his deep emotional pain. In July 1994, at the age of 33, he drove to a place he used to play as a child and hooked up a hose to his car's exhaust pipe. In his suicide note, Carter explained, "I am haunted by the vivid memories of killings & corpses & anger & pain."

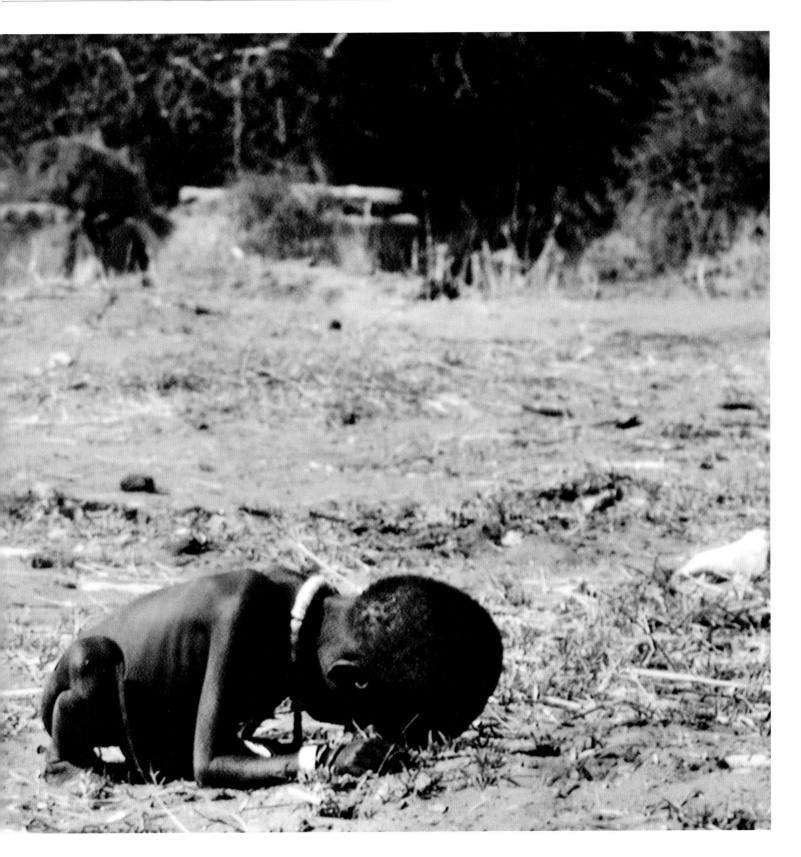

2011 >> KILLING OF OSAMA BIN LADEN

Ten years after 9/11, the U.S. finally had the attacks' mastermind, Osama bin Laden, in its sights. And on May 1, 2011, President Barack Obama and his national security team watched the drama unfold from inside the White House's Situation Room, as troops raided the al-Qaeda leader's hideout in Pakistan. Those packed into the room, including Vice President Joe Biden, remained glued to the live feed, seemingly unaware of photographer Pete Souza. What struck him the most, Souza recalled in 2017: "You have the most powerful people in the federal government...and they were essentially helpless."

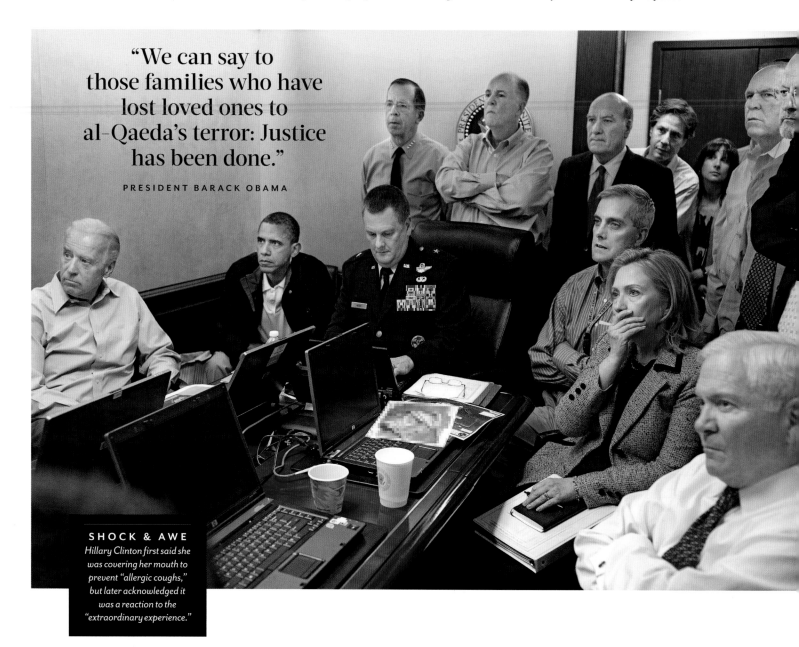

"We can say to those families who have lost loved ones to al-Qaeda's terror: Justice has been done."

PRESIDENT BARACK OBAMA

SHOCK & AWE
Hillary Clinton first said she was covering her mouth to prevent "allergic coughs," but later acknowledged it was a reaction to the "extraordinary experience."

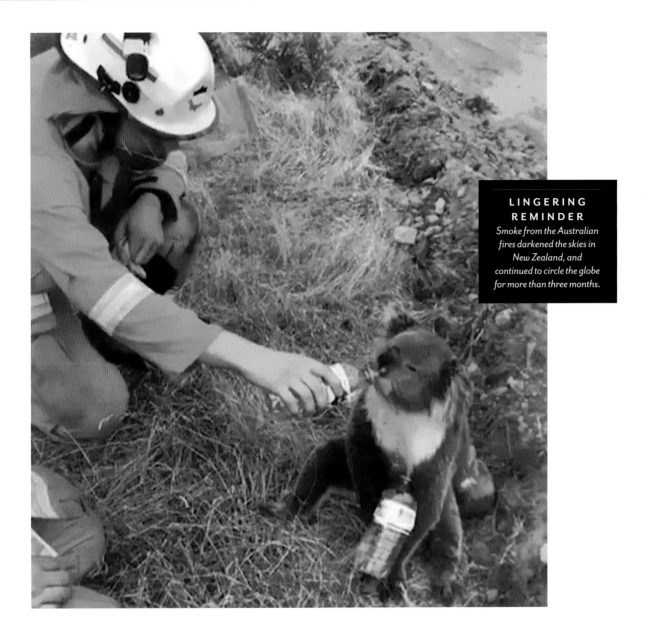

2019 >> FIREFIGHTER GIVES KOALA WATER DURING AUSTRALIAN FIRES

As brushfires ravaged Australia, an unimaginable 3 billion animals, mostly reptiles, were either killed or displaced—making "Black Summer" one of the worst wildlife disasters in modern history. Among the most heartbreaking images from the devastation, a firefighter in Cudlee Creek, South Australia, paused from battling the blaze on Dec. 22, 2019, to provide water to a thirsty koala who gratefully gulped from the plastic bottle. It would be another six months before the wildfires were under control, and their destruction was astounding: The blazes burned 46 million acres, destroyed 6,000 buildings (half of which were homes), killed at least 34 people and exceeded $4.4 billion in damage. The most defenseless victims, the wildlife that did survive, were left without food and water in many areas. And some endangered species are believed to have been driven to extinction altogether.

GLOBAL PANDEMIC, 2020

WHAT COVID-19 LOOKED LIKE AROUND
THE WORLD AS BILLIONS DEALT WITH
UNPRECEDENTED HARDSHIPS.

ITALY

ITALY

As COVID-19 spread across the globe, the first European country to be extremely affected by the virus was Italy. On March 27, 2020, two months after the first infection, an overwhelmed nurse at Tor Vergata Hospital in Rome (left) took a much-needed break as the number of cases in Italy at the time reached 100,000 (with more than 9,000 deaths).

NEW YORK

As the outbreak in the U.S. spread, New York City's Times Square was uncharacteristically a ghost town. On March 18, 2020, five days after President Donald Trump declared a state of emergency, ballet dancer Ashlee Montague—wearing a gas mask for extra effect—turned Broadway into her very own stage (right).

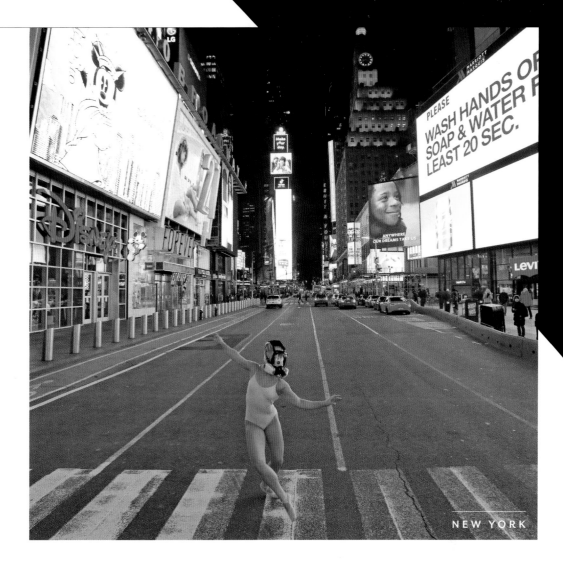

NEW YORK

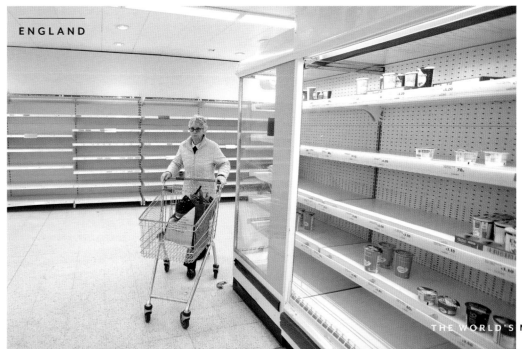

ENGLAND

ENGLAND

Preparing to go into quarantine, millions rushed to grocery stores. In Harpenden, about 30 miles from London, an elderly woman pushed her cart around a grocery store that had been emptied of food (left). Restrictions were later put in place to limit the number of items people could buy.

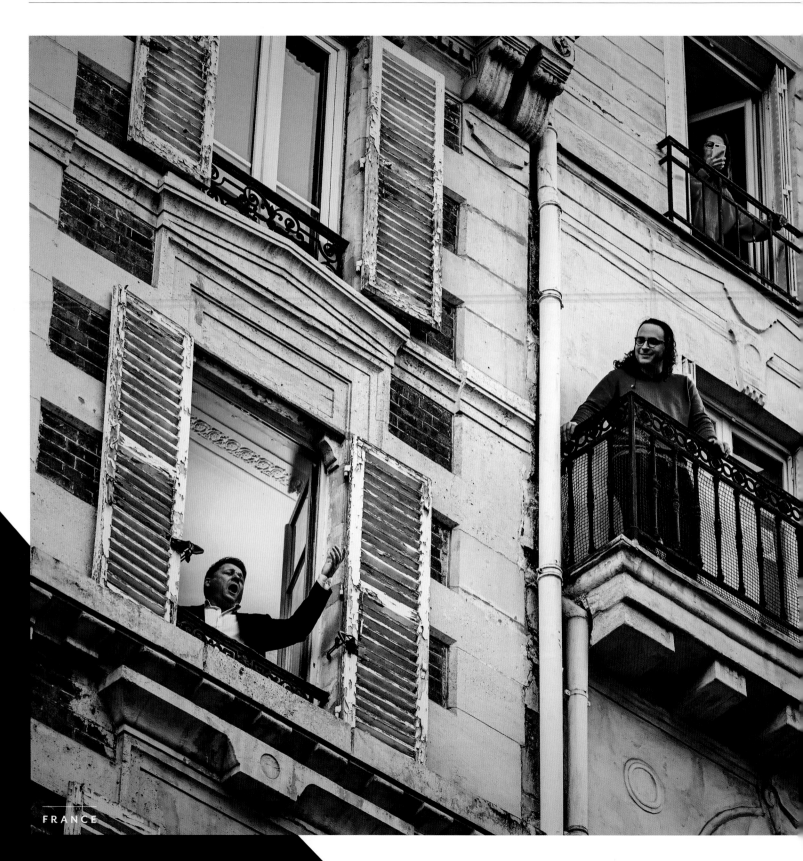

FRANCE

> ## "At my window, it's stronger than the opera because I'm not playing a role; I'm myself."
>
> STÉPHANE SÉNÉCHAL

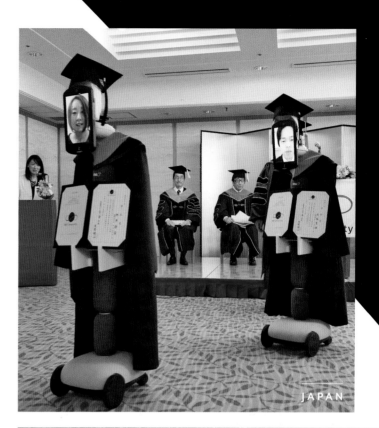

JAPAN

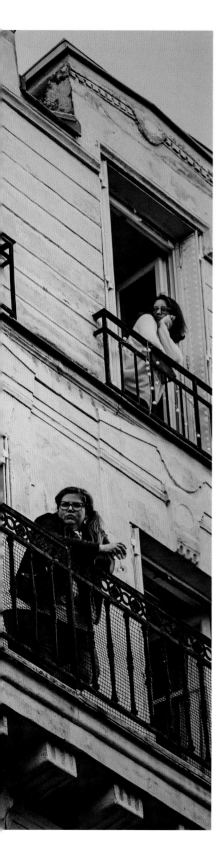

FRANCE

Throughout the lockdown in Paris, opera singer Stéphane Sénéchal routinely entertained his neighbors with exclusive concerts from his apartment window (at left, he performed "O Sole Mio").

JAPAN

With schools closed, graduation ceremonies went virtual. At the Business Breakthrough University in Tokyo, robots dressed in caps and gowns (above right) stood in for students—their faces displayed on tablets—who were stuck at home. As their names were called by an administrator, the humans were able to "accept" their diplomas as staff applauded.

CANADA

People found innovative ways to exercise while social distancing. In Toronto, pop-up Bubble Yoga offered classes to 50 people at a time inside private, clear domes (right)—with temperature control systems, no less.

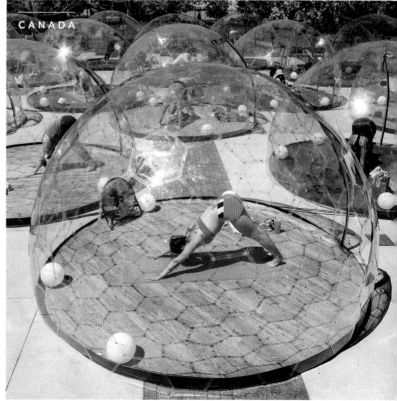

CANADA

DEATH

CAUGHT ON

FILM

AS THE SAYING GOES, A PICTURE IS WORTH A
THOUSAND WORDS, AND IN SOME MOVING MOMENTS,
THE IMAGES SAY EVEN MORE.

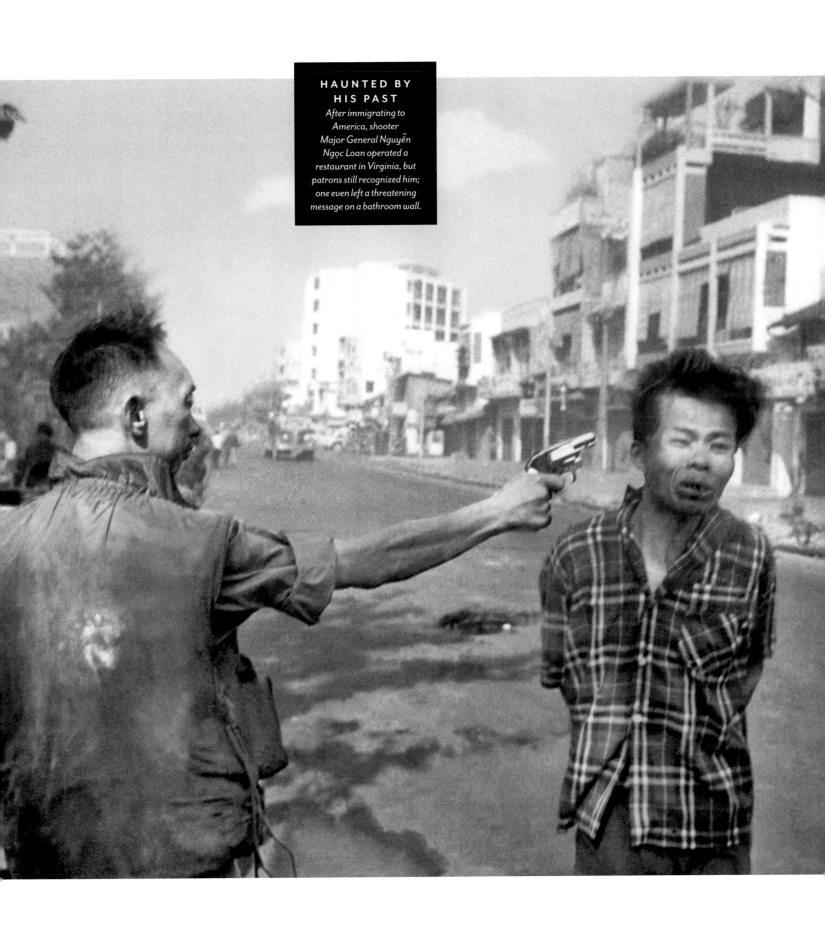

1968 » SAIGON EXECUTION *(previous page)*

One of the most powerful images that came out of the Vietnam War is also one of the most disturbing. It's the exact moment South Vietnam chief of national police Nguyễn Ngọc Loan fired a bullet into the temple of Viet Cong terrorist squad leader Nguyễn Văn Lém on Feb. 1, 1968. Associated Press photographer Eddie Adams initially believed he was documenting the interrogation of the prisoner, who had killed one of Loan's friends, his wife and six children. But as he began to click away, he witnessed Loan raise his pistol at Lém and pull the trigger. Incredibly, Adam's photo caught the millisecond the bullet passed through Lém's head, his pain evident in his reaction.

"It was gross," described Adams, who watched blood gush from the wound in Lém's head as he lay on the sidewalk. Sadly, all the same, it was just another day as a war photographer. "I thought absolutely nothing of it," he admitted. "I said, 'I think I got some guy shooting somebody.' And, uh, I went to lunch."

Back in the U.S., the brutal photo enraged those who already believed the country was fighting an unwinnable, immoral war. It also demonized Loan, who immigrated to America with his family after the conflict. In his new homeland, his reputation preceded him, and he struggled greatly. "Two people died in that photograph," noted Adams, who won a Pulitzer Prize in 1969. "The recipient of the bullet and Major General Nguyễn Ngọc Loan. The general killed the Viet Cong; I killed the general with my camera…. He never blamed me. He told me if I hadn't taken the picture, someone else would have, but I've felt bad for him and his family for a long time."

1912 » FLIGHT FAIL

Combining his skills as a tailor with his interest in aviation, Austrian-born Franz Reichelt invented a wearable parachute. To test it, he suited up dummies and dropped them from the fifth floor of his Paris apartment, all with great success. But Reichelt knew to truly prove his creation, he'd need to take it to even greater heights: the Eiffel Tower. However, when he arrived at the landmark on Feb. 4, 1912, he didn't have a test dummy in tow—he intended to take the leap himself. As two dozen reporters gathered to watch, he ascended the 984-foot structure. Despite warnings it was too windy, after a brief hesitation, he jumped and almost immediately the parachute folded around his body (see image, right). Reichelt, 33, died upon impact with the frozen ground.

> ## "Reichelt fell like a stone. His body was a shapeless mass when the police picked it up."
>
> ARTICLE IN *POPULAR MECHANICS*, 1912

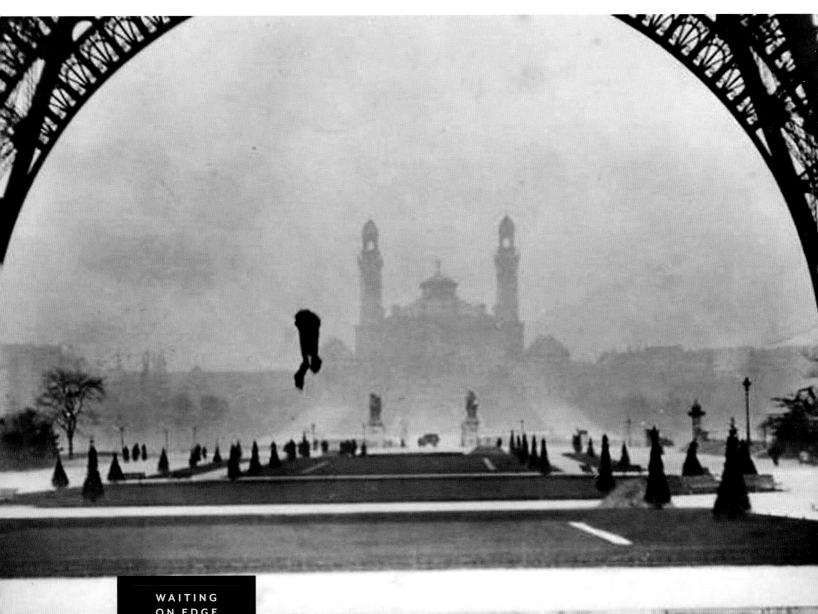

WAITING ON EDGE

Reichelt reportedly stood on a table by the guardrail for a full 40 seconds before jumping.

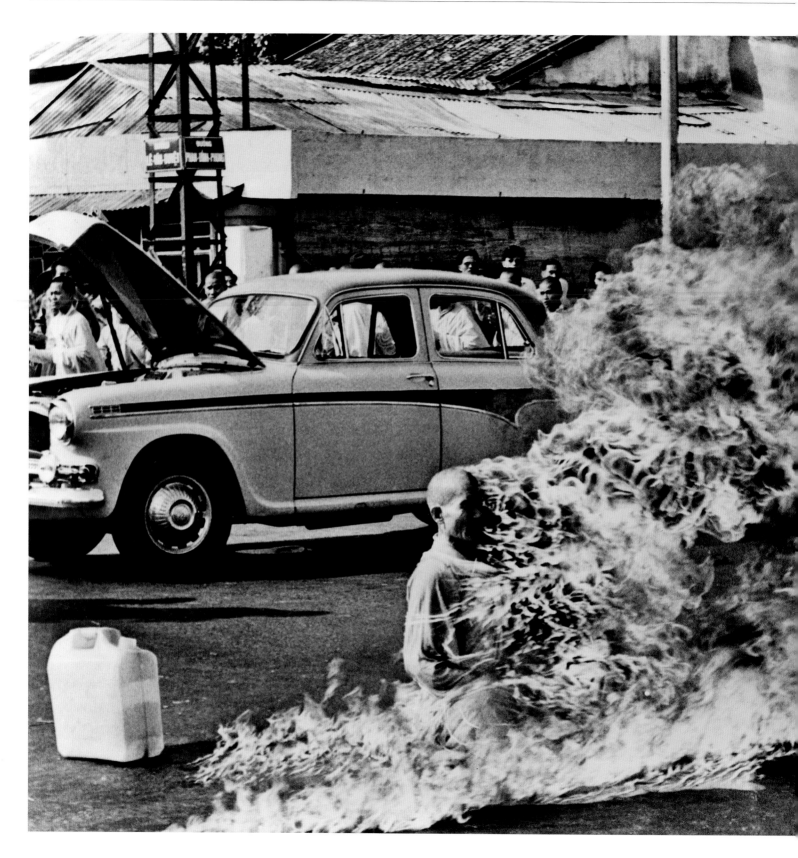

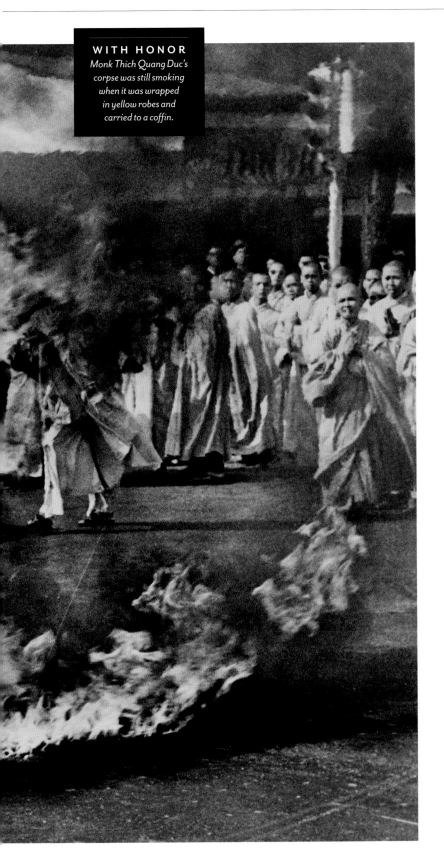

"Take a mind of compassion toward the people of the nation and implement religious equality."

THICH QUANG DUC'S LAST
WORDS TO PRESIDENT NGO DINH DIEM

1963 » THE BURNING MONK

In South Vietnam in the early 1960s, as Catholicism was promoted by President Ngo Dinh Diem, Buddhists were persecuted. Protests for religious equality escalated on June 11, 1963, when a monk named Thich Quang Duc sat down on a cushion at a busy intersection in Saigon, and with the help of a colleague who doused him in gasoline, struck a match and lit himself on fire.

Acting on a tip that "something important" was going to happen, Associated Press photographer Malcolm Browne was on the scene that day—and captured the shocking moment. With him was *New York Times* reporter David Halberstam, who described with words the haunting image captured by Browne (who went on to win a Pulitzer Prize for photography for the picture): "Flames were coming from a human being; his body was slowly withering and shriveling up, his head blackening and charring. In the air was the smell of burning human flesh; human beings burn surprisingly quickly. Behind me I could hear the sobbing of the Vietnamese who were now gathering.... As he burned he never moved a muscle, never uttered a sound, his outward composure in sharp contrast to the wailing people around him."

Thich Quang Duc did not die in vain. Months later, as tensions worsened, a military coup captured and executed President Diem without interference from the U.S. government. President John F. Kennedy was especially moved by Browne's photo: "No news picture in history has generated so much emotion around the world as that one," he stated.

1963 » ASSASSINATION OF PRESIDENT JOHN F. KENNEDY

It was a day that was supposed to cement his reelection. Instead, President John F. Kennedy's motorcade through Dallas on Nov. 22, 1963, ended the 46-year-old's life and brilliant political career.

Shortly after 12:30 p.m., Kennedy was riding in an open-top limousine waving to the crowd gathered in Dealey Plaza when the jubilation was silenced by three gunshots. The first struck him in the back and exited through his neck. As the president clutched his throat, a second bullet ripped through his head, blowing off a piece of his skull and sending bone and brain matter all over the car—and his wife beside him. "I remember falling on him and saying, 'Oh my God, they have shot my husband,'" recalled Jacqueline. (Texas Gov. John Connally, seated in front of the president, was also shot in the back, but survived.)

When Kennedy arrived at Parkland Hospital, his heart was still beating. But after 12 minutes of lifesaving efforts, an EKG machine confirmed there was no longer activity—and the president was declared dead. Less than two hours later, Vice President Lyndon B. Johnson was sworn in, with JFK's shell-shocked widow beside him, still in her bloodstained suit.

FAMOUS FILM
President John F. Kennedy's shooting was captured by local dressmaker Abraham Zapruder on his Zoomatic movie camera.

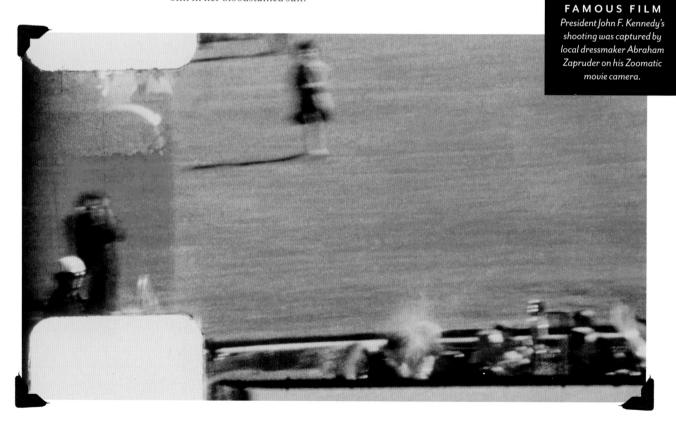

1963 » LEE HARVEY OSWALD SHOT BY JACK RUBY

The nation was still reeling from the gruesome public assassination of President Kennedy when his accused killer met a similar fate. Former U.S. Marine turned Marxist Lee Harvey Oswald was being escorted from Dallas police headquarters to the nearby jail on the morning of Nov. 24, 1963, when local nightclub owner Jack Ruby emerged from the crowd of reporters and rushed the handcuffed suspect. In a split second, as TV news cameras broadcast live, Ruby shoved his .38 revolver into Oswald's stomach and fired once.

Mortally wounded, Oswald, who had denied shooting the president, was rushed by ambulance to Parkland Hospital—just as Kennedy had been two days earlier—where he was pronounced dead. An autopsy revealed the bullet entered the 24-year-old's left side and caused damage to a number of vital organs, including his aorta, spleen, kidney and liver.

Oswald's murder has fueled conspiracy theories over Kennedy's assassination and his role in it. Did Ruby kill Oswald to keep him quiet? During his trial, Ruby claimed that rage over the president's death caused a psychomotor epileptic seizure during which he shot Oswald unconsciously. A jury found him guilty of first-degree murder in March 1964 and sentenced him to death, which he appealed. In January 1967, while awaiting a new trial, Ruby, 55, died of lung cancer.

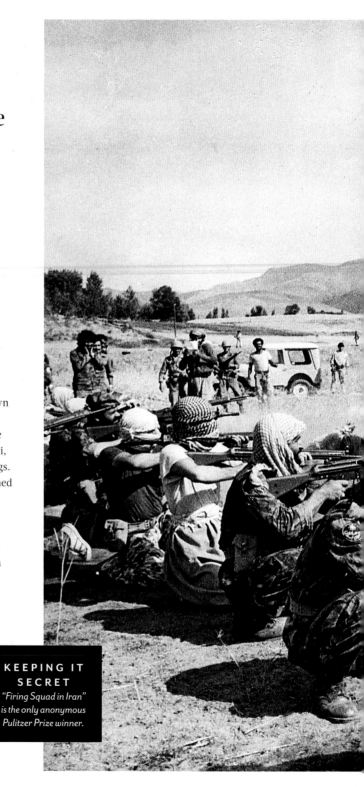

"I hope I can act as a responsible journalist in bringing truth to the people."

JAHANGIR RAZMI IN HIS PULITZER
PRIZE ACCEPTANCE SPEECH IN 2007

1979 » FIRING SQUAD IN IRAN

Convicted of being "counterrevolutionary," 11 Kurdish men were dragged out to a dusty field in the Iranian province of Kurdistan to be executed on Aug. 27, 1979. Blindfolded and lined up in the dirt, one by one they were gunned down by members of a firing squad. As Iranian ruler Ayatollah Khomeini had banned international journalists from the country, the only press presence was photographer Jahangir Razmi, who burned through two rolls of film as he documented the killings. The next day, Aug. 28, 1979, two of the graphic photos were published on the front page of the Iranian daily *Ettela'at*, but anonymously to protect Razmi—who didn't reveal his identity until 2006. The photograph went on to win the Pulitzer Prize in 1980, with the jury declaring: "It is not only a picture of enduring and memorable quality but also has the power to shape the viewer's feeling about a compelling international crisis."

KEEPING IT SECRET
"Firing Squad in Iran" is the only anonymous Pulitzer Prize winner.

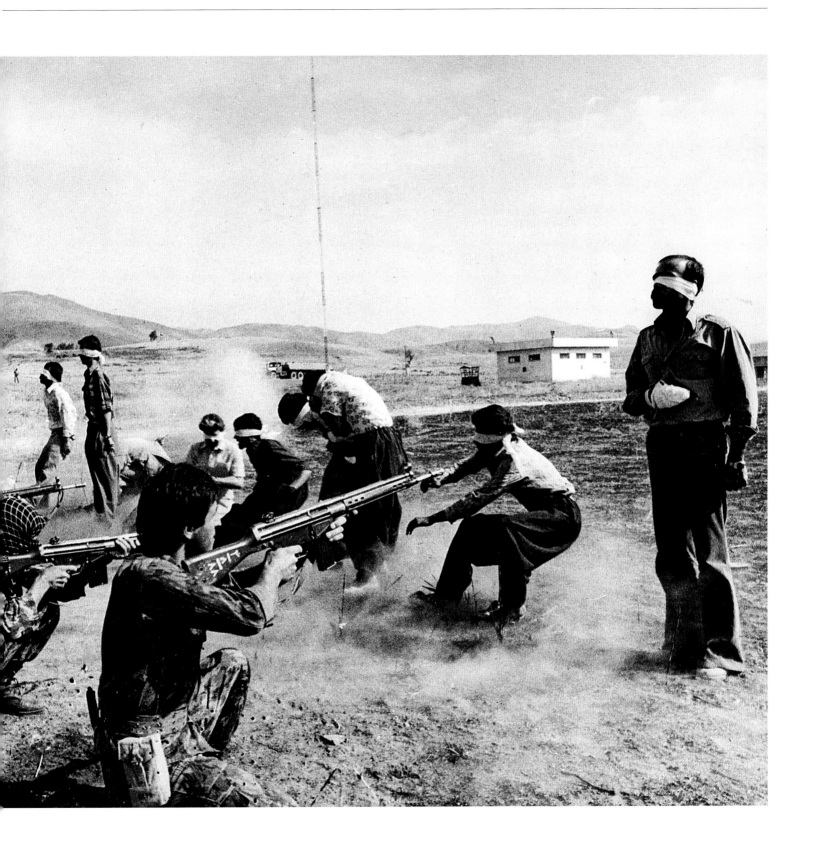

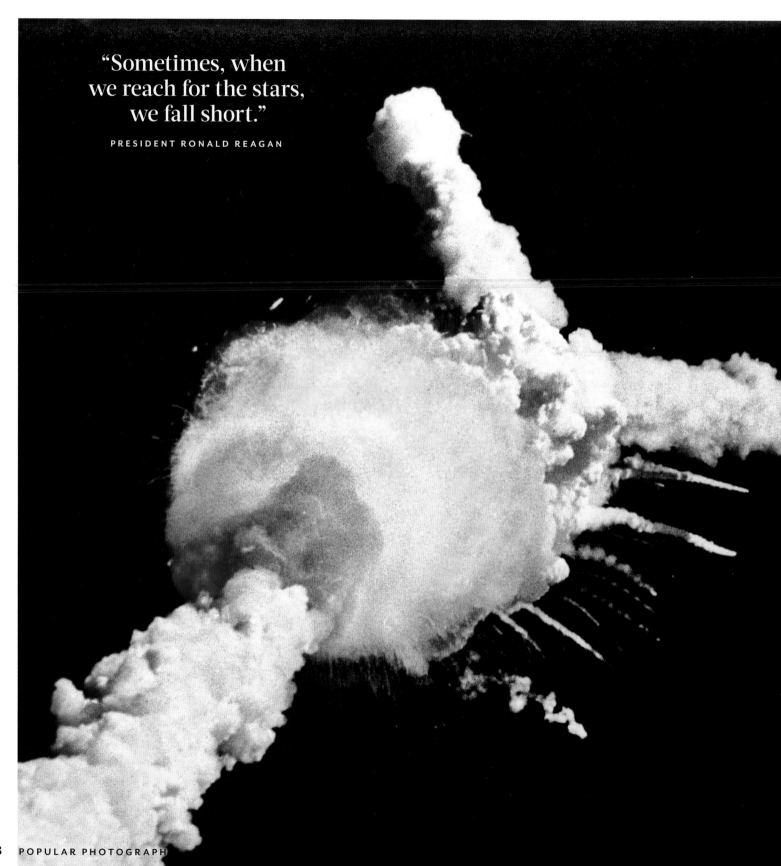

"Sometimes, when
we reach for the stars,
we fall short."

PRESIDENT RONALD REAGAN

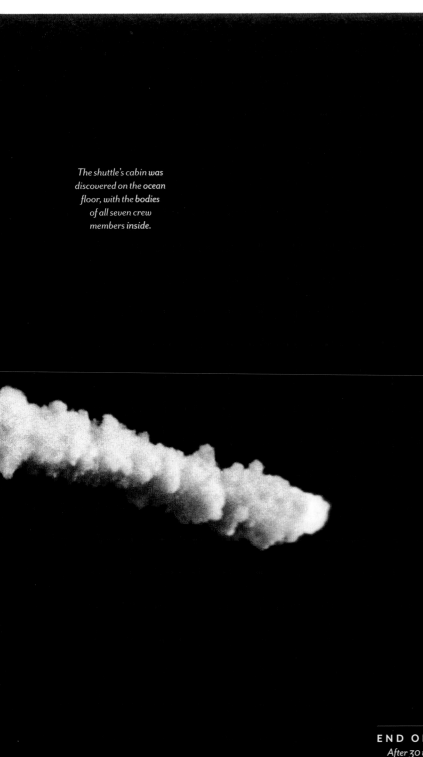

The shuttle's cabin was discovered on the ocean floor, with the bodies of all seven crew members inside.

1986 » THE *CHALLENGER* EXPLOSION

Throughout the 1960s and 1970s, space exploration captivated Americans as the country led the world to the final frontier. In 1976, NASA made another great stride when it introduced the first reusable manned spacecraft. One of its star space shuttles, *Challenger*, had completed nine missions when it was chosen to bring the first civilian, teacher Christa McAuliffe, into space in a highly publicized event.

On Jan. 28, 1986, McAuliffe, along with six astronauts, excitedly boarded the *Challenger* in front of a television audience of millions, primarily students whose schools paused classes to watch a teacher make history. But just 73 seconds after liftoff, the space shuttle exploded, killing all on board, and the fiery wreckage plummeted into the ocean below.

It was later determined that two rubber O-rings in the rocket booster failed due to unusually chilly weather. As a result, NASA suspended all shuttle missions for more than two years.

END OF AN ERA
After 30 years and 135 successful missions, NASA ended its space shuttle program in 2011.

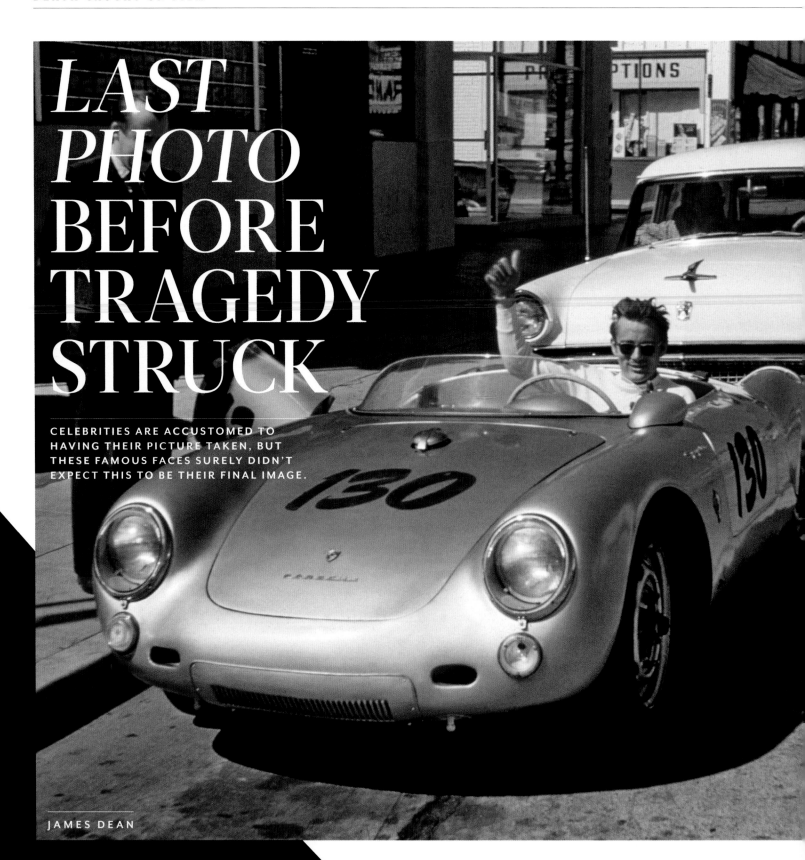

LAST PHOTO BEFORE TRAGEDY STRUCK

CELEBRITIES ARE ACCUSTOMED TO HAVING THEIR PICTURE TAKEN, BUT THESE FAMOUS FACES SURELY DIDN'T EXPECT THIS TO BE THEIR FINAL IMAGE.

JAMES DEAN

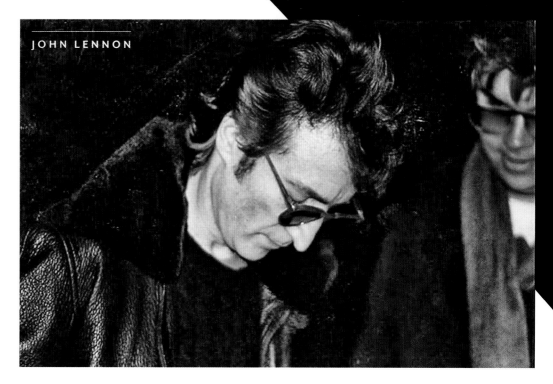

JOHN LENNON

"He's still alive, he's still with us, his spirit will go on, you can't kill a person that easily."

YOKO ONO, TO BBC REPORTER TOM BROOK

1980 » JOHN LENNON

The ex-Beatle was signing autographs for fans outside his New York City apartment on Dec. 8, 1980, when one, Mark David Chapman, asked him to sign his copy of the *Double Fantasy* album—a seemingly innocuous moment caught by another fan's camera (above). Five hours later, when Lennon returned home with his wife, Yoko Ono, Chapman was waiting and shot him four times.

1955 » JAMES DEAN

The movie heartthrob (left) had his Porsche 550 Spyder for only nine days before he was killed in a high-speed crash on the way to a racetrack near Paso Robles, California, on Sept. 30, 1955. Hours earlier, the promising young actor was snapped in his car, "Little Bastard," while parked on Vine Street in Hollywood.

JOHN CANDY

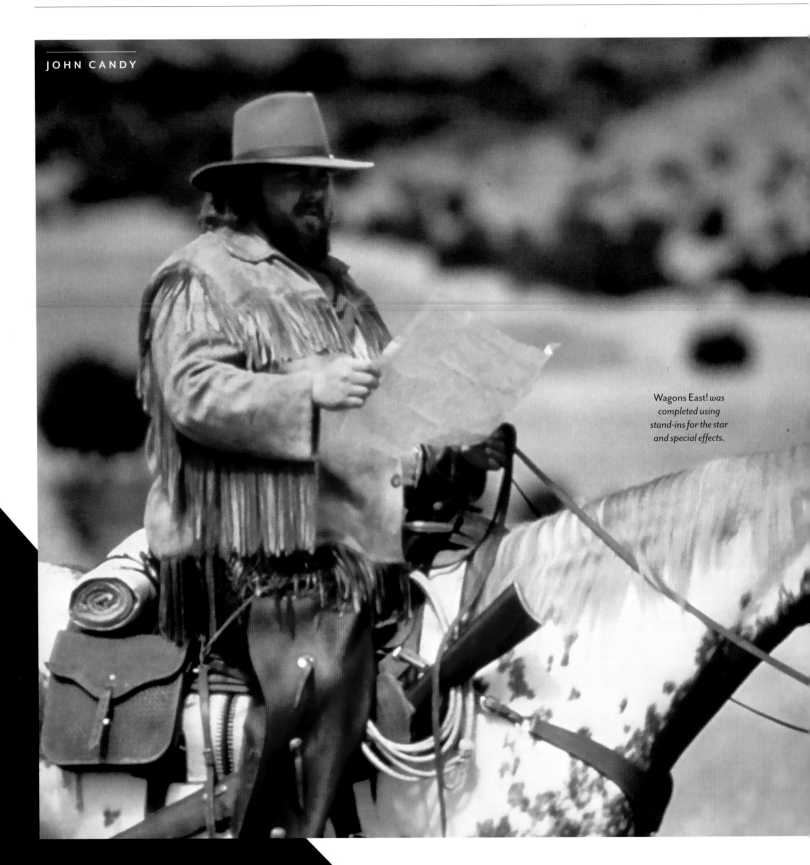

Wagons East! *was
completed using
stand-ins for the star
and special effects.*

1994 » JOHN CANDY

The funnyman was in Mexico filming *Wagons East!* (left) when he died in his sleep of heart failure on March 4, 1994. Perhaps suspecting something wasn't right, the *Uncle Buck* star, 43, reached out to loved ones on the eve of his death. "It was a Friday," son Chris later recalled. "He said, 'I love you and good night.' And I will always remember that."

1997 » PRINCESS DIANA

When the British royal was killed in a car crash in Paris just after midnight on Aug. 31, 1997, she and her lover, Dodi Fayed, were being chased by photographers on motorcycles. Seconds after the last pic was snapped (top right), the chauffeured Mercedes entered the Pont de l'Alma tunnel at 65 miles per hour. Driver Henri Paul lost control and hit a pillar. Fayed and Paul were killed instantly; Diana died after going into cardiac arrest at the hospital.

2014 » ROBIN WILLIAMS

Just weeks before committing suicide at his Paradise Cay, California home on Aug. 11, 2014, Williams celebrated his 63rd birthday with his *Night at the Museum* co-star, Crystal the Monkey, on July 21. In one of his last Instagram posts (right), he shared this pic with the caption: "Happy Birthday to me! A visit from one of my favorite leading ladies."

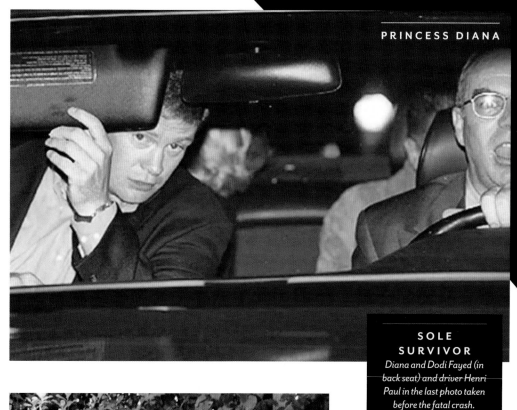

PRINCESS DIANA

SOLE SURVIVOR
Diana and Dodi Fayed (in back seat) and driver Henri Paul in the last photo taken before the fatal crash. Bodyguard Trevor Rees-Jones suffered serious injuries, but lived.

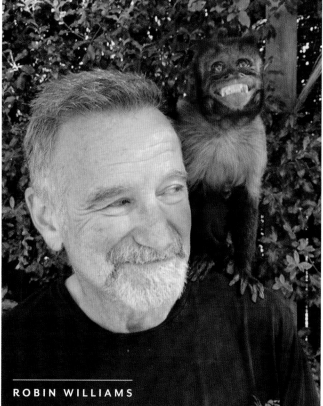

ROBIN WILLIAMS

"We remember her love, strength and character— qualities that made her a force for good around the world."

PRINCES WILLIAM AND HARRY, ON THEIR MOTHER, PRINCESS DIANA

POP
CULTURE'S MOST
ICONIC
MOMENTS

HISTORY IN THE MAKING: FROM HOLLYWOOD TO
WOODSTOCK, NOSTALGIA LIVES ON FOR GENERATIONS
PAST, PRESENT AND FUTURE.

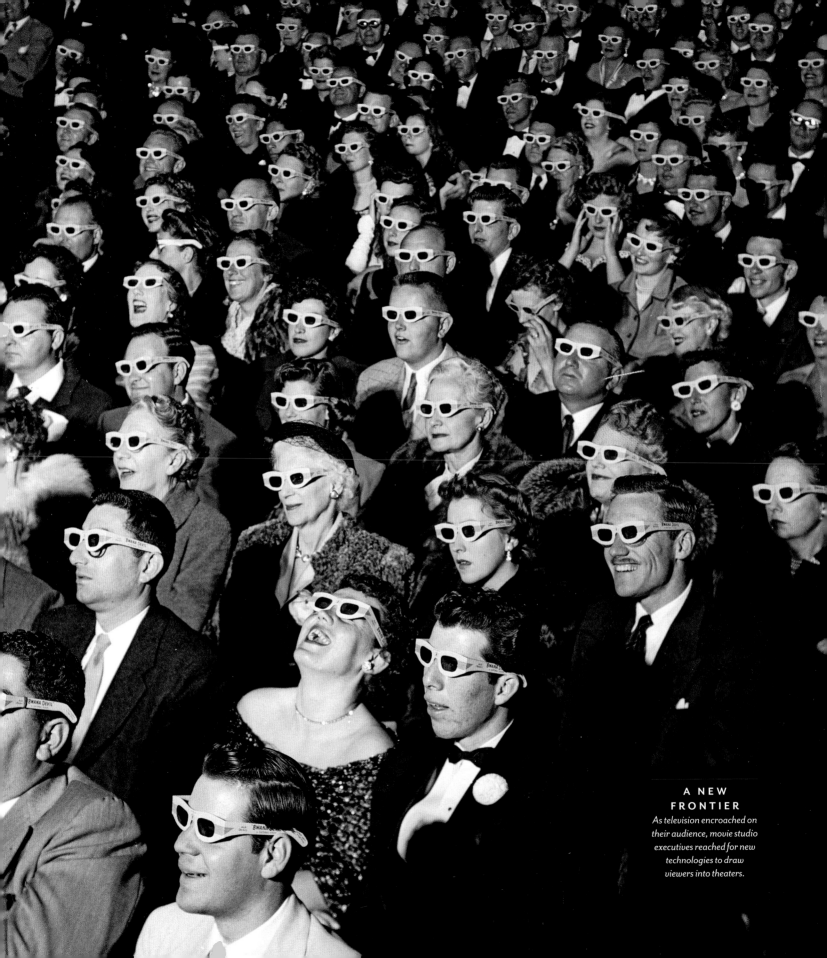

A NEW FRONTIER

As television encroached on their audience, movie studio executives reached for new technologies to draw viewers into theaters.

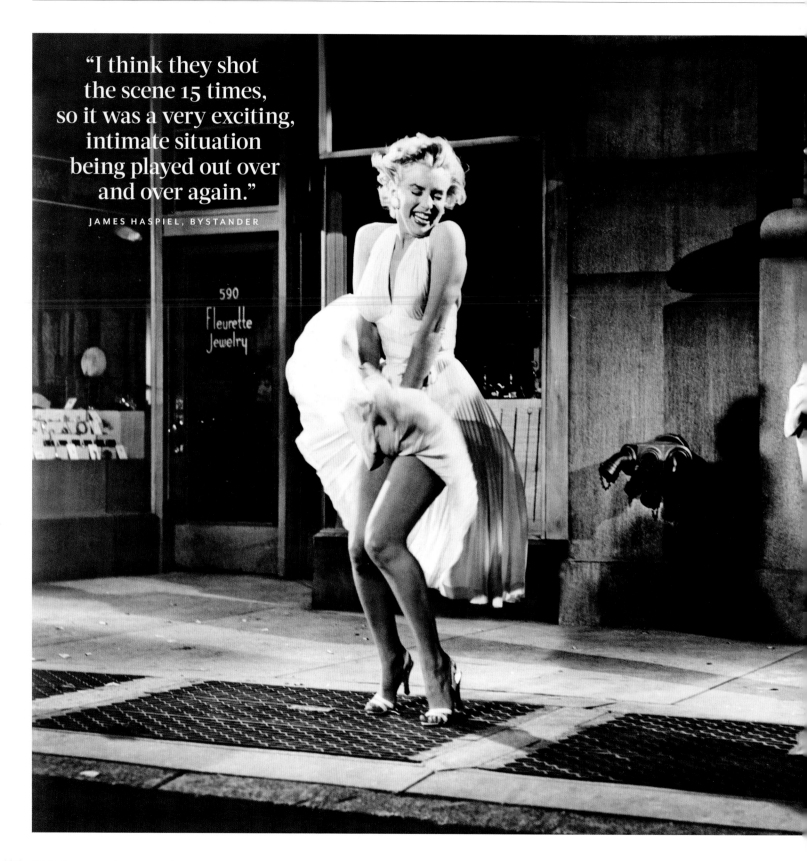

"I think they shot the scene 15 times, so it was a very exciting, intimate situation being played out over and over again."

JAMES HASPIEL, BYSTANDER

1952 » 3D MOVIE AUDIENCE *(page 105)*

As cinema evolved from black and white to color, Hollywood introduced its latest novelty: 3D films. On Nov. 26, 1952, the sold-out crowd at LA's Paramount Theater sported special glasses to watch man-eating lions jump off the screen in *Bwana Devil*, the first full-length film to utilize the new technology. Although the audience complained that the glasses were uncomfortable, moviegoers were intrigued by the new trend. *Bwana Devil*, which cost $323,000 to make three-dimensional, earned more than $2.5 million at the box office and was one of the most popular films of 1953.

1954 » MARILYN MONROE'S DRESS BLOWS UP

If there were any questions about whether Marilyn Monroe was a sex symbol, they were answered with her 1955 flick, *The Seven Year Itch*. The script called for the actress, who played the object of a married neighbor's desire, to have a provocative moment in a low-cut, flimsy dress as she stood over a breezy New York City subway grate. Knowing the scene would be eye-popping, the studio's publicity team informed the press of the filming, promising that it would "stop the traffic" at 52nd Street and Lexington Avenue—and it did. Five thousand onlookers gathered at the intersection at 1 a.m. on Sept. 15, 1954, to bear witness to the iconic moment when a train passed below and Monroe's dress blew up, revealing her undergarments.

Although the actress wore two pairs of panties to protect her modesty, the intense klieg lights used by the production crew didn't leave much to the imagination. "I must confess I had no trouble seeing through Marilyn's sheer panties," bystander James Haspiel happily admitted.

One onlooker who wasn't as thrilled by what he saw was Monroe's husband, Joe DiMaggio. Already a jealous guy, the baseball great flew into a rage the moment he saw his wife's dress blow up in front of the thousands of gawkers gathered on the street. As director Billy Wilder later put it, DiMaggio gave "the look of death." Once back in their hotel room at the St. Regis, things turned physical between the couple, according to friends who noticed Monroe was visibly bruised at dinner later that night. "That was the last straw," recalled sportswriter Stacy Edwards. "After he hit her, she told him she'd had enough and wanted out of the marriage." Sure enough, on Oct. 5, Monroe filed for divorce from DiMaggio after nine months of marriage.

MONEY MAKER
In 2011, Marilyn Monroe's famous halter-style pleated white dress was auctioned off for a whopping $5.6 million—three times the expected price.

"If you can dream, you can do it. Always remember, this thing was started by a mouse."

WALT DISNEY

1955 » FIRST DISNEY PARK OPENS

Riding on the success of his animated films, including *Snow White and the Seven Dwarfs*, *Dumbo* and *Bambi*, Walt Disney began designing a sprawling 160-acre amusement park to be built near his Los Angeles studio in Anaheim, California. Disney dreamed of a park that would educate and entertain both young and old.

On July 17, 1955, Disneyland opened its doors to a select number of people who had received special invitations. Just one problem: The passes were counterfeited—and thousands more visitors showed up that day. Disneyland ran out of food and drinks, a woman's high heel got stuck in the still-wet asphalt on Main Street USA, and the Mark Twain Steamboat nearly capsized due to being over capacity.

Still, the chaos proved there was a demand for Disney. Sixteen years later, in 1971, a second theme park—Disney World—was opened in Orlando, Florida. It was followed by Disneyland Tokyo, in 1983; Paris-based Euro Disney, in 1992; and Disneyland Hong Kong, in 2005. Today, Disneyland welcomes more than 18 million people—and the $3 billion they spend—per year.

HIDDEN TREASURE

A time capsule was buried in front of Sleeping Beauty Castle on the occasion of Disneyland's 40th anniversary in 1995; it will be opened in 2035.

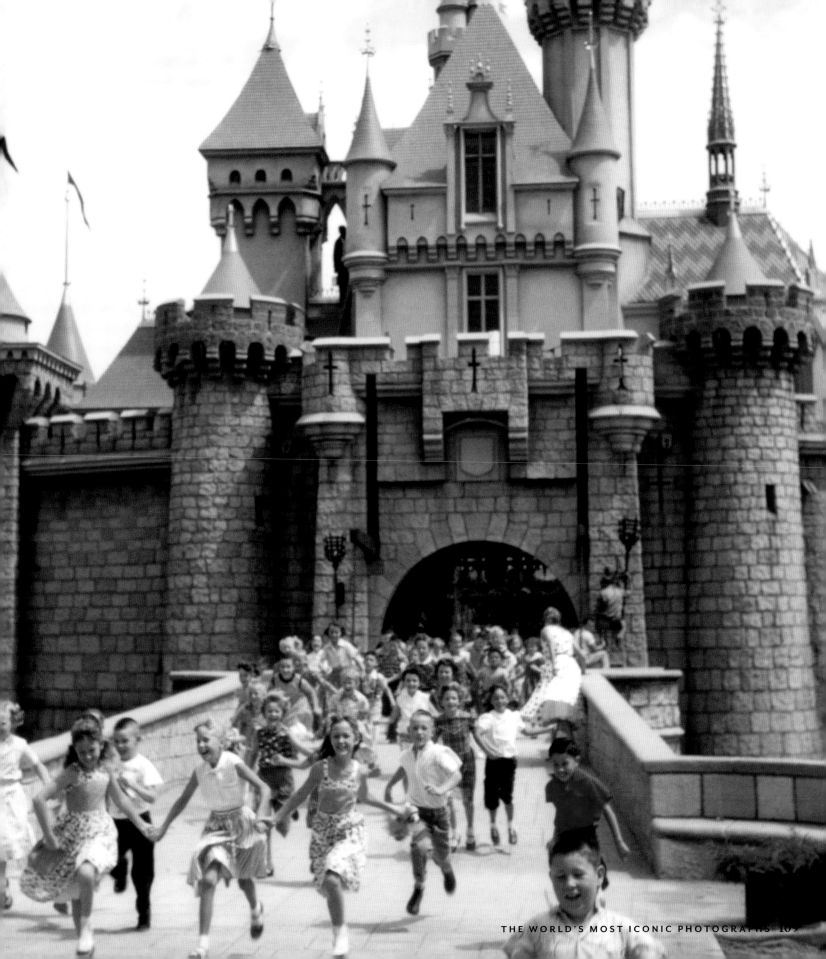

HIGH NOTE
Louis Armstrong's jazz-diplomacy trips were so successful that he was nicknamed "Ambassador Satch."

1961 >> LOUIS ARMSTRONG AND HIS WIFE, LUCILLE

During the Cold War, the U.S. State Department sent a number of famous jazz musicians to perform in Africa, the Middle East and South America in an effort to counter communist propaganda. Louis Armstrong, Dizzy Gillespie, Benny Goodman and Duke Ellington were all ambassadors of "jazz diplomacy," and their job was to showcase the cultural freedoms of America through their music.

In 1961, Armstrong's 27-city tour was stopped in Egypt when he took the opportunity to create a romantic moment for his wife, Lucille, who was a constant fixture on his global treks. As the two were taking in the pyramids in Giza, the trumpeter, nicknamed Satchmo, stopped to serenade his love at the foot of the Great Sphinx. In this iconic photo from the picturesque scene, Lucille can be seen smiling at her husband as she listens intently to his music.

"I got a trumpet and I got a young wife, and I ain't got time to fool with none of the stuff you guys talking about."

LOUIS ARMSTRONG

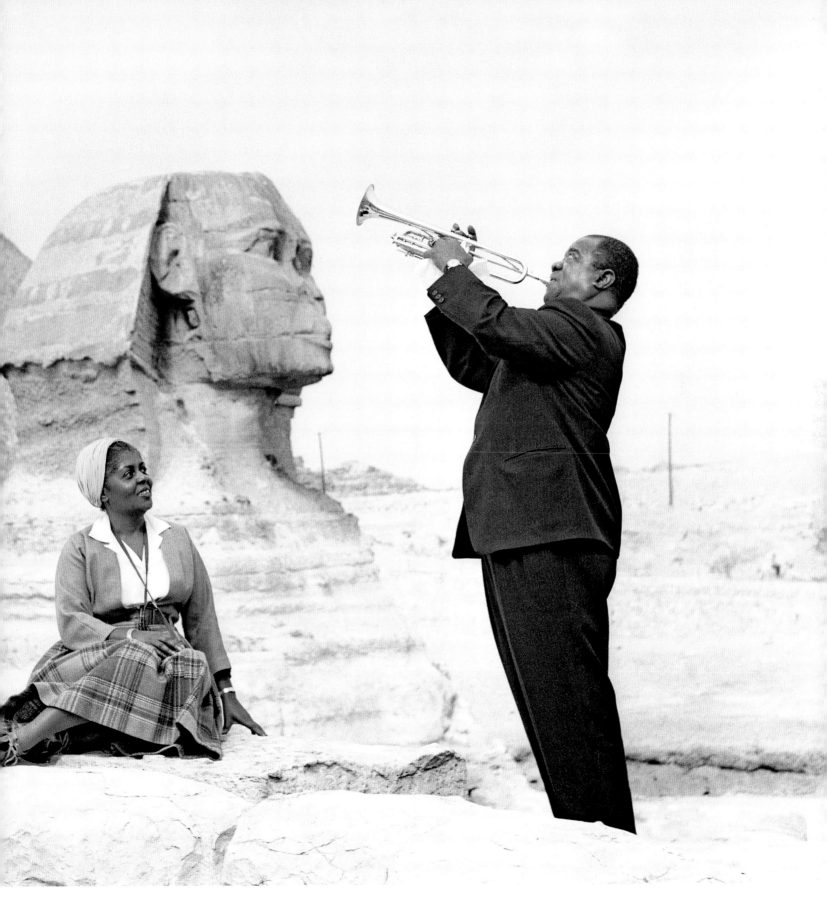

"[They] embodied Hollywood's most elemental myth...a life without the constrains of fidelity, monogamy, sobriety."

1996 *NEW YORK TIMES* ARTICLE ON THE RAT PACK

1962 » THE RAT PACK

In the 1960s, there was no group of guys in Hollywood cooler than Frank Sinatra, Dean Martin, Sammy Davis Jr., Peter Lawford and Joey Bishop. The Rat Pack, as they were dubbed, first got together after meeting at a party thrown by original leader Humphrey Bogart—and a brotherhood was founded upon cocktails and pretty women. Their "mascots" included some of the biggest stars in the world, including Marilyn Monroe, Judy Garland, Angie Dickinson and Shirley MacLaine. Even John F. Kennedy, who was Lawford's brother-in-law, wanted to hang with the Rat Pack. Whenever the politician joined in their festivities in Las Vegas or Palm Springs, California, they'd temporarily change their name to the "Jack Pack."

The main members of the quintet weren't just handsome and charming—they were talented actors and singers. Any time a member played the Sands Hotel and Casino, fans would flock to Sin City for their sold-out shows. Together, the Rat Pack recorded five live albums and starred in a number of movies, including the original *Ocean's 11* about Danny Ocean (Sinatra) and his World War II buddies who pull off a Vegas hotel heist. The 1960 film was a hit, but the group knew their popularity was fleeting. "The whole world is drunk, and we're just the cocktail of the moment," Martin joked. "Someday soon, the world will wake up, down two aspirin with a glass of tomato juice and wonder what the hell all the fuss was about."

RAT REDUX
In 1988, Frank Sinatra, Dean Martin and Sammy Davis Jr. reunited for a tour, but health problems forced Martin to quit after five shows.

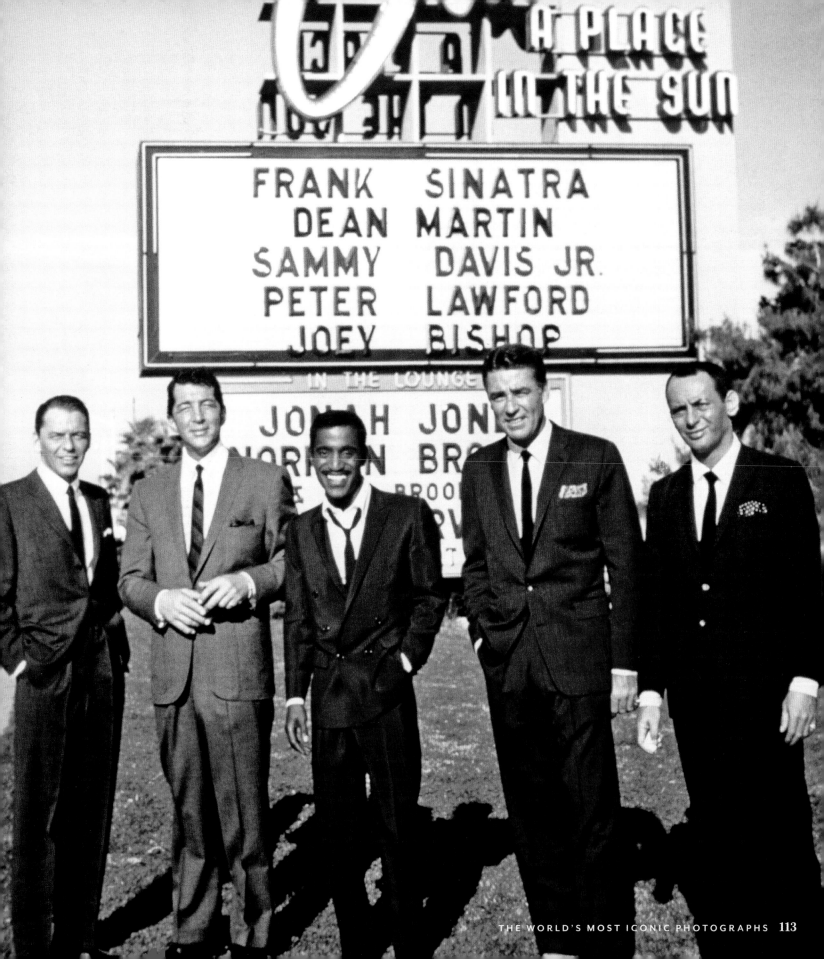

A PLACE
IN THE SUN

FRANK SINATRA
DEAN MARTIN
SAMMY DAVIS JR.
PETER LAWFORD
JOEY BISHOP

IN THE LOUNGE

JONAH JONE
NORMAN BRO
BROO

1964 » THE BEATLES COME TO AMERICA

Beatlemania was in full swing in the U.K. when the Fab Four— John Lennon, Paul McCartney, George Harrison and Ringo Starr—released their single "I Want to Hold Your Hand" in the U.S. in early 1964. Within three weeks, it sold 1.5 million copies, prompting The Beatles to plan a stateside invasion. On Feb. 7, the band landed at New York City's John F. Kennedy International Airport, where they were greeted by thousands of screaming fans. Two days later, The Beatles made their first live U.S. television appearance on *The Ed Sullivan Show.* According to Nielsen, an estimated 73 million viewers—45.3% of households with televisions—tuned in, a feat no one has surpassed in the 50 years since.

On Feb. 11, the band played their first U.S. concert, to 20,000 fans at the Coliseum in Washington, D.C., followed the next day by back-to-back sold-out shows at New York City's Carnegie Hall. On Feb. 22, The Beatles returned to the U.K.—but their popularity in America only continued to skyrocket.

TOP OF THE CHARTS
In April 1964, two months after the Fab Four invaded America, the top five songs in the country were all Beatles tunes.

"Skeptics have not felt compelled to offer much of a detailed argument."

DAVID DAEGLING, ANTHROPOLOGIST

1967 » BIGFOOT

One of the greatest mythical creatures seemed proven real when filmmakers captured footage of what they claimed was a bigfoot in Northern California. In the 59.5-second clip, an apelike figure, estimated to be over 7 feet tall, hulks away through a wooded area after being surprised by Roger Patterson and Bob Gimlin near Bluff Creek. Despite accusations of staging a hoax, the duo insisted the sighting was authentic. With no confirmation, it seems the truth is still out there.

1985 » WE ARE THE WORLD

On Jan. 28, 1985, the supergroup USA for Africa lent their famous voices to famine relief, recording the single "We Are the World." Featuring 45 of the biggest acts in music—including Michael Jackson, Cyndi Lauper, Stevie Wonder, Bob Dylan, Hall & Oates, Diana Ross and Bruce Springsteen—the lyrics suggest, "We are the ones who make a brighter day, so let's start giving," and that's exactly what Americans did. With 20 million copies sold, "We Are the World" raised $63 million (more than $157 million in 2021) for humanitarian aid for Africa.

The popularity of the song was due in large part to its video. Although a simple peek inside the recording studio, it was a musical melting pot of pop, rock, R&B and country, as unlikely duos including Dionne Warwick and Willie Nelson shared microphones during their respective solos. "We Are the World," written by pop stars Jackson and Lionel Richie, was also a critical hit, earning four Grammy Awards.

And its influence has lived on—a 2010 remake featuring Justin Bieber, Pink and Usher benefited the victims of the devastating earthquake in Haiti.

ALL-STAR CHORUS
Fifty singers who wanted to contribute vocals had to be turned down; others, such as Prince, passed on the opportunity.

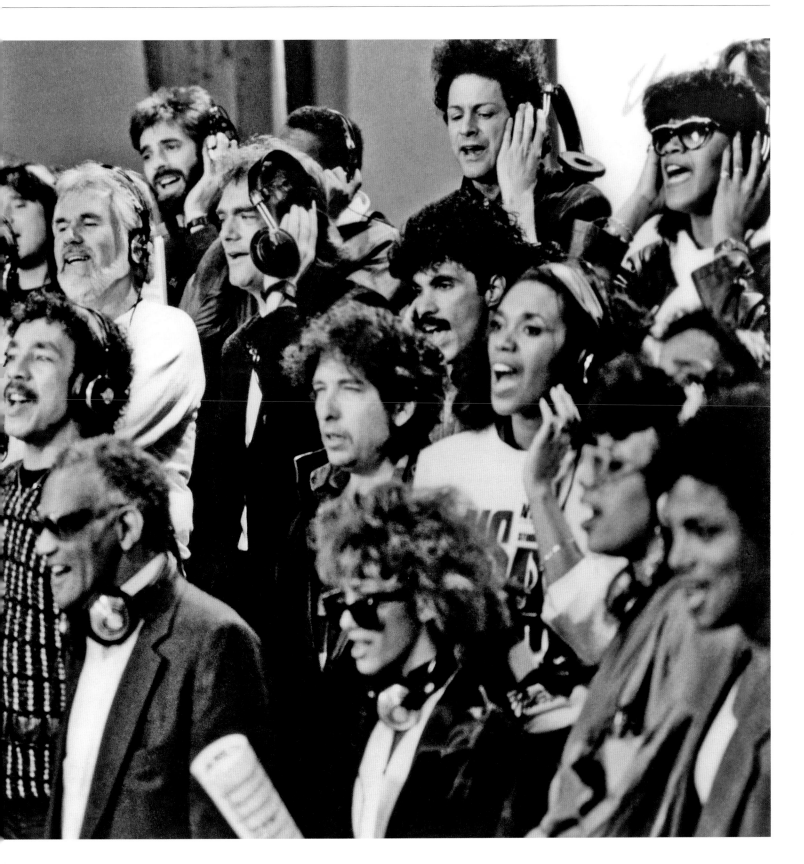

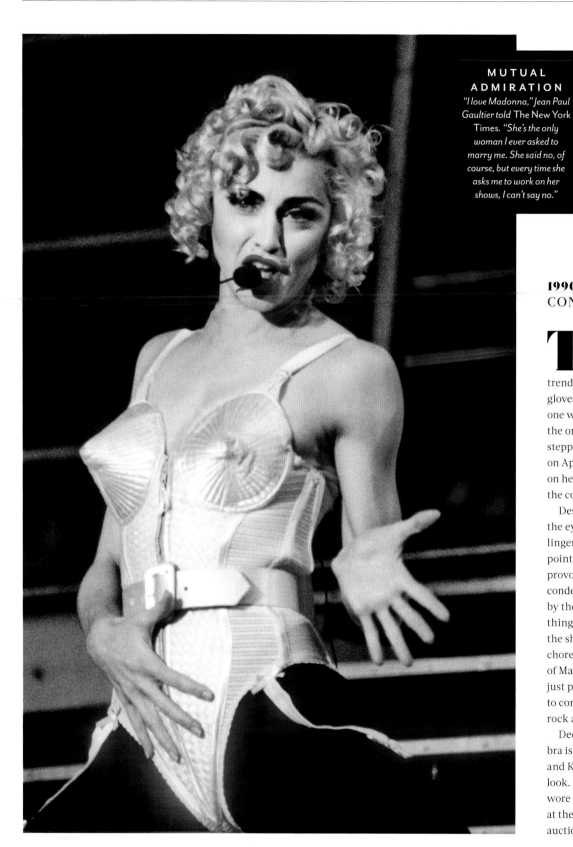

1990 » MADONNA'S CONE BRA

Throughout the 1980s, Madonna inspired a number of fashion trends, such as fingerless lace gloves and rosary necklaces. But no one was quite sure what to make of the one she introduced when she stepped onstage in Chiba, Japan, on April 13, 1990, for the first stop on her Blond Ambition World Tour: the cone bra.

Designed by Jean Paul Gaultier, the eye-popping piece of silk lingerie was the exclamation point on Madonna's sexually provocative tour—which was condemned for being "sinful" by the Vatican. "The biggest thing we tried to do is change the shape of concerts," explained choreographer Vincent Paterson of Madonna's vision. "Instead of just presenting songs, we wanted to combine fashion, Broadway, rock and performance art."

Decades later, Madonna's cone bra is still iconic—even Lady Gaga and Katy Perry have copied the look. And in 2012, two pieces she wore on the tour sold for $77,000 at the Christie's Pop Culture auction in London.

ROAD TRIP
The Bronco chase lasted just over two hours.

1994 » O.J. SIMPSON'S BRONCO CHASE

As a football star, O.J. Simpson was used to a cheering crowd—one that didn't turn their backs on him, even as a suspected murderer. On June 17, 1994, an arrest warrant was issued for Simpson in the stabbing deaths of his estranged wife, Nicole Brown Simpson, and Ron Goldman three days earlier. Although his lawyers had promised LAPD he would turn himself in, Simpson instead went on the run.

Driven by his friend Al Cowlings, the athlete sat in the back seat of his white Ford Bronco with a gun to his head as 20 police cars gave chase, albeit a slow one at 35 miles per hour, through Los Angeles. As TV cameras rolled, ABC, CBS and NBC all interrupted regularly scheduled programming to cover the event live. In LA, thousands of spectators lined up on the sides of roads and on overpasses to support Simpson as he drove past. Some even held up signs encouraging him to keep going. When he turned himself in—after sitting in the Bronco for another 45 minutes—he was greeted with cheers of "Free O.J.!" Simpson was charged with two counts of first-degree murder but was acquitted in 1995. The following year, the Brown and Goldman families filed a civil lawsuit; a jury found Simpson "responsible" for the murders and ordered him to pay $33.5 million.

"If only Bradley's arm was longer. Best photo ever. #oscars."

ELLEN DeGENERES

2014 » OSCARS SELFIE

How many Hollywood stars can you squeeze into one selfie? The world learned the answer at the 2014 Academy Awards when host Ellen DeGeneres convinced some of the event's biggest names to get out of their seats and pose together for a cellphone photo. As Bradley Cooper held out the device, Meryl Streep, Brad Pitt, Angelina Jolie, Jennifer Lawrence, Julia Roberts and more all flashed their megawatt smiles—and instantly went viral. Within 30 minutes of DeGeneres posting the epic selfie on Twitter, it received 1.1 million retweets, making it the most retweeted post ever at the time. Two hours later, that number climbed to 2 million. "We just crashed Twitter," the comedian informed the audience during the live broadcast. "We got an email from Twitter, and we crashed and broke Twitter. We have made history." The Oscars selfie eventually surpassed 3 million retweets (and 2 million likes), but it no longer holds the coveted record. As of 2021, it has dropped down to No. 5.

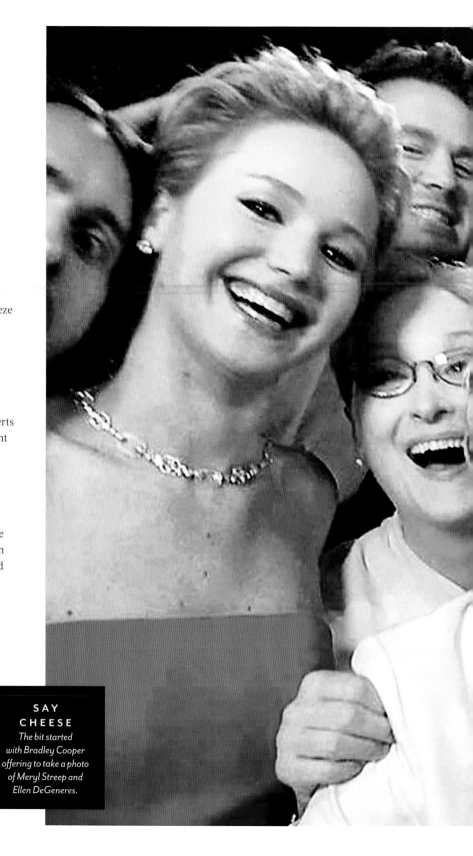

SAY CHEESE
The bit started with Bradley Cooper offering to take a photo of Meryl Streep and Ellen DeGeneres.

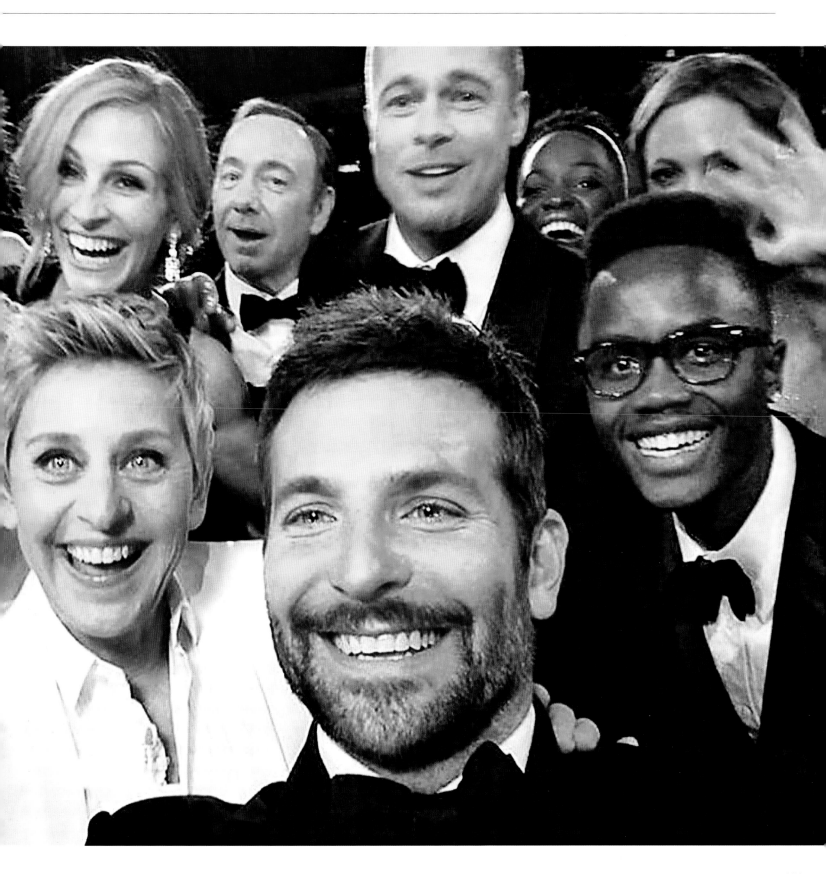

PEACE & MUSIC

A WATERSHED MOMENT IN AMERICAN POP CULTURE, THE FESTIVAL WASN'T JUST A BUNCH OF HIPPIES—IT WAS THE DEFINITIVE EXPRESSION OF CULTURAL AND POLITICAL IDEALISM OF THE 1960s.

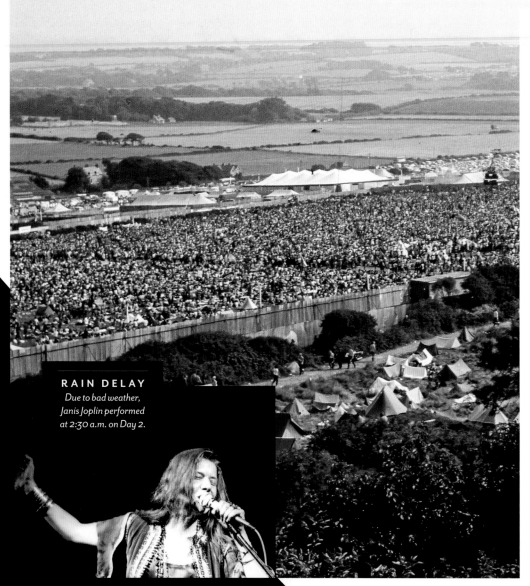

RAIN DELAY
Due to bad weather, Janis Joplin performed at 2:30 a.m. on Day 2.

1969 » WOODSTOCK

Three days of music (and mud) in rural New York turned into a pop culture phenomenon when the Woodstock festival took over 300 acres of farmland in August 1969. An estimated 400,000 people—300,000 more than expected—turned out for the historic event that boasted 32 acts headlined by Santana, The Who, Creedence Clearwater Revival and Jefferson Airplane. The "peace" aspect of Woodstock was truly genuine: There was not one reported incident of violence. Still, it wasn't all harmonious. Dozens of lawsuits were filed by local farmers to pay for the destruction caused by the massive crowds. As a result, promoters were left nearly bankrupt, despite their role in pop culture history. In the years since, Woodstock's anniversaries have been commemorated, with its 25th being the most prominent; Green Day, Nine Inch Nails, Metallica and Sheryl Crow were on the bill. In 2019, the planned 50th anniversary was hampered by financial and logistical issues— and it was ultimately canceled.

PLAYED OUT
The Grateful Dead played a 40-minute rendition of "Turn on Your Love Light."

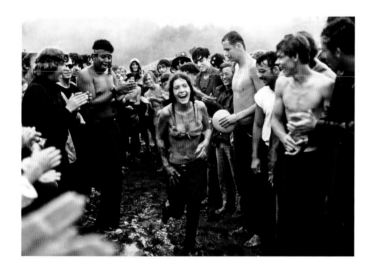

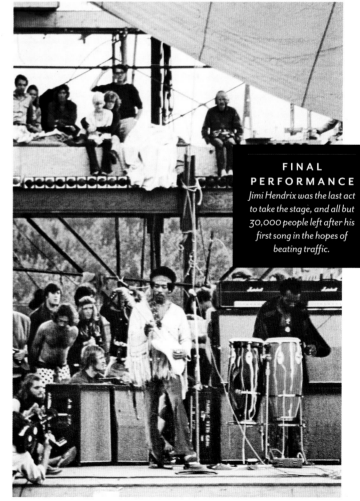

FINAL PERFORMANCE
Jimi Hendrix was the last act to take the stage, and all but 30,000 people left after his first song in the hopes of beating traffic.

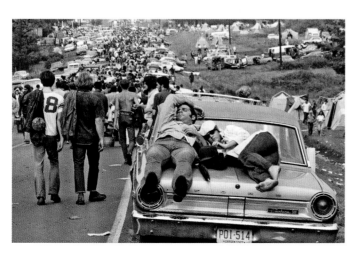

HOW A
SINGLE
PHOTO

INSPIRED CHANGE

SINCE THE 19TH CENTURY, REFORMS HAVE BEEN MADE
TO FIRE SAFETY, CHILD LABOR, VOTING RIGHTS
AND ENVIRONMENTAL PRESERVATION—ALL BECAUSE
AN IMAGE FROM THE TIME MADE PEOPLE TAKE
NOTICE AND DEMAND ACTION.

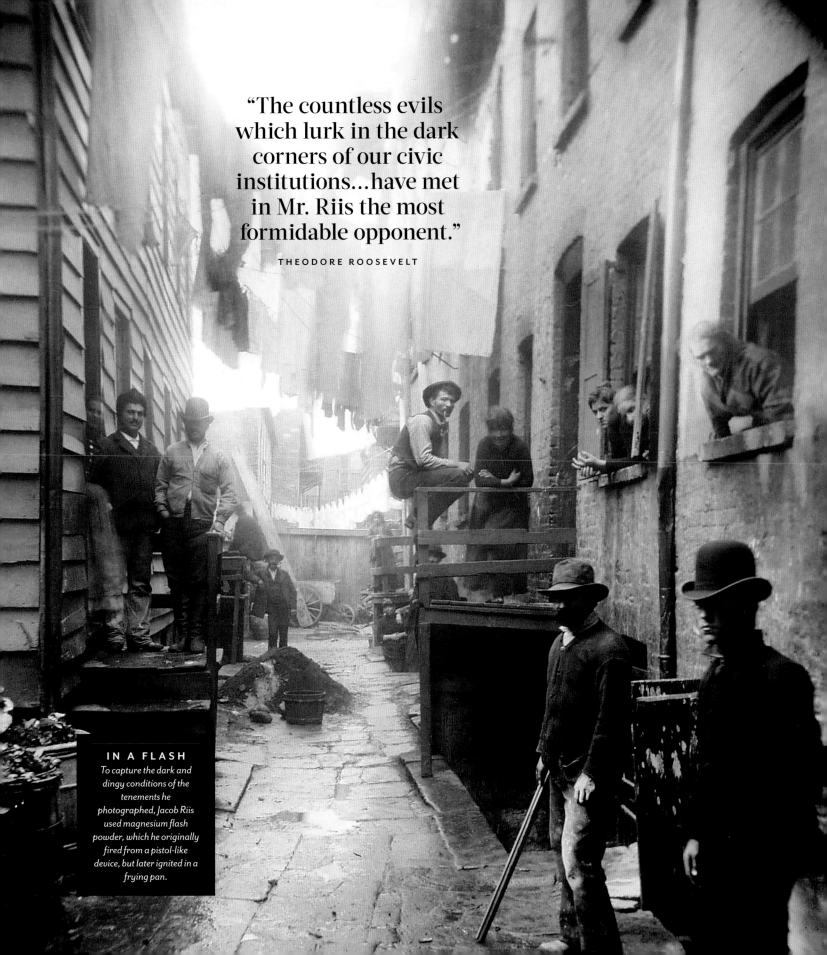

"The countless evils which lurk in the dark corners of our civic institutions...have met in Mr. Riis the most formidable opponent."

THEODORE ROOSEVELT

IN A FLASH
To capture the dark and dingy conditions of the tenements he photographed, Jacob Riis used magnesium flash powder, which he originally fired from a pistol-like device, but later ignited in a frying pan.

1888 » BANDIT'S ROOST *(previous page)*

Through Jacob Riis' photo lens, America got to truly see how the other half lived, as he documented the struggles of immigrants in New York City at the turn of the 20th century. The photographer exposed the abject poverty that gripped the downtown slums, with families crammed into windowless tenements, children sleeping on piles of garbage and deadly sweatshop conditions. At first glance, his photo "Bandit's Roost" depicts gang members gathered menacingly in an alley—but a closer look reveals the grim reality all around them, the hopelessness of squalor written on their faces. In 1890, Riis published his first portrait collection, *How the Other Half Lives.* "I have read your book," wrote then-police commissioner Theodore Roosevelt, "and I have come to help." It took more than a decade, but in 1901 the landmark New York State Tenement House Act banned the construction of poorly ventilated buildings and required outward-facing windows in every room, open courtyards, indoor toilets and fire safeguards.

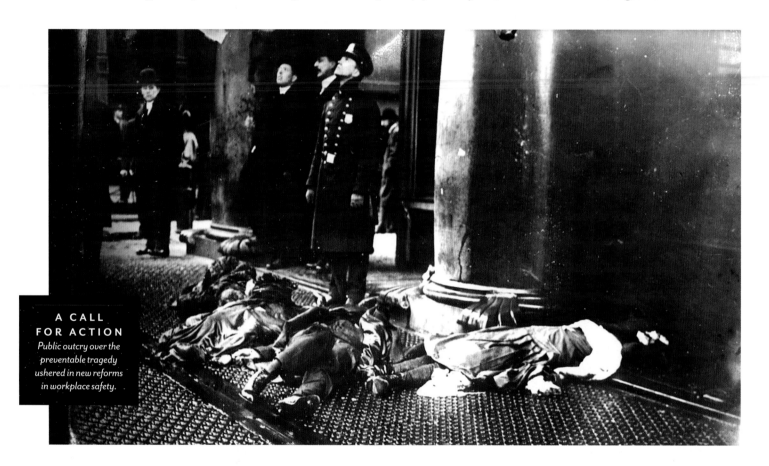

A CALL FOR ACTION
Public outcry over the preventable tragedy ushered in new reforms in workplace safety.

1911 » TRIANGLE SHIRTWAIST FACTORY FIRE

On March 25, 1911, a fire broke out inside New York City's Triangle Shirtwaist Co., a sweatshop that employed immigrant women to sew 12 hours a day, seven days a week. As panicked workers tried to escape, they encountered multiple obstacles. The one working elevator could hold only 12 people; those who couldn't get in ran down the stairwell, only to find the doors locked. Others rushed to the fire escape, but it collapsed under their weight. As flames consumed the eighth floor, some saw no option but to jump: 58 onto the sidewalk, another 36 down the elevator shaft. Within minutes, 146 were dead. Photos like this one caused outrage over the lack of safety. That October, New York enacted the Sullivan-Hoey Fire Prevention Law and created the Factory Investigating Commission.

1936 » MIGRANT MOTHER

After the stock market crash of 1929, the United States plummeted into a financial crisis that affected both rich and poor. As the country fell deeper into the Great Depression, the government created the Resettlement Administration (RA) to help relocate those who were struggling. In March 1936, Dorothea Lange, a photographer working for the RA, was driving past a pea-pickers camp that had been destroyed by freezing rain when she witnessed something that tugged at her heartstrings: Migrant woman Florence Owens Thompson huddled with her seven starving children in a makeshift tent. Lange documented the family's struggle with six iconic black-and-white photos. Within days of publication, the federal government sent 20,000 pounds of food to the struggling workers at the pea farm.

DESPERATE TIMES
When Dorothea Lange met her, Florence Owens Thompson had just sold her car tires to buy food.

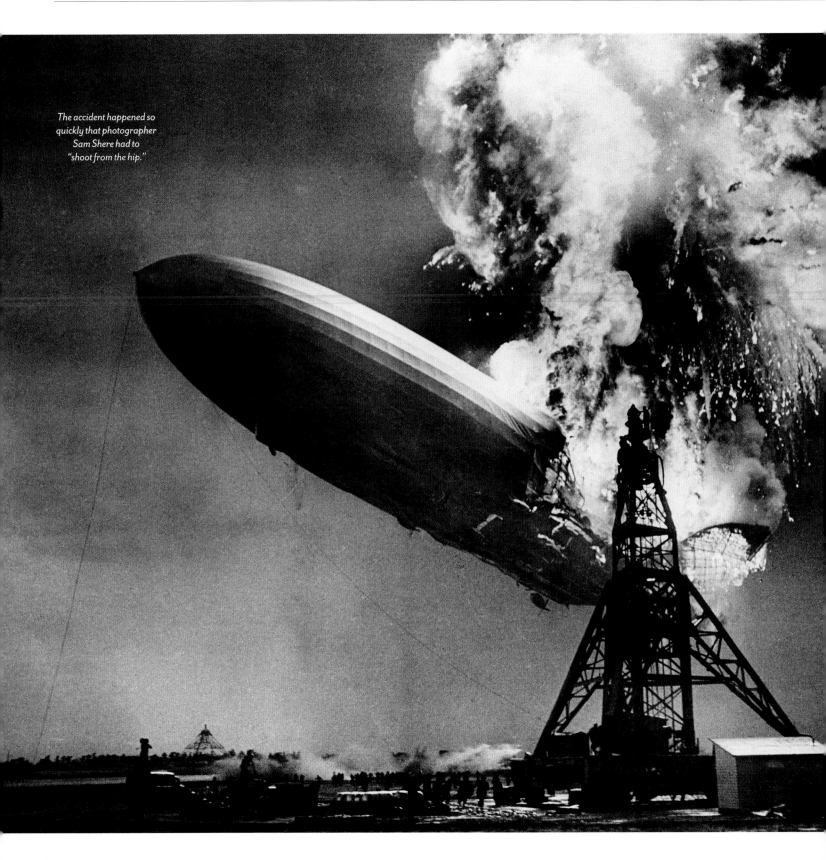

The accident happened so quickly that photographer Sam Shere had to "shoot from the hip."

> "It burst into flames, it burst into flames! And it's falling, it's crashing...it's crashing terrible.... Oh, the humanity!"

HERBERT MORRISON, CHICAGO RADIO REPORTER

1937 » THE *HINDENBURG* DISASTER

In Germany in the 1930s, the *Hindenburg*, a new type of passenger-carrying airship, was all the rage and thought to be the future of air travel. In its maiden year, 1936, the hydrogen-filled zeppelin, which could hold up to 70 people, made 17 transatlantic flights to the United States and Brazil. The second year promised another 10 between Europe and the U.S., the first departing Frankfurt, Germany, on May 3, 1937, bound for New Jersey.

Due to strong winds and storms, the LZ 129 *Hindenburg* was hours behind schedule when it arrived in the U.S. on May 6. At 7 p.m., it made its descent to dock at the Naval Air Station Lakehurst in New Jersey. As scores of spectators watched, disaster suddenly struck when the ship's hydrogen fuel caught fire, causing the 804-foot-long *Hindenburg* to burst into flames, killing 35 of the 97 people on board. Catastrophic images of the explosion captured by photojournalists, such as this one by Sam Shere, had people so scared to fly, they essentially ended the brief age of airship travel.

FINAL HOURS
Just before the explosion, the Hindenburg drifted over Boston before treating its passengers to an aerial tour over New York City later that afternoon.

"Shall we say that this is a noble sight? Shall we say that this is a fine thing, that they should give their lives for their country?"

STATEMENT FROM *LIFE* EDITORS

1943 » DEAD AMERICANS AT BUNA BEACH

World War II was so devastating that the government banned the publication of photos depicting U.S. casualties. But when photojournalist George Strock captured three dead soldiers on Buna Beach in Papua New Guinea in February 1943, he was determined to show Americans what was really going on overseas. For months, his editors at *Life* magazine lobbied military censors to be allowed to print Strock's image. "I went from Army captain to major to colonel to general," said *Life* correspondent Cal Whipple, "until I wound up in the office of an assistant secretary of the Air Corps, who decided, 'This has to go to the White House.'"

The persistence paid off. Fearing Americans had become complacent about the war, President Franklin D. Roosevelt gave his approval for Strock's photo to be published. *Life* magazine's Sept. 20, 1943, issue included a special editorial explaining that FDR "decided that the American people ought to be able to see their own boys as they fall in battle."

PRIVACY PRESERVED
Even though FDR allowed images of soldiers' remains to be published, their faces were not shown—a practice that continued until the Korean War in the early 1950s.

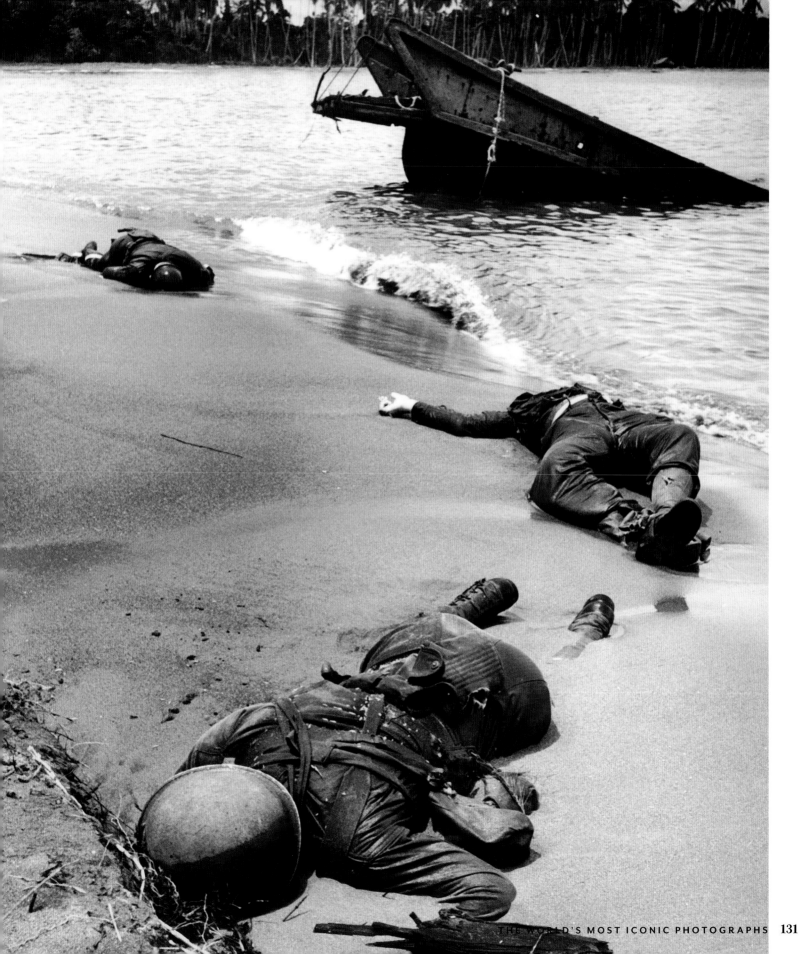

"There is no Southern problem. There is no Northern problem. There is only an American problem."

PRESIDENT LYNDON B. JOHNSON

1965 » BLOODY SUNDAY

To raise awareness of the discrimination against Black voters, Dr. Martin Luther King Jr. organized a 54-mile march in Alabama—from Selma to the state's capital, Montgomery. But on Sunday, March 7, 1965, the 600 peaceful protestors didn't get far: At Edmund Pettus Bridge, they were attacked by Alabama state troopers wielding nightsticks and tear gas, as well as white vigilantes on horseback. Dozens of activists were injured in the assault, and 17 marchers were hospitalized.

After briefly ordering the protests to halt, on March 17, U.S. District Court Judge Frank Johnson Jr.—the same judge who had ruled in favor of Rosa Parks in her pivotal Montgomery bus boycott lawsuit—determined that the demonstrators in Selma had a constitutional right to march along the highway.

Two weeks after "Bloody Sunday," King and the protestors once again assembled to march, this time protected by National Guard troops. More people joined the march along the way, and the activists numbered over 25,000 by the time they reached Montgomery and delivered a petition for Alabama Gov. George Wallace.

Haunted by images such as this one from the Associated Press, Congress passed the Voting Rights Act that August.

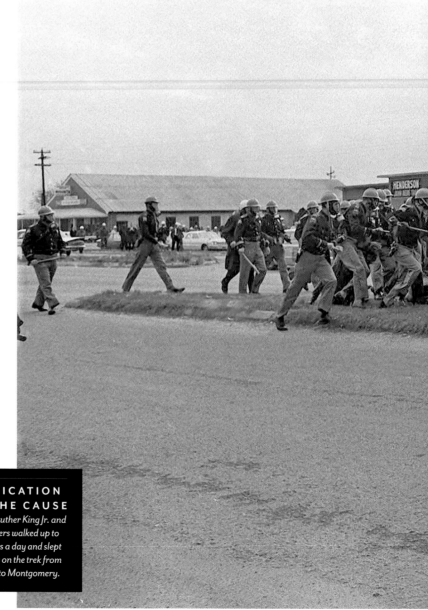

DEDICATION TO THE CAUSE
Martin Luther King Jr. and marchers walked up to 12 hours a day and slept in fields on the trek from Selma to Montgomery.

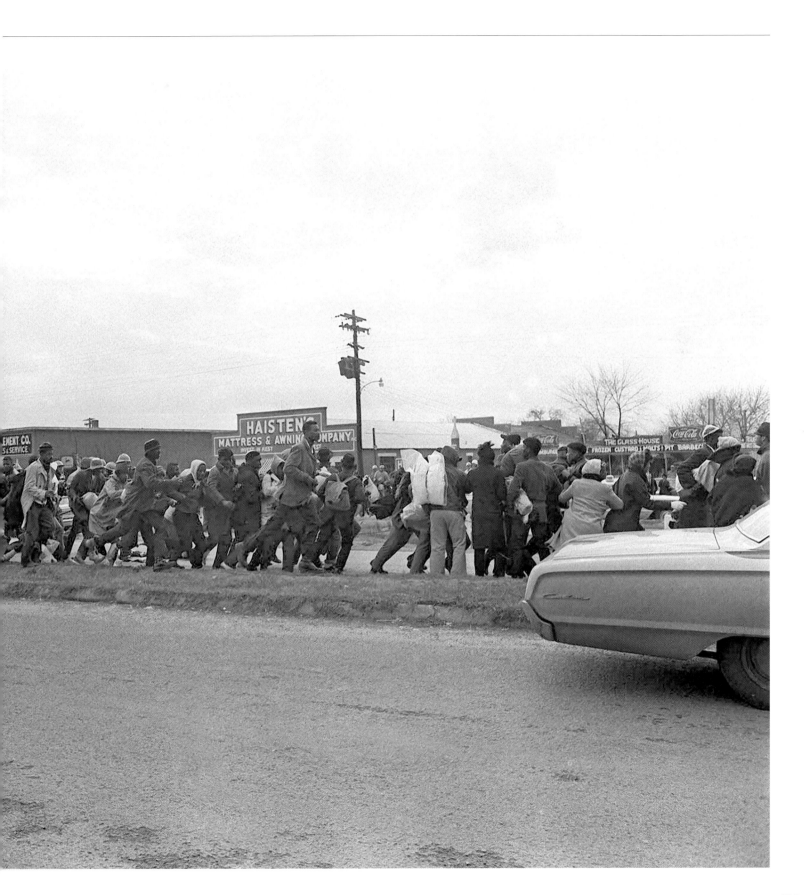

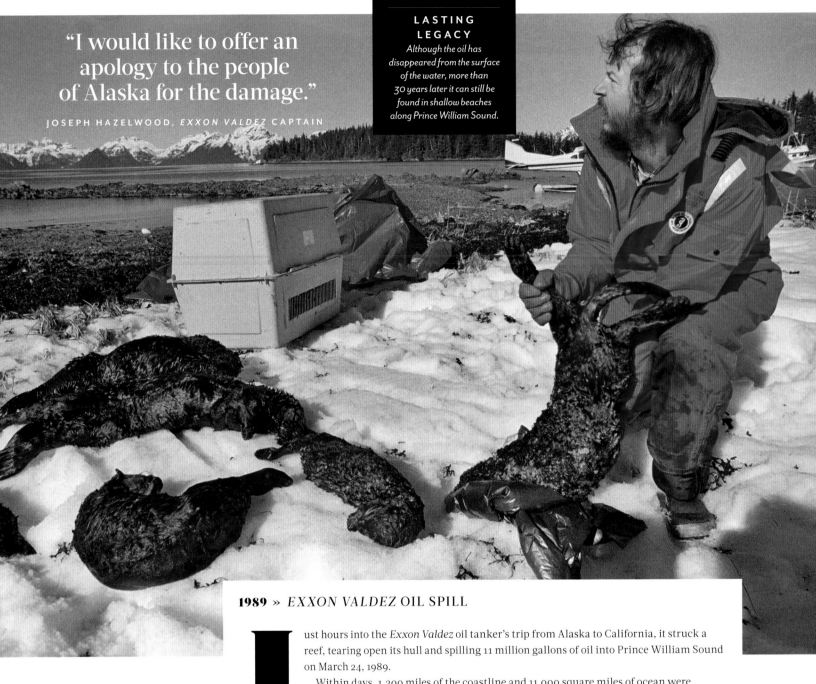

"I would like to offer an apology to the people of Alaska for the damage."

JOSEPH HAZELWOOD, *EXXON VALDEZ* CAPTAIN

LASTING LEGACY
Although the oil has disappeared from the surface of the water, more than 30 years later it can still be found in shallow beaches along Prince William Sound.

1989 » *EXXON VALDEZ* OIL SPILL

Just hours into the *Exxon Valdez* oil tanker's trip from Alaska to California, it struck a reef, tearing open its hull and spilling 11 million gallons of oil into Prince William Sound on March 24, 1989.

Within days, 1,300 miles of the coastline and 11,000 square miles of ocean were contaminated and the ecosystem destroyed. As many as 250,000 seabirds, 2,800 sea otters, 300 harbor seals, 247 bald eagles, 22 orcas and countless salmon and herring were wiped out. Photos like this one of rescue workers pulling oil-soaked animals from the water were a shock to many people who had never considered the environmental impact of oil use.

As a result of the *Exxon Valdez* incident, Congress passed the Oil Pollution Act (OPA), which prohibited any vessel that had caused a spill of more than 1 million gallons of oil from operating in Prince William Sound. The OPA also included provisions for the double hulling of new oil tankers and phasing out of existing single hulls by 2015.

1990 » THE FACE OF AIDS

When AIDS was discovered in 1981, little was known about the deadly disease. But as the number of reported cases grew, so did fear. In 1985, 13-year-old Ryan White, who had contracted AIDS during a blood transfusion, was denied admittance to his school in Kokomo, Indiana, after parents petitioned to ban him. But photos showing White as a very real boy helped reveal the human side of AIDS. He was eventually allowed to return by the board of education. Sadly, White died at 18, just one month shy of his high school graduation in 1990.

That same year, *Life* magazine published a picture of 32-year-old AIDS patient David Kirby on his deathbed, surrounded by his grief-stricken family. Considered the "picture that changed the face of AIDS," it humanized the disease to those who had stigmatized it. In 1993, President Bill Clinton established the Office of National AIDS Policy to help reduce the number of infections through prevention.

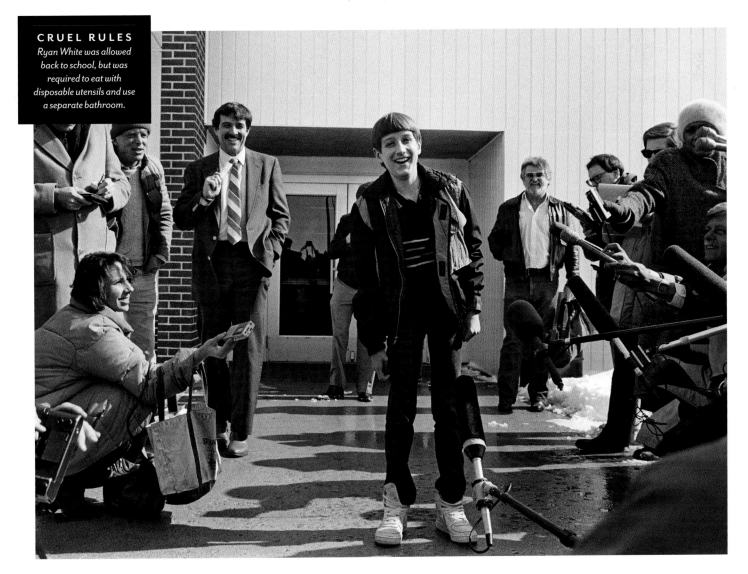

CRUEL RULES
Ryan White was allowed back to school, but was required to eat with disposable utensils and use a separate bathroom.

2004 » CASUALTIES OF WAR

During the Gulf War, the U.S. government banned news organizations from showing the coffins of dead soldiers returning home, arguing that doing so violates the privacy of grieving families. But by the time America was fighting the Iraq War a decade later, digital photography hit its stride as most everyone had a digital camera or cellphone, including Tami Silicio, a government contractor who was working for a cargo company in Kuwait.

In 2004, the second year of fighting, approximately 700 U.S. soldiers had been killed overseas. Silicio had seen her fair share of human freight, and she felt Americans should face the harsh reality too. On April 7, after watching 20 flag-draped coffins loaded onto a plane bound for Dover Air Force Base in Delaware, she snapped two quick photos of the somber scene with her Nikon Coolpix and emailed one to a friend, who forwarded it on to the *Seattle Times*.

The newspaper printed the grim image on its front page—and ignited a national debate over ethics. Three days later, Silicio was fired from her job at Maytag Corp. In the years that followed, she couldn't get other military-contracting jobs and she lost her home. "I still feel like I did the right thing," maintained Silicio. "The photo was honest. It captured the respect for the dead and that's what it should have been about."

Many agreed, and in 2009, during President Barack Obama's first year in office, his administration decided to lift the ban.

SELFLESS ACTS
"The picture is about them, not me," said Tami Silicio when warned of backlash, "about how they served their country."

2020 » THE DEATH OF GEORGE FLOYD

Racial injustice has been an issue in America for hundreds of years—and on May 25, 2020, it was exposed for all the world to see. That day in Minneapolis, cops arrested George Floyd, a Black man, for trying to use a suspected counterfeit $20 bill. While he was handcuffed facedown on the ground, white police officer Derek Chauvin knelt on Floyd's neck, ignoring his repeated cries that he couldn't breathe. For a shocking 9 minutes and 29 seconds, Chauvin never once let up as Floyd lost consciousness and died. Several witnesses snapped photos, and Darnella Frazier, who was just 17 at the time, recorded the whole incident on her phone.

When images of Floyd's death went viral, outrage bubbled over in Minneapolis and across the country. In all 50 states and several foreign countries, as many as 26 million people protested against police brutality, inciting the activation of 96,000 service members of the National Guard—the largest military operation other than war in U.S. history. The unrest also inspired change: On both state and federal levels, legislative proposals have addressed systemic racism and police brutality. And around the country, monuments associated with racism, such as the Confederate War Memorial in Dallas, have been removed.

In June 2021, Frazier was awarded a 2021 Pulitzer Prize Special Citation for documenting the murder.

> ## "I'm going to put up a fight every day because I'm not just fighting for George anymore. I'm fighting for everybody around this world."
>
> PHILONISE FLOYD, BROTHER

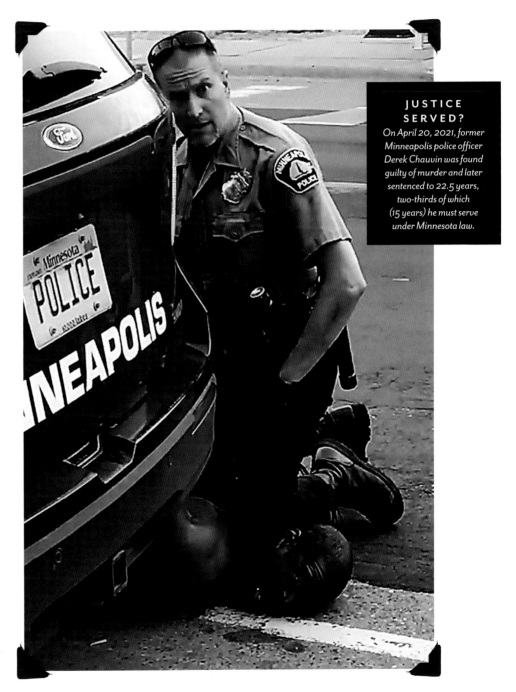

JUSTICE SERVED?

On April 20, 2021, former Minneapolis police officer Derek Chauvin was found guilty of murder and later sentenced to 22.5 years, two-thirds of which (15 years) he must serve under Minnesota law.

CHILD LABOR UNCOVERED

LEWIS HINE'S SHOCKING IMAGES OF CHILDREN WORKING IN FACTORIES AND MINES WERE INSTRUMENTAL IN GETTING THE KEATING-OWEN CHILD LABOR ACT PASSED.

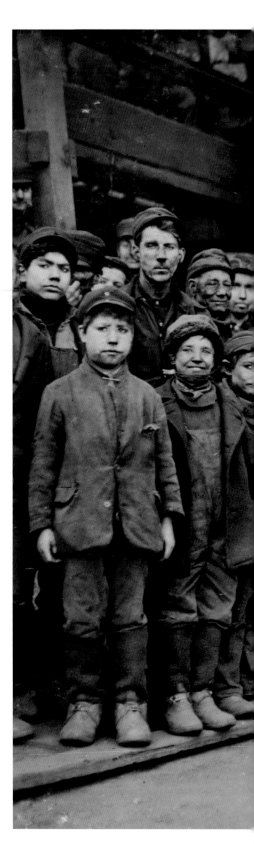

1911 » BREAKER BOYS

In the early days of America, it wasn't uncommon for a child to drop out of school and go to work to help support his or her family. An estimated 2 million youngsters worked long hours in poor conditions and for little money. In 1908, schoolteacher Lewis Hine left his job to become an investigative photographer for the National Child Labor Committee. For more than a decade, he documented children—some as young as 4—employed in factories, mines and fields.

It was Hine's photo series of Pennsylvania's Breaker Boys, whose job was to separate slate rock from coal in mines for as many as 16 hours a day, that finally shamed the country into action. In his haunting images, the faces of the youngsters are smeared in dark soot, their expressions exhausted. "The dust was so dense at times as to obscure the view," Hine captioned one photo taken. "This dust penetrates the utmost recess of the boy's lungs."

As a result of Hine's work, Congress passed the Keating-Owen Child Labor Act in 1916. Under the new law, signed by President Woodrow Wilson, a minimum age of 14 was required to work in factories, 16 in mines; workdays could not exceed eight hours. Astonishingly, two years later, the Supreme Court ruled the law unconstitutional.

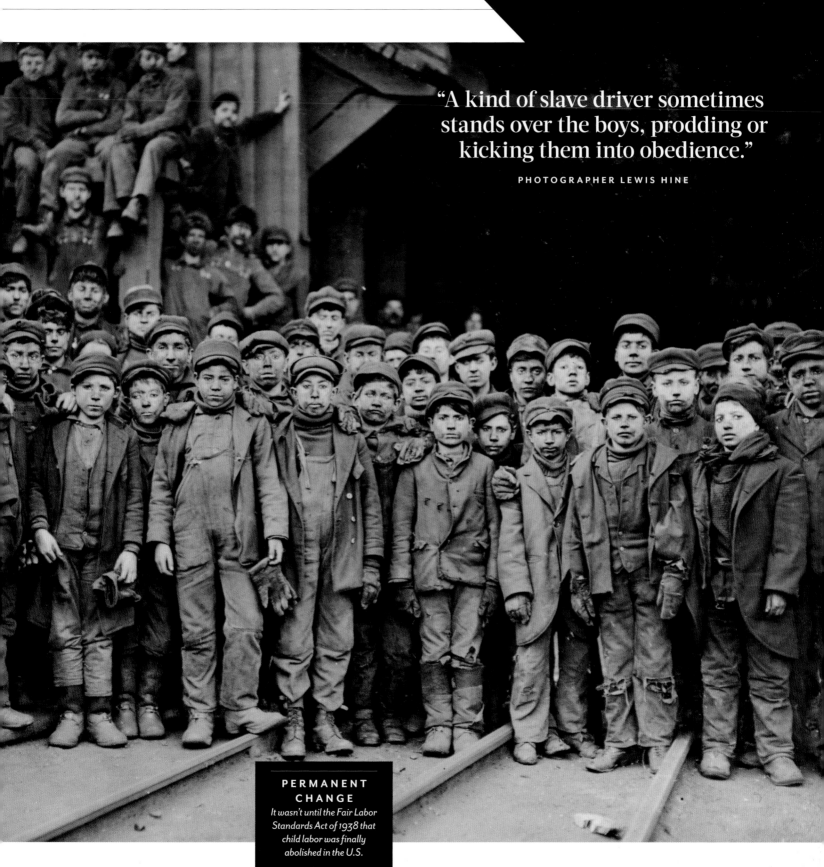

"A kind of slave driver sometimes stands over the boys, prodding or kicking them into obedience."

PHOTOGRAPHER LEWIS HINE

PERMANENT CHANGE

It wasn't until the Fair Labor Standards Act of 1938 that child labor was finally abolished in the U.S.

1908 » GIRL WORKING IN COTTON MILL

Children often were used as cheap labor to power a large number of textile factories and sweatshops in the early 20th century. The number of children under age 15 who worked industrial jobs grew from 1.5 million in 1890 to 2 million in 1910. Businesses liked to hire children because their small hands made them more adept at handling small machinery parts. But conditions often were loud, dangerous and repetitive, and many child laborers suffered health problems, including stunted growth, curved spines and tuberculosis or bronchitis for those who worked in cotton mills or coal mines.

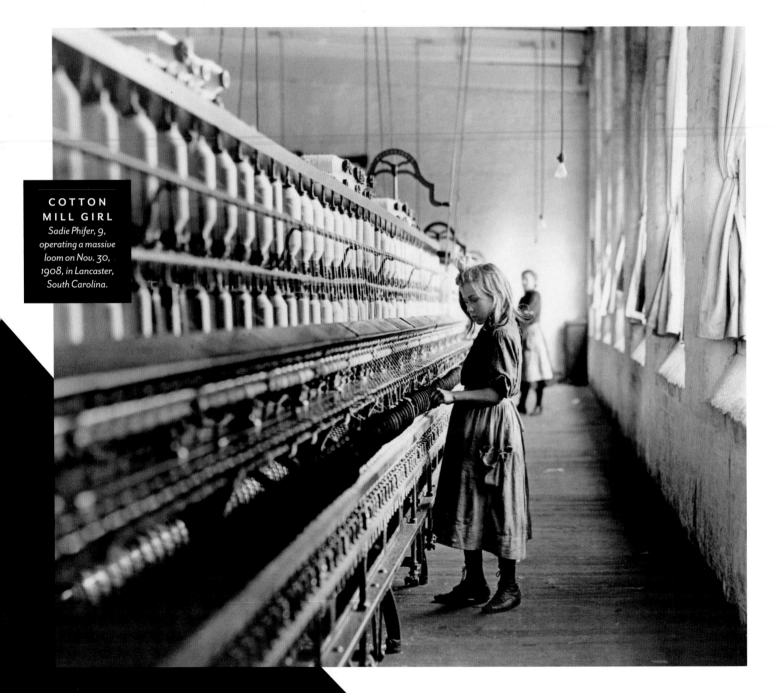

COTTON MILL GIRL
Sadie Phifer, 9, operating a massive loom on Nov. 30, 1908, in Lancaster, South Carolina.

1909 » BOB MILL NO. 1

In workplaces like this one, shot in a textile mill in Macon, Georgia, Hines had to trick his way into the factories to take pictures, pretending to be a salesman or industrial photographer there to record the machinery. Once inside, he would carefully document every photo he took. He would come up with excuses to interview the children, then scribbled notes with his hand hidden inside his pockets. "I had to be double-sure that my photo data was 100% pure—no retouching or fakery of any kind."

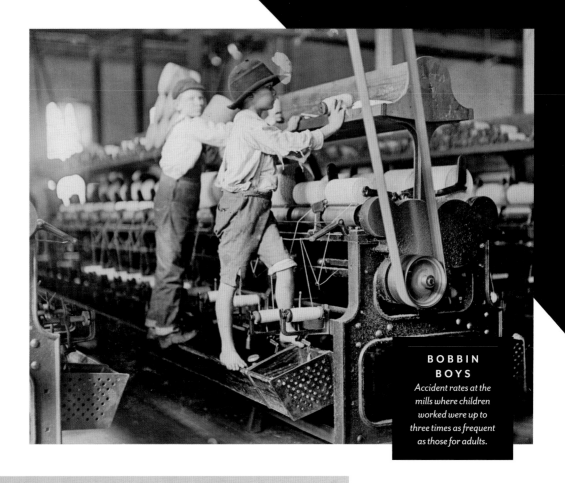

BOBBIN BOYS
Accident rates at the mills where children worked were up to three times as frequent as those for adults.

IN THE FIELD
Norma Lawrence, nearly 10, picked 100 to 150 pounds of cotton a day.

1916 » COTTON PICKER

Many children who worked on farms fell years behind their age group in school, often spending grueling weeks at a time performing heavy labor. In this photo of a young girl picking cotton in Comanche County, Oklahoma, Hines made the note: "Drags the sack which often holds 50 pounds or more before emptied." Workers were often paid by how much they picked, which meant many families had all of their children laboring in the fields. The day would start before dawn and last until dark, without a break for lunch. Many picked until their hands bled. Living conditions were often severe, with several families crammed together in one shack and little running water.

BRILLIANT
MINDS

WHERE WOULD WE BE WITHOUT MARIE CURIE'S
RADIATION RESEARCH, HENRY FORD'S MODEL T CAR
OR STEVE JOBS' PASSION FOR INNOVATION?
THESE GIFTED THINKERS HAVE CHANGED THE
WORLD WITH REMARKABLE ACHIEVEMENTS THAT
HAVE TRULY REVOLUTIONIZED DAILY LIFE.

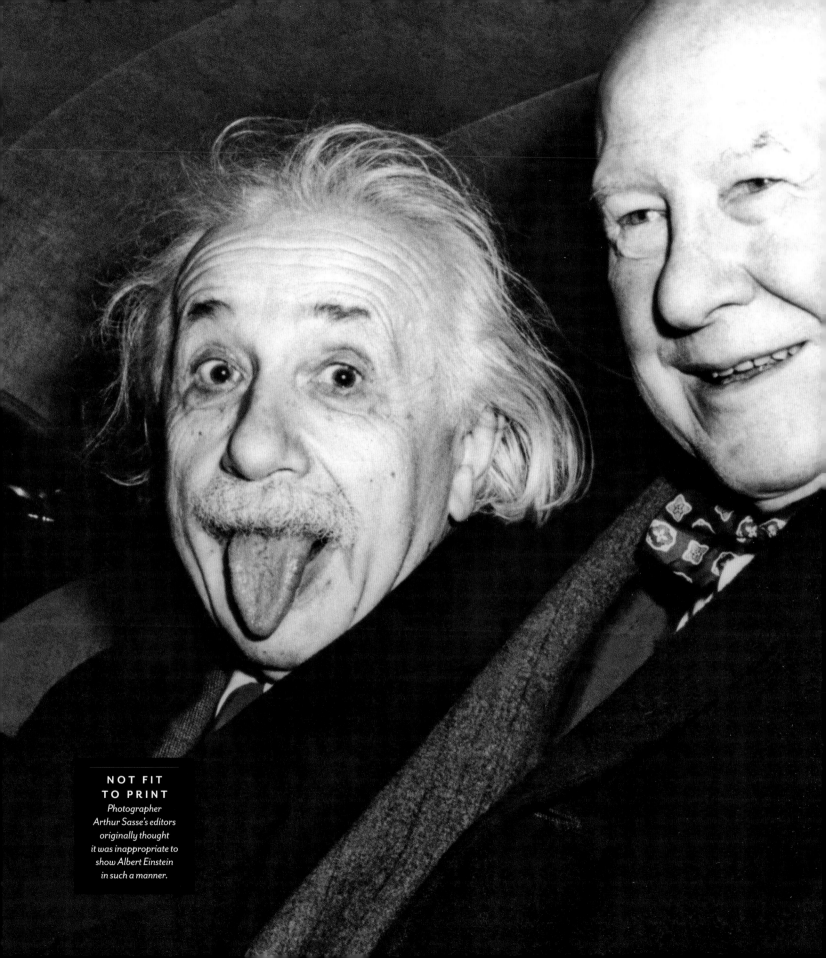

NOT FIT TO PRINT
Photographer Arthur Sasse's editors originally thought it was inappropriate to show Albert Einstein in such a manner.

1951 » ALBERT EINSTEIN BREAKS CHARACTER
(previous page)

lbert Einstein's name is synonymous with the word *genius.* The German physicist, who reportedly possessed an IQ of 160, developed the theory of relativity, won the Nobel Prize for his discovery of the law of the photoelectric effect and gave us the famous equation $E=mc^2$.

But Einstein also had a lighthearted side that came out from time to time. On the scientist's 72nd birthday on March 14, 1951, United Press photographer Arthur Sasse tried to get Einstein to smile for his camera as he sat in a car with friends; instead, Einstein stuck out his tongue.

The uncharacteristic image became an instant hit, and Einstein himself requested nine copies (with his friends, Princeton University professor Frank Aydelotte, and Aydelotte's wife, Marie Jeanette, cropped out) to use as greeting cards. In 2017, an original 7x10 featuring Einstein and the Aydelottes and autographed by the physicist sold at auction for $125,000.

1865 » PRESIDENT LINCOLN'S PORTRAIT

President Abraham Lincoln was already into his second term when he sat for Alexander Gardner at his Washington, D.C., studio on Feb. 5, 1865. The photograph was to be used by painter Matthew Wilson to create Lincoln's official portrait, since he didn't have the time to sit for multiple sessions.

At this point in his presidency, Lincoln had already led America through the Civil War, given the historic Gettysburg Address and abolished slavery—and he was dedicated to achieving even more for his country. "Let us strive on to finish the work we are in," he stated in his 1864 inaugural speech, "to bind up the nation's wounds…to do all which may achieve and cherish a just and lasting peace among ourselves and with all nations."

But his vision was cut short. On April 14, 1865, only two months after Gardner took his portrait, Lincoln was assassinated by Confederate sympathizer John Wilkes Booth at Ford's Theater in Washington.

SELF-EDUCATED
Before serving in the U.S. House of Representatives, Abraham Lincoln was a successful attorney in Illinois who taught himself law by reading books.

"Do good to those who hate you and turn their ill will to friendship."

ABRAHAM LINCOLN

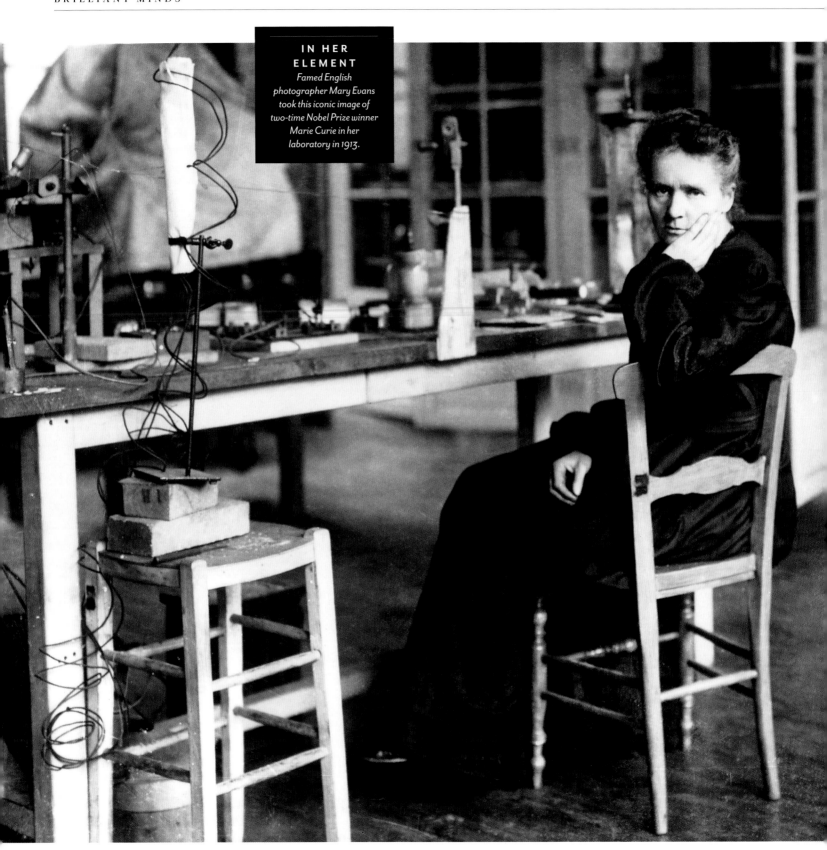

IN HER ELEMENT
Famed English photographer Mary Evans took this iconic image of two-time Nobel Prize winner Marie Curie in her laboratory in 1913.

1903 » MARIE CURIE WINS NOBEL PRIZE

Marie Curie was a woman of many firsts. In 1903, the Polish French physicist became the first woman in France to earn a PhD in physics, based on her thesis about radiation. That same year, her work earned her the Nobel Prize in physics, making her the first woman to ever receive the honor, sharing it with her husband, Henri Becquerel. Curie set another record, in 1911, when she was once again awarded the Nobel Prize—this time in chemistry, for her discovery of the elements polonium and radium.

But the long hours in her lab came at a price. Curie often felt sick and exhausted—unbeknownst to her, these were the early symptoms of radiation sickness. (In 1934, she died of aplastic anemia.) Following experiments with the radioactive material, her hands became raw and inflamed. In 1911, she underwent surgery to remove lesions from her uterus and kidney. After taking a few years to recover, Curie was back at work. During World War I, she developed mobile X-ray units that could diagnose injuries near the battlefront and also organized the installation of 200 radiological units in military hospitals. It's estimated that more than 1 million wounded soldiers were treated with Curie's X-ray units.

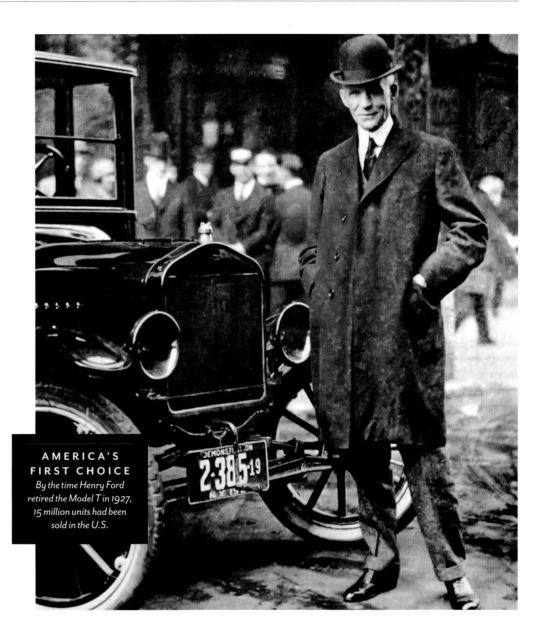

AMERICA'S FIRST CHOICE
By the time Henry Ford retired the Model T in 1927, 15 million units had been sold in the U.S.

1908 » HENRY FORD AND THE MODEL T

Before Henry Ford was a captain of industry, he was an engineer with the Edison Illuminating Co. In 1893, he began to experiment with gasoline engines, and within three years of tinkering, he had developed the Ford Quadricycle, a car with an ethanol-powered engine on four bicycle wheels. But he wanted to make it even greater. On the heels of the Oldsmobile Curved Dash, the first mass-produced car, Ford achieved his goal to "democratize the automobile" when he introduced his Model T in 1908. Dubbed the "Tin Lizzie," the two-speeder was an affordable mode of transportation at $825 (approximately $24,500 today). And after Ford added a moving assembly line in his plants and could mass-produce his Model T, the price fell to $300. In his biography, Ford wrote he hoped the car would "be so low in price, no man making a good salary will be unable to own one."

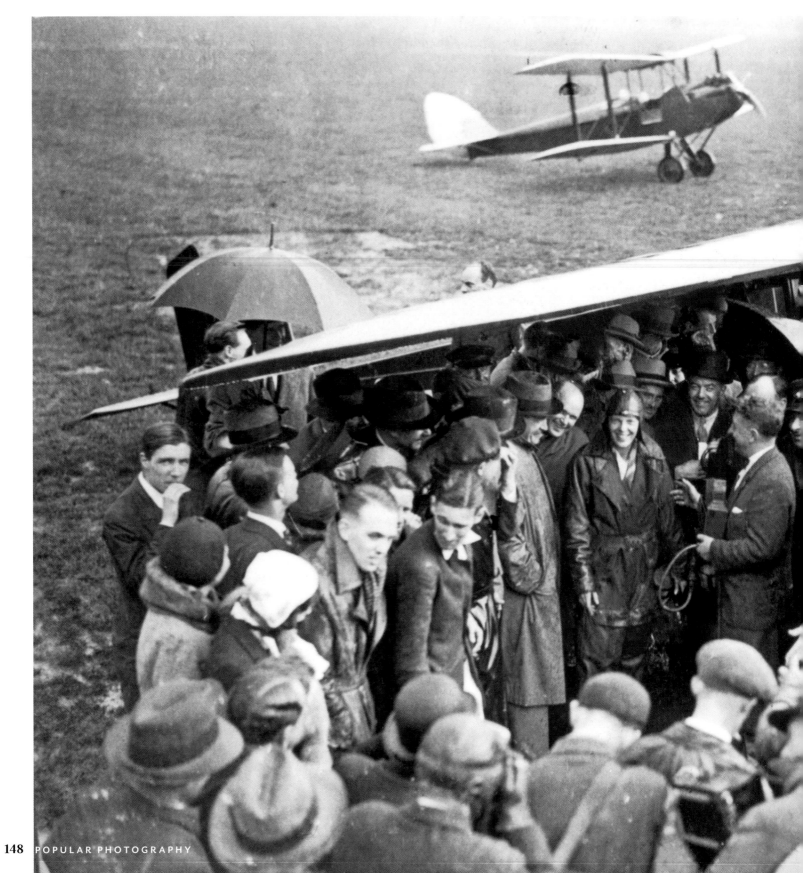

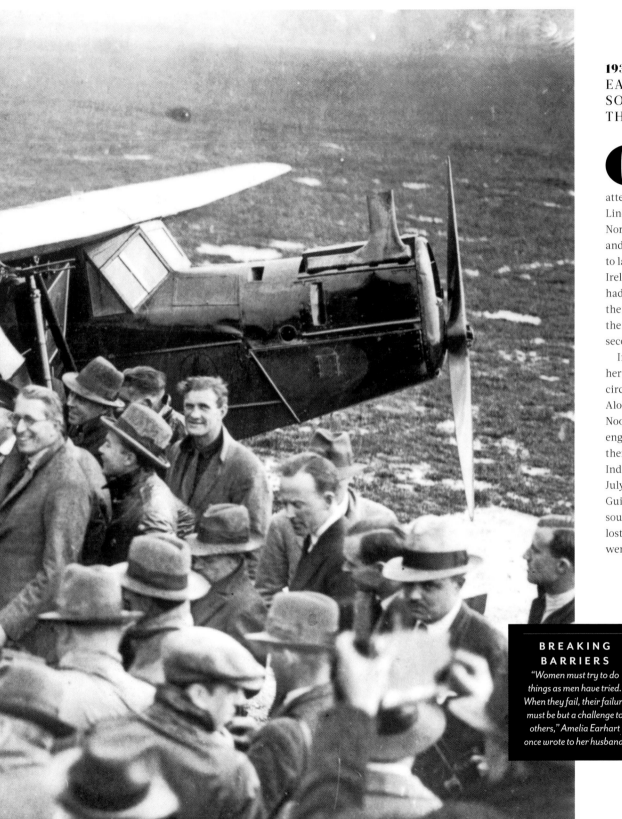

1932 » AMELIA EARHART FLIES SOLO ACROSS THE ATLANTIC

On May 20, 1932, 34-year-old pilot Amelia Earhart attempted to echo Charles Lindbergh's 1927 flight from North America to Paris. Weather and mechanical issues forced her to land in a pasture in Northern Ireland (shown here). Still, she had made history: Earhart was the first woman to fly solo across the Atlantic Ocean—and only the second person to do so.

In June 1937, Earhart attempted her most remarkable stunt: circumnavigating the globe. Along with her navigator, Fred Noonan, she flew her twin-engine Electra plane to Miami, then to South America, Africa, India and Southeast Asia. On July 2, the pair departed New Guinea for Howland Island, just southeast of Honolulu—but they lost radio contact en route and were never heard from again.

BREAKING BARRIERS

"Women must try to do things as men have tried. When they fail, their failure must be but a challenge to others," Amelia Earhart once wrote to her husband.

"A person who's happy will make others happy; a person who has courage and faith will never die in misery!"

ANNE FRANK, IN HER DIARY

1942 » ANNE FRANK RECORDS HISTORY

With an estimated 17 million people killed, the Holocaust is arguably the world's darkest, most shameful hour. In the aftermath, there was one small light: Anne Frank, the schoolgirl whose powerful diary documented the unimaginable tragedy of Jewish persecution in Europe during World War II. From inside the Secret Annex, where she and her family hid in Amsterdam, she wrote about the everyday struggles and overwhelming fears of life in hiding—until betrayal eventually led to the Nazis discovering her family in 1944. Sent to a concentration camp, within seven months, Frank contracted typhus during an outbreak at Bergen-Belsen and succumbed to the deadly disease just short of her 16th birthday.

But through the pages of *The Diary of a Young Girl*, her spirit lives on to inspire others around the world: Since its 1947 publication, more than 30 million copies have been sold in 70 languages. And nearly 80 years later, Frank's influence has never been greater—and her words continue to encourage those trying to overcome strife. "It's difficult in times like these: ideals, dreams and cherished hopes rise within us, only to be crushed by grim reality," she wrote on July 15, 1944, weeks before her capture. "Yet I cling to them because I still believe, in spite of everything, that people are truly good at heart."

BETTER DAYS
Anne Frank only had her diary for 23 days of freedom before her family was forced to go into hiding.

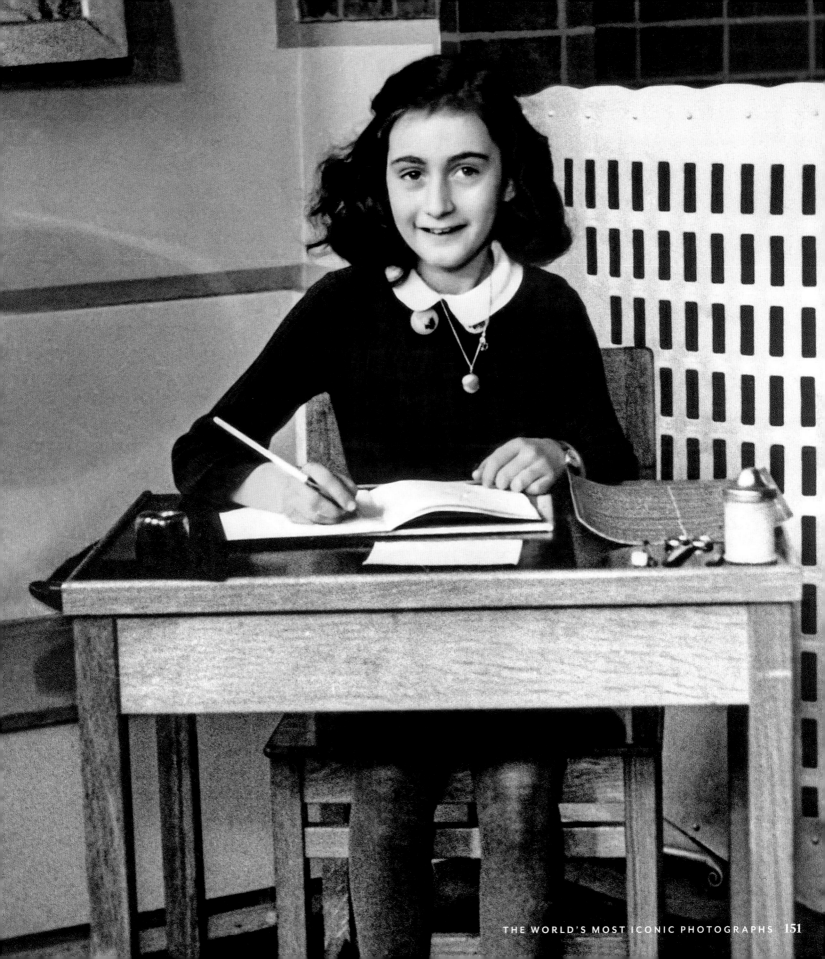

1948 » SALVADOR DALÍ GETS WEIRD

The art world has always welcomed the most avant-garde, but Spanish surrealist Salvador Dalí broke the mold with his wonderfully wacky "nuclear mysticism" style, defined by melting clocks ("The Persistence of Memory"), double imagery ("Swans Reflecting Elephants") and paranoia personified ("Metamorphosis of Narcissus").

A true creative mind, Dalí made his distinct mark on all aspects of art, from film and fashion to poetry and photography, famously as the subject of Philippe Halsman's "Dalí Atomicus." In the portrait, the mustachioed maestro levitates in a room as his painting "Leda Atomica," three cats, a chair and a splash of water fly through the chaotic scene. It took 26 attempts to get right—but Halsman believed it captured the essence of Dalí. "When you ask a person to jump, his attention is mostly directed toward the act of jumping and the mask falls so that the real person appears."

Today, thousands of Dalí's works are on display all over the world, but the most significant collections can be found at the Dalí Theatre-Museum in Figueres, Spain, and the Salvador Dalí Museum in St. Petersburg, Florida.

JUMP AROUND
Philippe Halsman also got Audrey Hepburn and Richard M. Nixon to pose for his "jumpology" series.

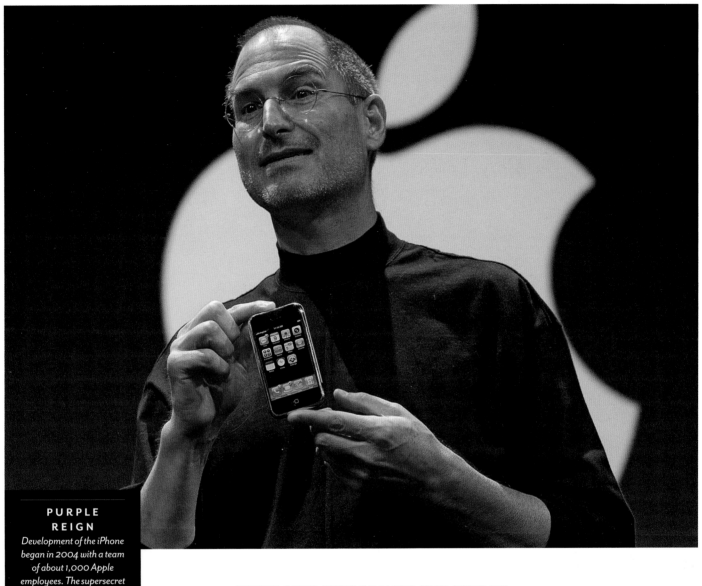

2007 » STEVE JOBS INTRODUCES THE IPHONE

Thirty years after Apple CEO Steve Jobs unveiled Apple II, the first mass-produced home computer, he bested himself with arguably the greatest invention of the 21st century, the iPhone. On Jan. 9, 2007, Jobs—clad in his uniform of a black turtleneck and Levi's jeans—stood onstage at MacWorld 2007 in San Francisco and introduced the world to his company's "revolutionary product" that could allow users to play music, make phone calls, take photographs and, most important, surf the web—all on a touch screen.

When the iPhone was released on June 29, 2007, demand was so high that people camped outside Apple stores nationwide to snag technology's new coveted toy. By the following spring, it was also made available in the U.K., France, Germany, Ireland and Austria. In the first five quarters after its introduction, Apple sold 6.1 million units. In July 2008, the second-generation iPhone 3G, which boasted three key features, including GPS, hit shelves in 22 countries initially before expanding to 60 more. Sadly, just one day after the iPhone 4S was released on Oct. 4, 2011, Jobs died from pancreatic cancer.

MODERN GENIUSES

TODAY'S BIG THINKERS CAN MOST OFTEN BE FOUND IN THE WORLD OF TECH, WHERE INNOVATIONS SHAPE EVERYTHING FROM SOCIAL CONNECTIONS TO SPACE TRAVEL.

2018 » MARK ZUCKERBERG TESTIFIES TO CONGRESS

On April 10, 2018, Facebook CEO Mark Zuckerberg faced dozens of senators to discuss how his company handles user data. "I started Facebook, I run it, and I'm responsible for what happens here," he declared. Those roots date back to 2004, when the Harvard sophomore helped launched a social network designed to connect people around the campus. A year later, the network expanded to 21 universities with 6 million users. Today, with more than 2.85 billion monthly active users, Facebook has revolutionized the way people connect online.

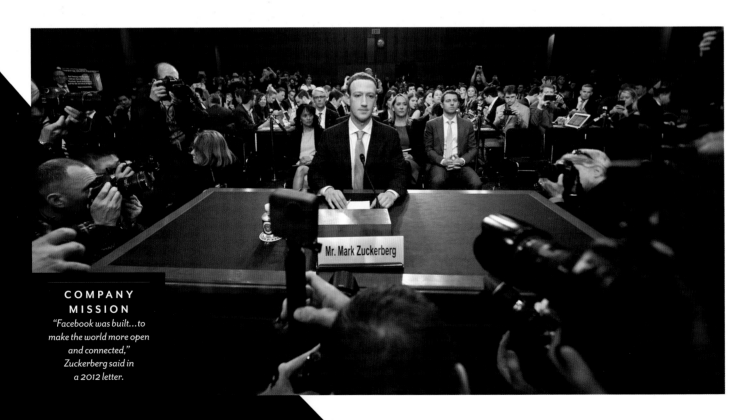

COMPANY MISSION
"Facebook was built…to make the world more open and connected," Zuckerberg said in a 2012 letter.

2019 » ELON MUSK UNVEILS THE TESLA TRUCK

From colonies on Mars to cyborg brain implants, self-made billionaire Elon Musk has made a name for himself by pushing the limits of possibility. But he is perhaps best known as the co-founder of Tesla, an all-electric vehicle company that is revolutionizing the roads with its sustainable energy solutions, including the upcoming Cybertruck, which was unveiled at the Tesla Design Studio on Nov. 21, 2019.

KEEP ON TRUCKIN'
The all-electric vehicle is Tesla's sixth model since it was founded in 2003.

2021 » JEFF BEZOS BLASTS INTO SPACE

What's a multibillionaire do for fun? If you're the founder of Amazon, riding in a rocket ship sounds like a good time. Bezos, who also founded aerospace manufacturer Blue Origin, took a 10-minute flight to an altitude of about 66 miles on July 21, 2021. "Best day ever!" he declared when his capsule touched down. Bezos founded Amazon in 1994 as an online bookseller; through the late '90s he diversified inventory, branching out into consumer goods. By 1999, Amazon had become the largest online retailer—helping to make Bezos one of the richest people on Earth today.

GOING FURTHER
Fellow billionaire Richard Branson launched into space as the first private flight, but Jeff Bezos' ship flew more than 10 miles higher.

2021 » ANNE WOJCICKI TAKES 23ANDME PUBLIC

To unlock the mysteries of your DNA—from unraveling your ancestry to knowing the genetic predisposition for certain diseases—all you need to do is spit in a vial and stick it in an envelope. That's the beauty behind 23andMe, a company CEO Anne Wojcicki helped to start in 2006 and took public on June 17, 2021. Since then, it has provided insight for millions of consumers who want to know more about their genes and what they may portend. In 2018, 23andMe announced a collaboration with British pharmaceutical company GSK to tap into 23andMe's genetic database of consented customers. "This collaboration will enable us to deliver on what many customers have been asking for—cures or treatments for diseases," said Wojcicki, whose net worth is an estimated $1.3 billion.

CRACKING THE CODE
"This simple code—A C G and T—has built this incredible world, all this diversity," Anne Wojcicki declared at 23andMe's Nasdaq opening ceremony.

THRILLING
MOMENTS
IN
SPORTS

THE WINS, LOSSES, CELEBRATED COMEBACKS,
ICONIC MATCHUPS AND ODDITIES—THESE IMAGES
ARE IN A LEAGUE OF THEIR OWN.

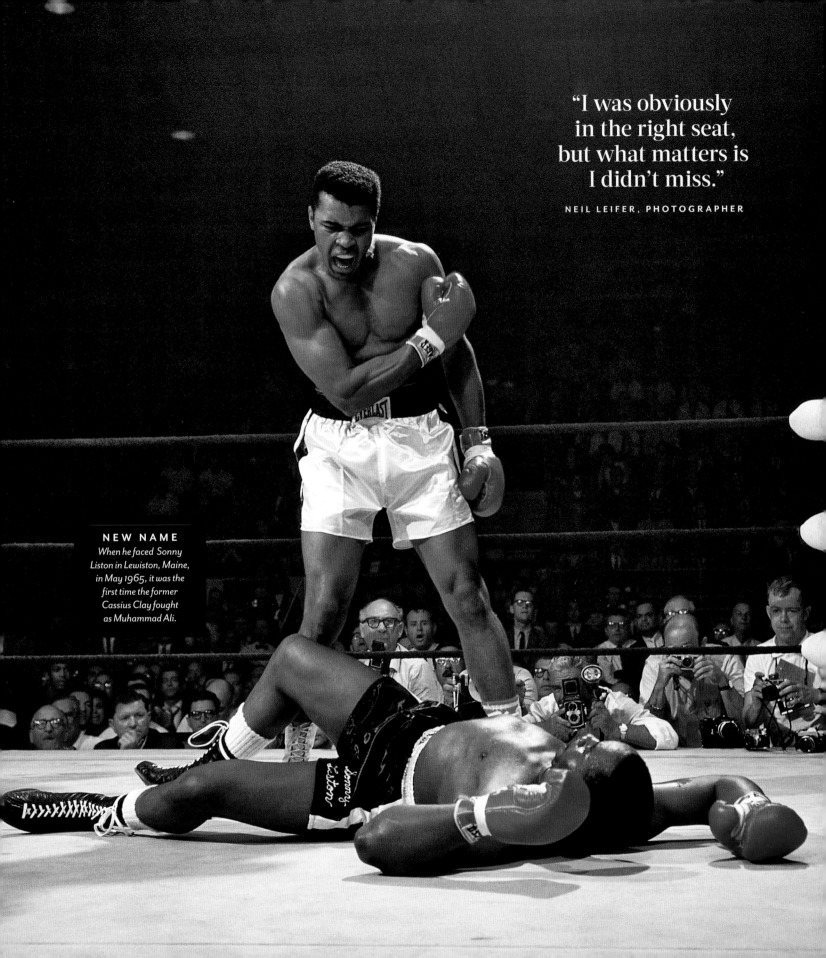

"I was obviously in the right seat, but what matters is I didn't miss."

NEIL LEIFER, PHOTOGRAPHER

NEW NAME
When he faced Sonny Liston in Lewiston, Maine, in May 1965, it was the first time the former Cassius Clay fought as Muhammad Ali.

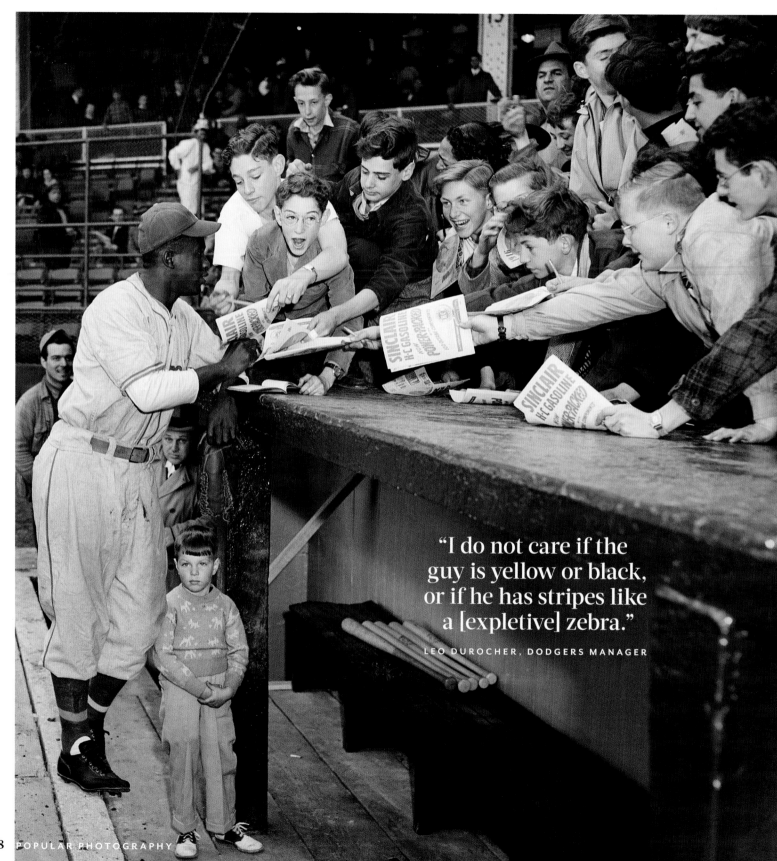

"I do not care if the guy is yellow or black, or if he has stripes like a [expletive] zebra."

LEO DUROCHER, DODGERS MANAGER

1965 >> ALI VS. LISTON *(page 157)*

It was the heavyweight knockout heard round the world: In just 1 minute and 44 seconds, Muhammad Ali leveled Sonny Liston for the second year in a row with a right hook to the chin on May 25, 1965. Standing over his woozy opponent sprawled out in the center of the ring in Lewiston, Maine, cigar smoke billowing in the rafters overhead, the 23-year-old world heavyweight champion taunted 34-year-old Liston, "Get up and fight, sucker!"

The image captured by *Sports Illustrated* photographer Neil Leifer is considered one of the greatest of all time—much like its gloating subject. But it took a few rounds. At the time, Ali's star was still on the rise—he had been known as Cassius Clay when he'd beaten heavily favored Liston to win the championship title in Miami Beach, Florida, the year before—and his "phantom punch" didn't make the covers of newspapers or magazines. It would actually be another decade before Leifer's photo earned the respect it deserved. "The picture became special because Ali became so special," the photographer said. Even so, Leifer insisted it was simply a case of being in the right place (ringside) at the right time. "That's what separates the best sports photographers from the ones that are just good," he said. "You have to get lucky in sports photography."

1947 >> JACKIE ROBINSON BREAKS THE COLOR LINE

The first Black baseball player in the major leagues, Jackie Robinson shattered segregation in sports when he signed with the Brooklyn Dodgers in 1947. Until that point, African Americans had been relegated to the Negro Leagues. Although white players—including some of Robinson's own teammates—made him feel unwelcome, and several even threatened a league-wide walkout, fans were impressed with the first baseman, who was named Rookie of the Year. And his presence led to increased diversity of spectators, as more and more Black fans turned out to catch Robinson in action when the Dodgers came to town. By the start of the 1948 season (pictured), there were four Black athletes competing in the major leagues. During Robinson's 10-year career (all of which was with Brooklyn), he was a six-time All-Star and helped his team beat the New York Yankees in the 1955 World Series, before retiring the following year at the age of 37.

SUPERSTAR
Jackie Robinson lettered in football, basketball, track and baseball at UCLA.

"We had great players....
Who could they put out on
the field that we couldn't
compete with and defeat?"

THE PACKERS' JIM TAYLOR

1967 » FIRST SUPER BOWL

MOST VALUABLE PLAYER

Packers quarterback Bryan Bartlett "Bart" Starr completed 16 of 23 passes during the game.

The competing National Football League and American Football League were already rivals when the first-ever NFL-AFL championship was organized on Jan. 15, 1967, at Memorial Coliseum in Los Angeles. Some 60 million fans tuned in to watch the underdog Kansas City Chiefs take on the NFL's Green Bay Packers. Although the AFL team managed to keep it close during the first half, the Packers took over in the second and crushed the Chiefs, 35–10. Despite the blowout, it was clear fans enjoyed the competition—and the Super Bowl was born. In the third annual championship, Joe Namath led the AFL's New York Jets to victory over the NFL's Baltimore Colts. In 1970, the NFL and AFL merged, and nearly 50 years later, the Super Bowl remains the country's most popular sporting event.

1973 » BATTLE OF THE SEXES

In the early 1970s, four decades after his prime, Bobby Riggs wanted to wage a comeback—and he believed defeating a female tennis player half his age would do the trick. In 1972, he pulled off the publicity stunt when he beat 30-year-old Margaret Court. Hungry for more attention, Riggs next challenged Billie Jean King, fresh off wins at Wimbledon and the US Open, to square off in the ultimate "Battle of the Sexes" match. She agreed.

On Sept. 20, 1973, Riggs and King put on a show at Houston's Astrodome before an international TV audience of 90 million people. Both athletes arrived on the court in style: She dressed as Cleopatra carried by four shirtless muscular men, he in a rickshaw pulled by sexy models. The 29-year-old then presented her opponent with a squealing piglet to represent his male chauvinism.

But once the match began, the two got serious. Riggs took an early lead, but King bounced back, forcing the pompous 55-year-old to drop his act and focus. It was too little too late: King defeated Riggs in three straight sets and earned the $100,000 prize. "I thought it would set us back 50 years if I didn't win that match," said King. "It would ruin the women's tour and affect all women's self-esteem."

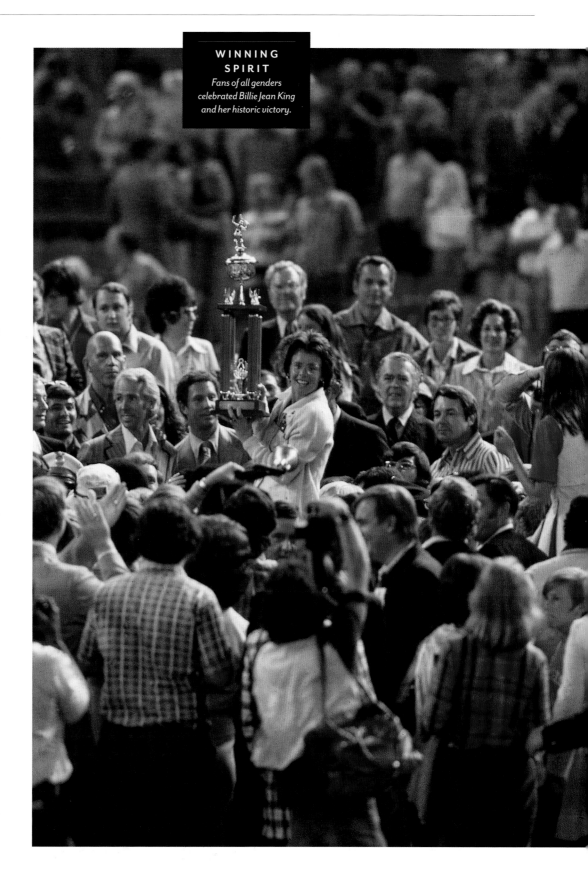

WINNING SPIRIT
Fans of all genders celebrated Billie Jean King and her historic victory.

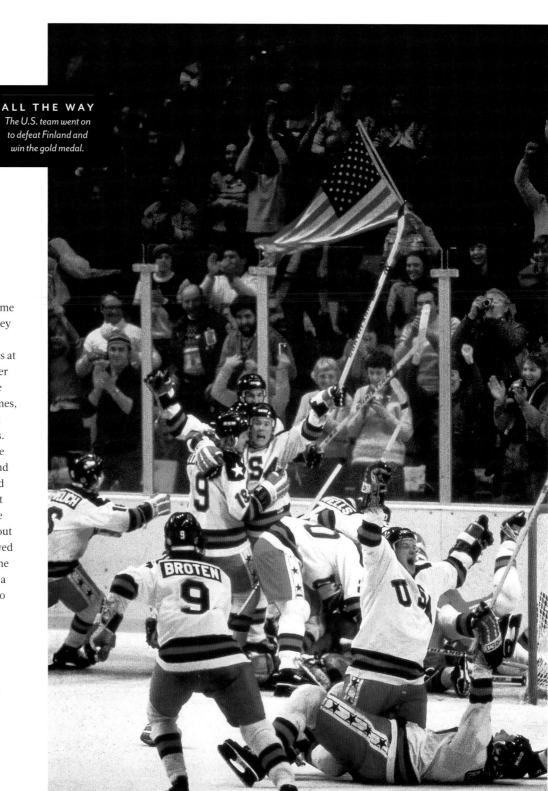

1980 » MIRACLE ON ICE

It was supposed to be a game the Soviet men's ice hockey team would easily win when they faced the Americans at the 1980 Winter Olympics. After all, they had taken the gold the previous five of six Winter Games, and the U.S. team was a ragtag group of mostly college players. Before a sold-out crowd in Lake Placid, New York, the Soviet and American teams were neck and neck, trading goals throughout the first half. At the start of the second half, the Soviets came out with a new goalie, and a renewed drive to win. But once again, the underdogs battled back to nab a 4–3 lead—which they held on to until the end. "Do you believe in miracles?" announcer Al Michaels famously marveled.

"The only thing I can think back upon is that with a few seconds left in the game is the word that came into my head was 'miraculous,'" Michaels explained in 2020, "and it got turned into a question and I answered it."

1997 >> MIKE TYSON BITES EVANDER HOLYFIELD'S EAR

Mike Tyson was fueled by revenge when he met Evander Holyfield in the ring on June 28, 1997. Eight months earlier, his opponent had defeated him in one of the biggest upsets in heavyweight history. In the rematch, no matter how hard Tyson fought, Holyfield dominated. In the third round, Holyfield's head clashed with Tyson's, but it was deemed unintentional by referee Mills Lane. So Tyson handed out his own retribution—he bit off a chunk of Holyfield's right ear. Holyfield raged in agony, blood streaming down his face, but shockingly, Tyson was not immediately disqualified and the fight continued. And he was hungry for more. As the round wound down, Tyson sunk his teeth into Holyfield's other ear, effectively ending the match. "I thought my ear had fallen off," Holyfield later recalled. "I just couldn't believe it." After Lane inspected Holyfield's ears between rounds, he disqualified Tyson.

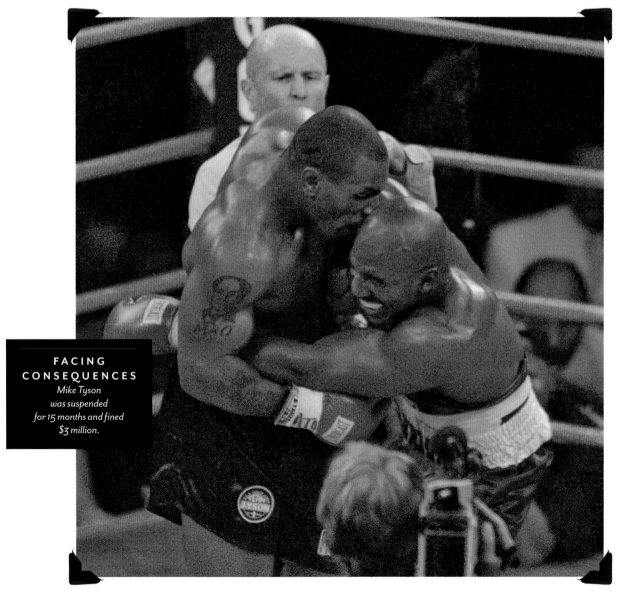

FACING CONSEQUENCES
Mike Tyson was suspended for 15 months and fined $3 million.

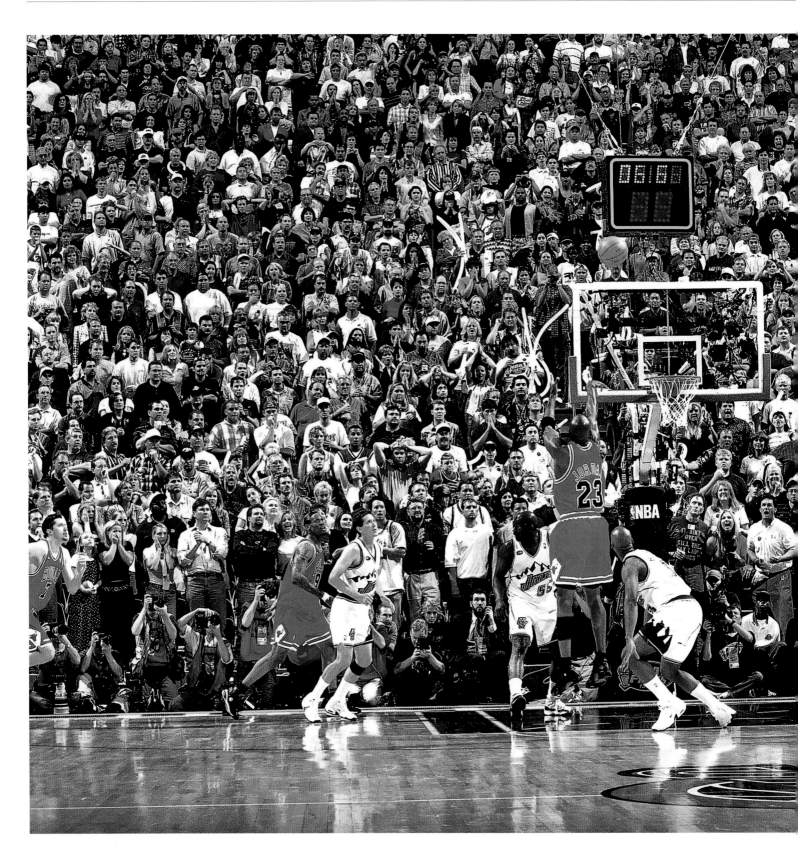

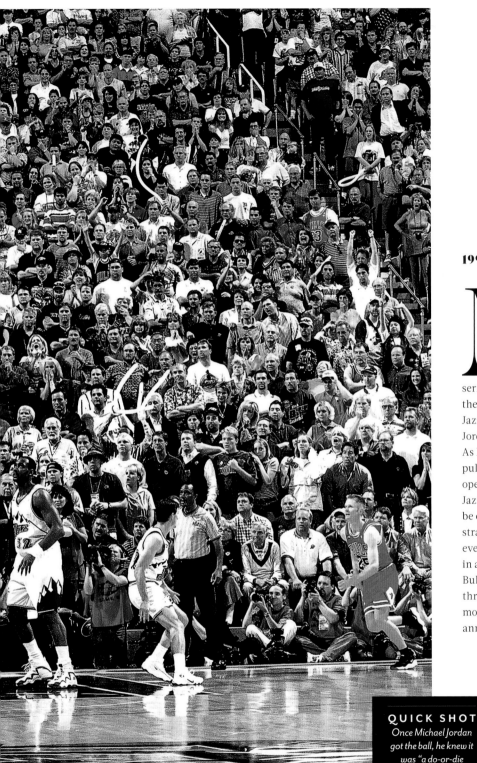

> ## "Talent wins games, but teamwork and intelligence win championships."
>
> MICHAEL JORDAN

1998 >> MICHAEL JORDAN'S GAME WINNER

Michael Jordan made infinite game-winning shots throughout his epic 15-season career, but none were as enthralling as the jumper he sank in Game 6 of the 1998 NBA Finals. The Chicago Bulls led the Utah Jazz in the series 3–2, but Karl Malone and his team were close to winning the matchup, thus forcing a Game 7. With 18.9 seconds left, the Jazz were ahead 86–85 and had possession of the ball when Jordan came up behind Malone and swatted it out of his hands. As No. 23 made his way up the court to the Bulls basket, he pulled a crossover dribble on Bryon Russell, creating a wide-open jump shot for himself—which was nothing but net. The Jazz took a timeout with 5.2 seconds left, but no strategy would be enough to defeat the Bulls, as the team clinched its third straight championship. "I think this was the best performance ever that we've seen from Michael Jordan to win a game, win in a critical situation and critical game in the series," raved Bulls coach Phil Jackson. "Michael's the guy who always comes through in the clutch. He's a real-life hero." Jordan's shining moment was his last in a Bulls jersey: Six months later, he announced his retirement.

QUICK SHOT
Once Michael Jordan got the ball, he knew it was "a do-or-die situation."

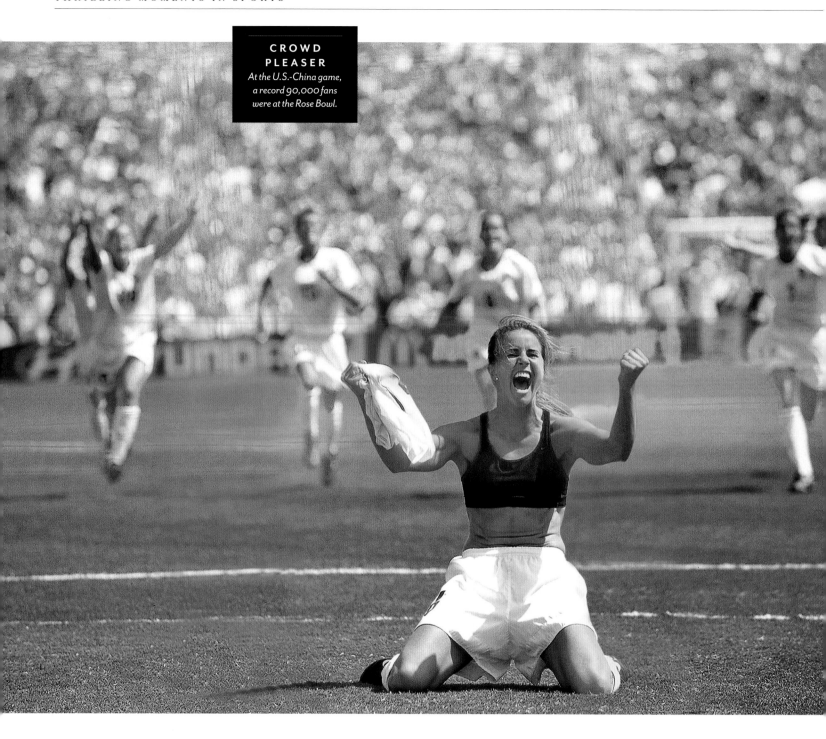

CROWD PLEASER
At the U.S.-China game, a record 90,000 fans were at the Rose Bowl.

1999 >> BRANDI CHASTAIN'S CELEBRATION

The 1999 FIFA Women's World Cup finals game between the United States and China came down to a penalty kick, and when Brandi Chastain won it for the U.S., she celebrated by ripping off her shirt—a gesture typical of male soccer players. "I had no idea that would be my reaction," she said. "It was truly genuine and it was insane and it was a relief and it was joy and it was gratitude all wrapped into one."

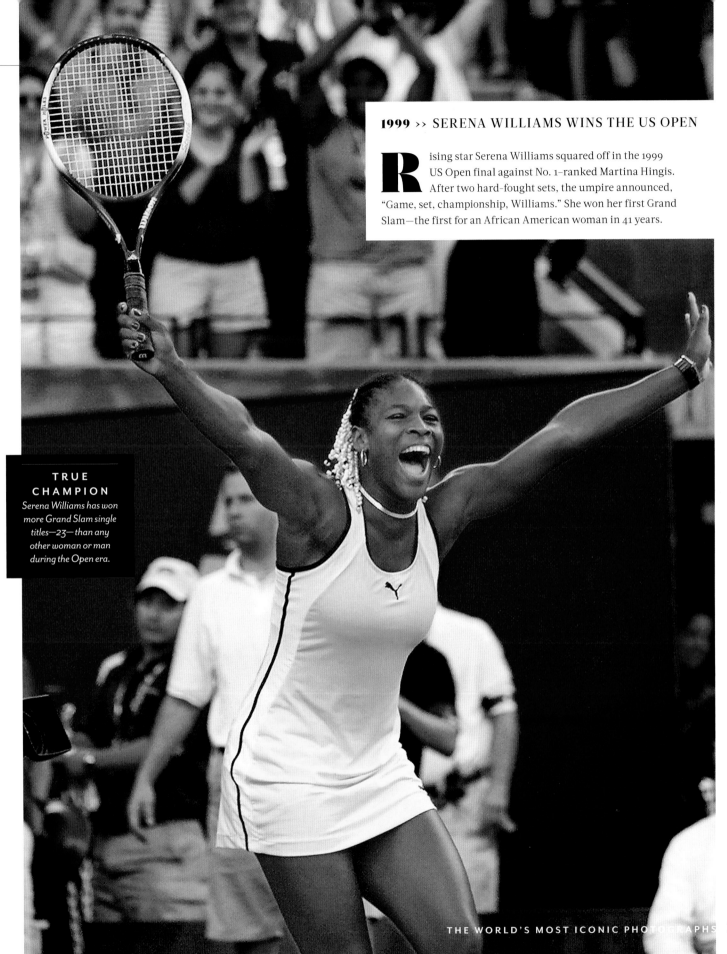

1999 >> SERENA WILLIAMS WINS THE US OPEN

Rising star Serena Williams squared off in the 1999 US Open final against No. 1–ranked Martina Hingis. After two hard-fought sets, the umpire announced, "Game, set, championship, Williams." She won her first Grand Slam—the first for an African American woman in 41 years.

TRUE CHAMPION
Serena Williams has won more Grand Slam single titles—23— than any other woman or man during the Open era.

"Believe in something. Even if it means sacrificing everything."

COLIN KAEPERNICK, VIA TWITTER

2016 » THE NFL TAKES A KNEE

Before the 2016 NFL season even officially started, San Francisco 49ers quarterback Colin Kaepernick was making headlines— but not for throwing a game-winning touchdown pass. During the Aug. 26 preseason game, Kaepernick was seen sitting on the bench as his teammates stood for the national anthem. "I am not going to stand up to show pride in a flag for a country that oppresses Black people and people of color," he explained after the game. After meeting with former NFL player and Green Beret soldier Nate Boyer, Kaepernick decided to modify his protest and kneel during the anthem to show respect to veterans. Still, his gesture received backlash, with some fans even burning his jersey. By the end of the season, Kaepernick decided to opt out of his contract with the 49ers and become a free agent, but no team signed him for the 2017 season. Even without Kaepernick in the NFL, athletes across multiple sports continue to kneel. "We're on the path to make the change we think we can make," explained Kaepernick's former teammate Eric Reid. "We are just not there yet."

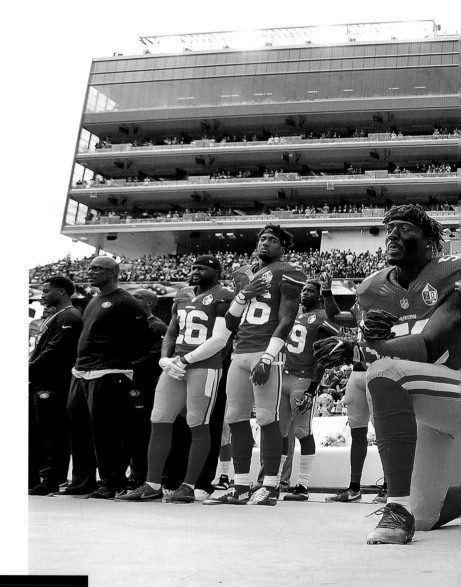

SHOE TIME
In 2018, Nike signed Colin Kaepernick as the face of the company's 30th anniversary "Just Do It" campaign.

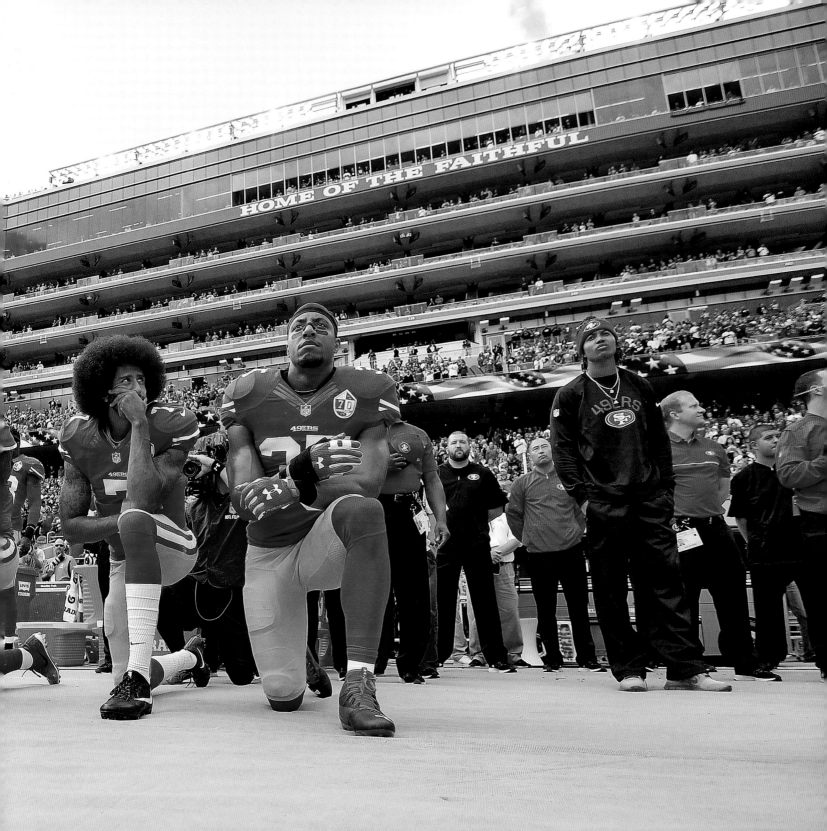

LAST DANCE

SOME OF SPORTS' ALL-TIME GREATS TAKE THEIR FINAL BOWS.

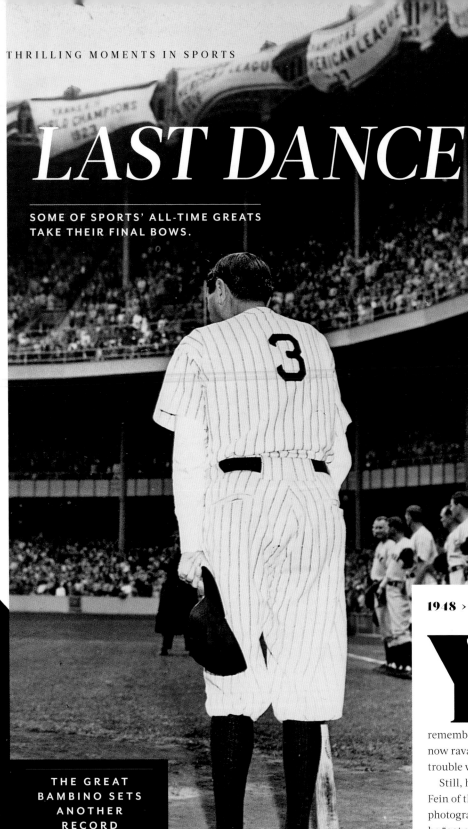

THE GREAT BAMBINO SETS ANOTHER RECORD
"The Babe Bows Out" earned Nat Fein a Pulitzer Prize; it's the only baseball-related photograph to ever win the award.

1948 >> BABE RUTH

Yankee Stadium was nicknamed The House That Ruth Built—so it was only fitting that Babe Ruth returned for its 25th anniversary celebration on June 13, 1948. But physically, the baseball great was not how fans remembered during his 15 seasons on the team. His body now ravaged by cancer, the 53-year-old was gaunt and had trouble walking, so he used a bat as a cane.

Still, he received a well-deserved hero's welcome. Nat Fein of the *New York Herald Tribune* was one of dozens of photographers waiting to snap the Great Bambino when he "got a feeling" and walked behind his subject, perfectly capturing his point of view as he basked in his final standing ovation. Two months later, Ruth died in his sleep at NYC's Memorial Hospital as fans kept vigil outside.

1999 >> WAYNE GRETZKY

It was the end of an era when Wayne Gretzky took his last lap around the ice rink after 20 seasons in the NHL. Tearfully, the New York Rangers star waved goodbye to the 20,000 cheering fans at Madison Square Garden on April 18, 1999. Despite the emotions, "My last game in New York was my greatest day in hockey," explained Gretzky, who drove to the arena with his father, just as he had as a kid. Throughout the game, he swapped out 40 hockey sticks, which he numbered and handed out to teammates and club staff.

LONE RANGER
Wayne Gretsky had announced his retirement just three days earlier.

MAMBA OUT
Kobe Bryant remains the all-time leading scorer in L.A. Lakers history.

2016 >> KOBE BRYANT

After 20 seasons, 18 All-Star appearances, five championship rings, four MVP awards and two Olympic gold medals, it was only fitting Kobe Bryant close out his basketball career on April 13, 2016, with a feat only five other NBA players have achieved: scoring 60 points in a game. In his final minutes as a Laker, Bryant brought his team back from a 10-point deficit and scored 15 straight points for a 101–96 win. Bryant, 37, addressed fans one last time in a Lakers uniform. "This has been absolutely beautiful. I can't believe it's come to an end."

Bryant regularly returned to watch games, often with his young daughter Gianna, herself a basketball player. On Jan. 26, 2020, the two were traveling to her game when their helicopter crashed, instantly killing Kobe and Gianna, along with seven others.

BRAVERY

IN THE FACE OF

RESISTANCE

THE IDEA OF COURAGE TYPICALLY EVOKES IMAGES OF SOLDIERS ON THE BATTLEFIELD OR EMERGENCY RESPONDERS. BUT FEARLESSNESS IS ALSO DISPLAYED BY A YOUNG GIRL ON HER FIRST DAY AT A NEW SCHOOL, A LONE MAN STANDING IN THE PATH OF THE OPPOSITION OR SOCIETY'S OUTCASTS DEMANDING BASIC HUMAN RIGHTS. IN THE MOST TRYING OF TIMES, THESE VALIANT SOULS MADE THEIR VOICES HEARD LOUD AND CLEAR.

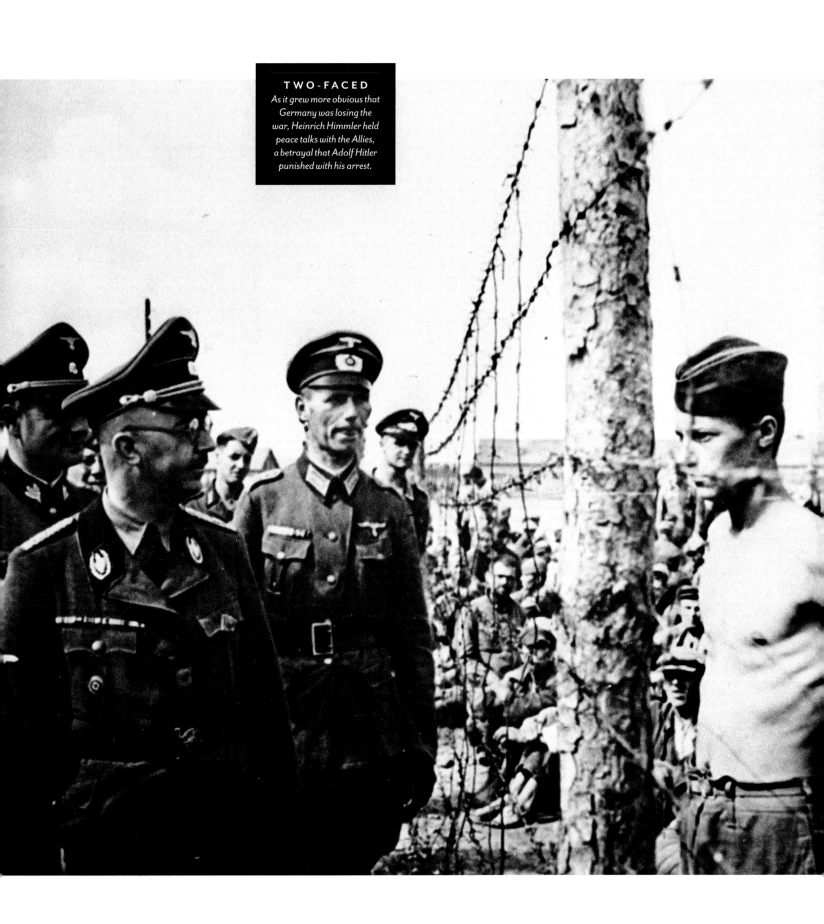

1941 » STANDING UP TO NAZI EVIL
(previous page)

During World War II, Nazis were feared by millions throughout the world, but most arguably by those they imprisoned. Heinrich Himmler, one of Adolf Hitler's highest-ranking henchmen, oversaw all concentration camps during the Holocaust, and he alone is responsible for orchestrating the killings of an estimated 11 million Jews, Poles and Soviets.

When Himmler, who was head of the SS, paid a visit to Shirokaya Street Concentration Camp in Minsk, Belarus, in 1941, he got the coldest of receptions from one fearless man. In a photo of the tense moment, the shirtless prisoner, so scrawny you can see his ribs, stares Himmler down through a barbed-wire fence. On this same day, the Nazi official ordered the execution of 100 Jewish prisoners merely so he could witness the "technique" for shooting them.

The identity of the man who stood up to Himmler is of great debate. Some have claimed he's an anonymous Soviet POW. But Joseph Horace "Jim" Greasley, a British soldier captured during WWII, maintained until his death that he is the man in question.

1957 » DESEGREGATION PIONEER

The Supreme Court ruling in 1954's *Brown v. Board of Education* declared segregation in U.S. schools unconstitutional. Little Rock Central High School in Arkansas was the first in the state to integrate—and on the morning of Sept. 4, 1957, nine Black students arrived for their first day. But they were met by an angry white mob, backed by the Arkansas National Guard, who blocked the entrance. When Elizabeth Eckford, 15, walked up to the door, the guardsmen didn't budge.

"They glared at me with a mean look, and I was very frightened and didn't know what to do," she recalled. "I turned around, and the crowd came toward me." In the most iconic photo from the incident, Eckford remains poised while surrounded by jeering protestors chanting, "Two, four, six, eight, we don't want to integrate!" The Little Rock Nine never made it into school that day. They finally did two weeks later, after President Dwight Eisenhower intervened.

FAMOUS FACE OF HATE
Hazel Bryan, the 15-year-old girl who can be seen behind Elizabeth Eckford, yelled at her to "go back to Africa!"

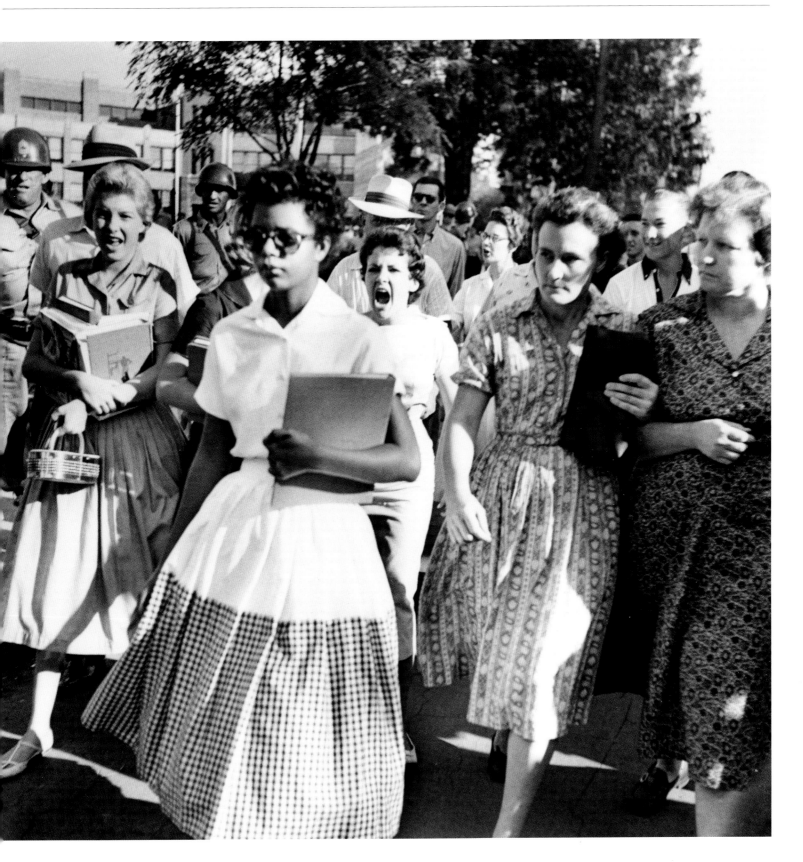

> "I entered ['Flower Power'] in contests, and it started winning everything and being recognized."
>
> BERNIE BOSTON

1967 » FLOWER POWER

During the Vietnam War, protesters focused on peaceful means to counteract the violence overseas, like flower power, in which participants handed out blossoms. The gesture took center stage at the March on the Pentagon in Washington on Oct. 21, 1967. More than 2,500 soldiers surrounded the building, their guns drawn at the crowd of 250,000. Instead of clashing with the military, demonstrators placed flowers in the barrels of their rifles. The juxtaposition created a gripping image, most notably seen in Bernie Boston's "Flower Power." In the photo, George Harris, 18, holds a bouquet of carnations, earnestly "decorating" the soldiers' weapons. Boston knew he had something special, but his *Washington Star* editors didn't agree—and buried it inside the newspaper. "Flower Power" went on to be a finalist for the Pulitzer Prize.

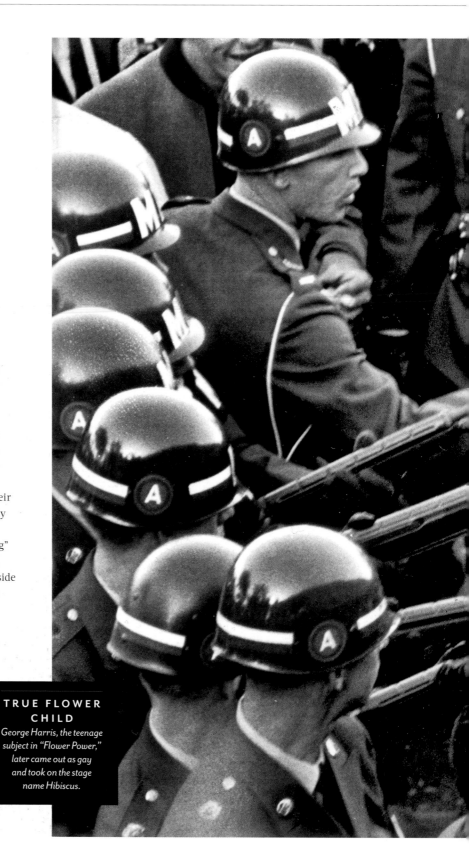

TRUE FLOWER CHILD
George Harris, the teenage subject in "Flower Power," later came out as gay and took on the stage name Hibiscus.

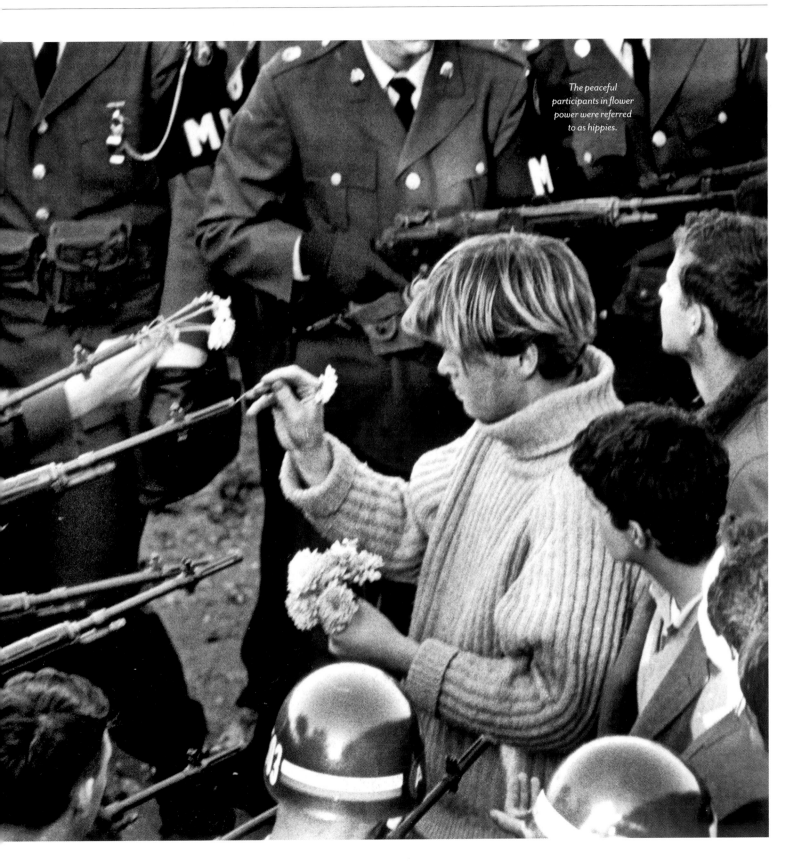

The peaceful participants in flower power were referred to as hippies.

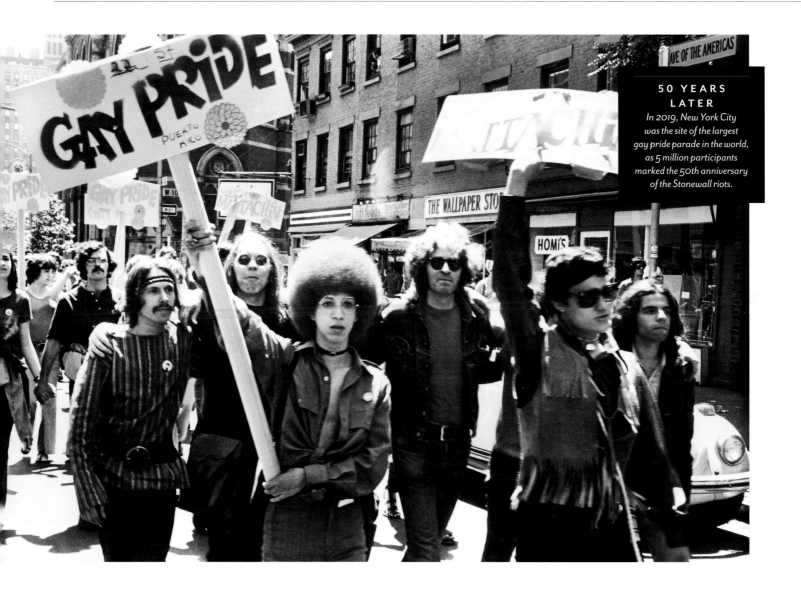

50 YEARS LATER

In 2019, New York City was the site of the largest gay pride parade in the world, as 5 million participants marked the 50th anniversary of the Stonewall riots.

"We had no idea we were going to finish the march.... We didn't expect we'd ever get to Central Park."

JOHN O'BRIEN

1970 » GAY PRIDE MARCH

The 1969 Stonewall riots in New York City were a watershed moment for the gay community. Fed up with decades of discrimination, patrons fought back after yet another police raid on Greenwich Village's Stonewall Inn in the early hours of June 28. During the blitz, NYPD officers roughed up gay patrons, made cross-dressers prove their gender and arrested 13 people. When police warned the crowd of hundreds to disperse, they refused—and tensions erupted into a violent riot after an officer struck a lesbian over the head. For days, thousands protested outside the bar on Christopher Street.

As a result, a number of gay rights organizations were established, and on the one-year anniversary of Stonewall in 1970, activists came together for simultaneous gay pride marches in NYC, Chicago and Los Angeles. At the Big Apple event, protestors waved flags and banners for 51 blocks (almost 3 miles)—from Christopher Street to Central Park. "We had gotten death threats, so we went up Sixth Avenue really fast," revealed demonstrator Jerry Hoose. "When we started, there were maybe a couple hundred people. But as we kept going, the crowd grew and grew and grew.... I always say that gay liberation was conceived at Stonewall in 1969 and was born at that first march."

1989 » FACE-OFF IN BEIJING

Several hundred civilians protesting government corruption were killed as they attempted to block military tanks from entering Beijing's Tiananmen Square on June 4, 1989. The next day there was a moment of quiet resistance: As a succession of oncoming tanks rolled down the square's Avenue of Eternal Peace, a man clad in a white shirt and black pants took a step into their path. After slamming to a halt, the lead tank attempted to drive around the man—but he again stepped in its way. A minute-long stare down ensued before he jumped onto the tank and briefly spoke with a soldier. "After a while, the young man jumps down and the tank turns on the motor and the young man blocks him again," recalled witness Jan Wong, then a correspondent for Toronto's *Globe and Mail.* "I started to cry, because I had seen so much shooting and so many people dying that I was sure this man would get crushed." Two men eventually pulled Tank Man away, and the trio disappeared into the crowd.

WHERE IS HE?
In 1990, Barbara Walters interviewed Chinese leader Jiang Zemin and asked about Tank Man's fate. Flustered by the question, he answered, "I think…never killed."

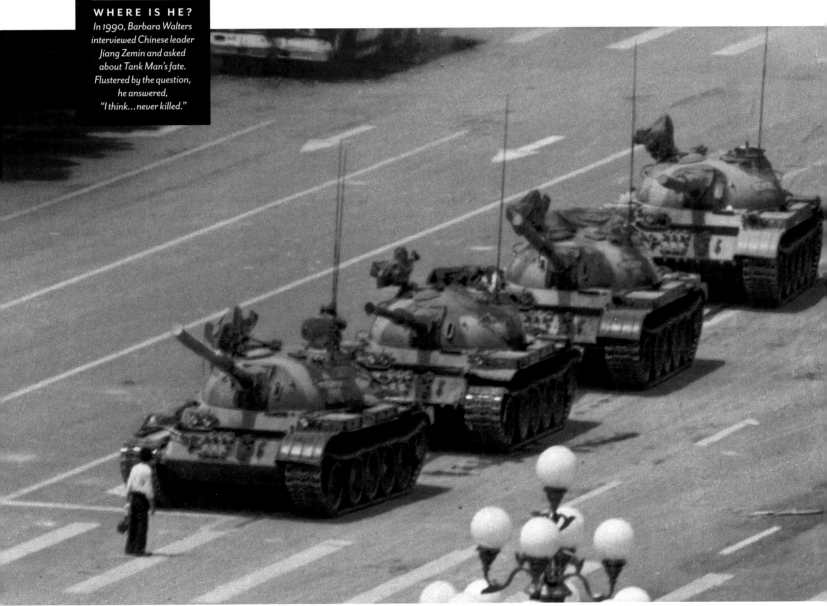

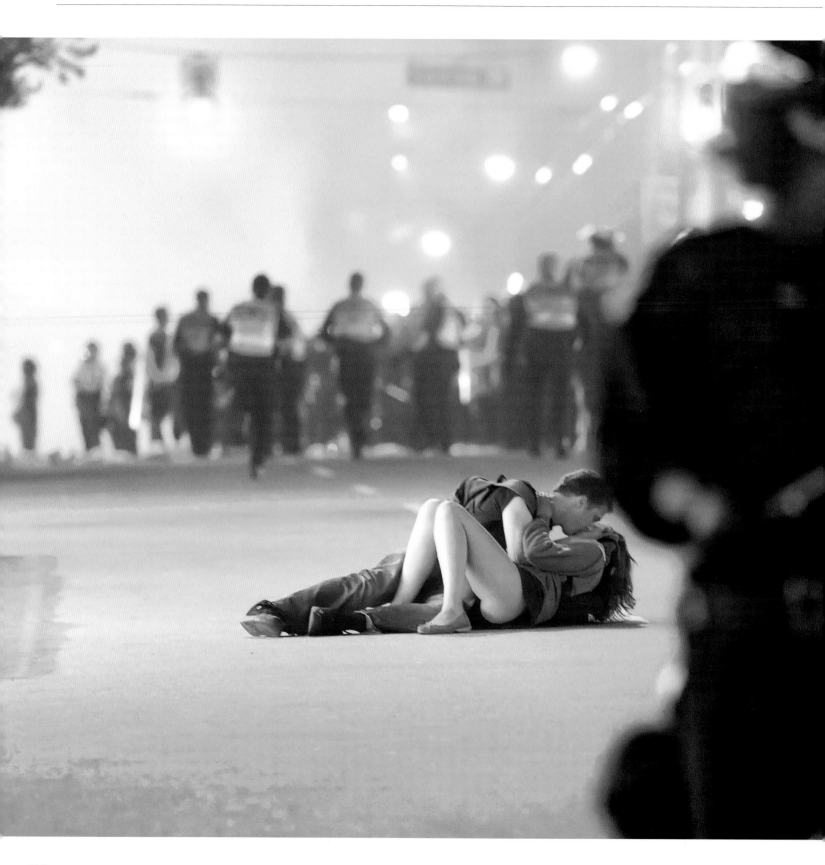

2011 >> VANCOUVER RIOT KISSING COUPLE

Although most famous kissing photos are set against a romantic backdrop, this one is anything but. On June 15, 2011, the Boston Bruins beat the Vancouver Canucks in Game 7 of the Stanley Cup Final, and the loss in the Canadian hometown incited hockey fans to riot. Alexandra Thomas and her boyfriend, Scott Jones, headed downtown after watching the game and quickly got caught up in a swarm of police trying to clear the streets of raging fans.

In the chaos, Thomas was knocked to the ground by an officer's shield and "didn't want to move," explained Jones, so he did what he could to comfort his scared girlfriend—he kissed her. Getty photographer Rich Lam had been documenting the violence when he turned his camera to the tender moment amid the presence of armed police.

Thanks to social media, the photo instantly went viral, and over the following weeks, Thomas and Jones gave a number of TV and print interviews. Their 15 minutes of fame are now up, but their time together continues. And every night, the couple sleeps under a blown-up version of their famous photo—a gift from Lam.

SOCIAL MEDIA STARS
The pair were not aware that their photo had been taken until they awoke the next morning to a barrage of Facebook notifications.

THE *NEW GENERATION*

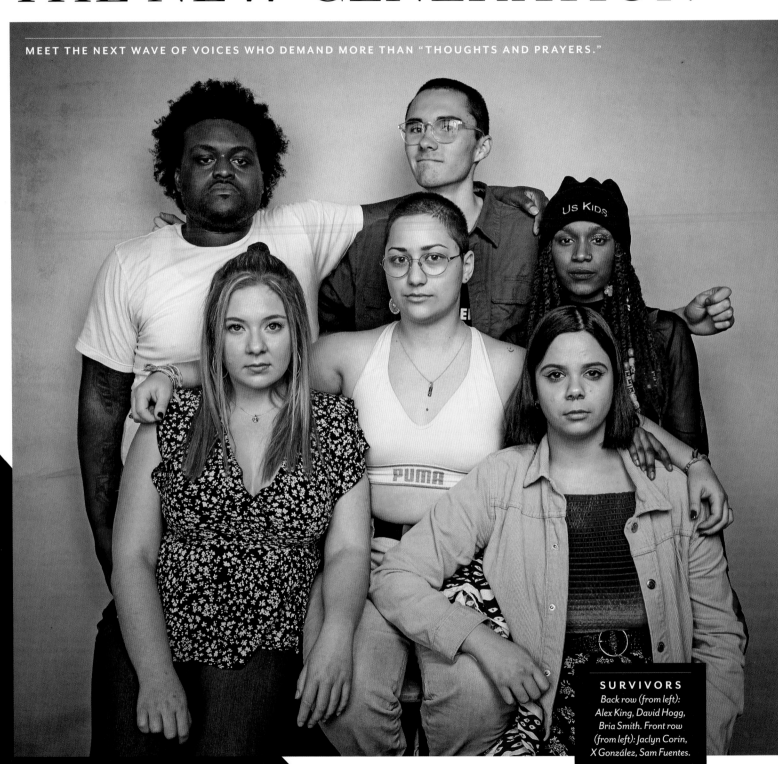

MEET THE NEXT WAVE OF VOICES WHO DEMAND MORE THAN "THOUGHTS AND PRAYERS."

SURVIVORS
Back row (from left): Alex King, David Hogg, Bria Smith. Front row (from left): Jaclyn Corin, X González, Sam Fuentes.

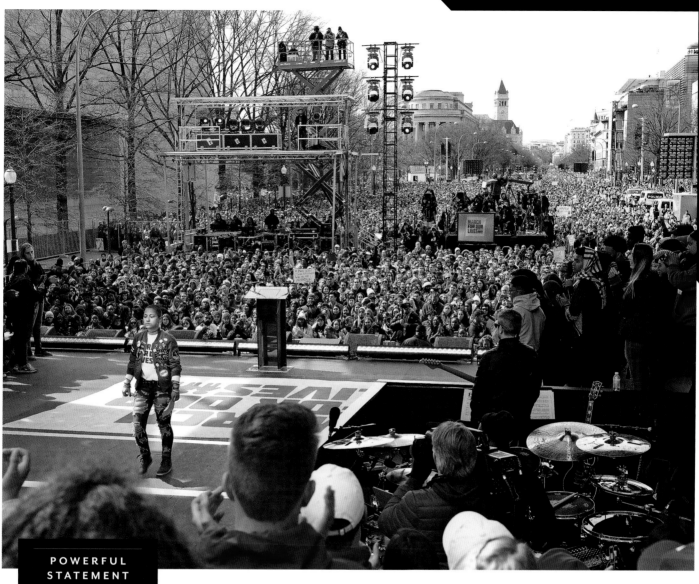

POWERFUL
STATEMENT
*At March for Our Lives,
X González was onstage for
six minutes—the length of
the Parkland shooting spree.*

2018 >> NEVER AGAIN

When a gunman killed 17 people at Marjory Stoneman Douglas High School in Parkland, Florida, on Feb. 14, 2018, it could have been just another mass shooting in America. Instead, within days, its students founded Never Again, demanding gun control. On March 9, the organization scored its first win when Florida passed a bill to impose waiting periods and background checks—the first time in 30 years the state had issued gun restrictions. With the power of social media, the teens' message spread like wildfire, and hundreds of thousands joined them two weeks later for the March for Our Lives demonstration in Washington. Around the country, another million participated locally—making March for Our Lives one of the largest protests in U.S. history. But the movement didn't end there. Their continued progress, chronicled in the 2020 documentary *Us Kids*, has broadened their scope to advocate for Black students facing gun violence. "We should all be working together," X (formerly Emma) González said during a May 2021 interview on *The Tonight Show Starring Jimmy Fallon.* "We should not be fighting with each other."

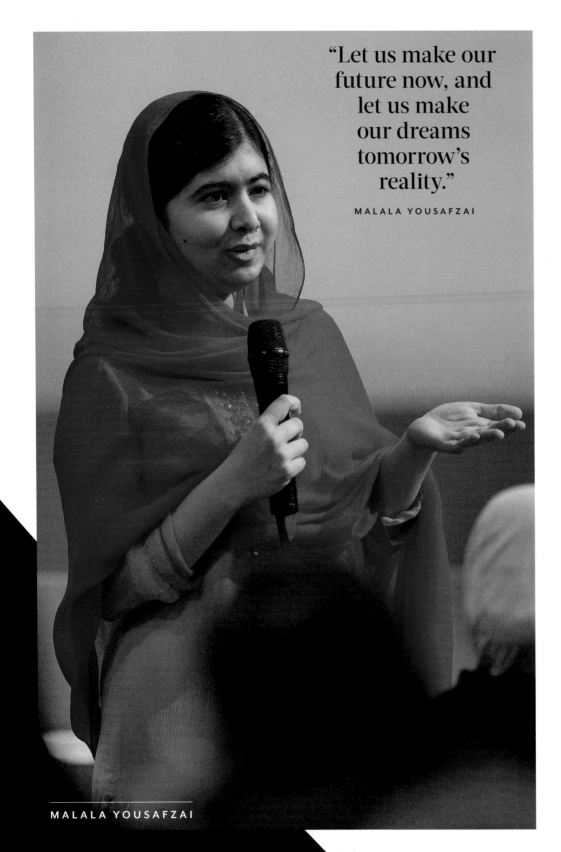

"Let us make our future now, and let us make our dreams tomorrow's reality."

MALALA YOUSAFZAI

MALALA YOUSAFZAI

2016 >> IESHIA EVANS

Drawing comparisons to "Tank Man" 25 years before her, Ieshia Evans went viral in 2016 for peacefully challenging corruption. In the image known as "Taking a Stand in Baton Rouge," the bespectacled 35-year-old nurse is arrested by police in riot gear for protesting the death of Alton Sterling, a local Black man who had been shot by authorities during his arrest.

2016 >> MALALA YOUSAFZAI

A movement in Pakistan to educate women and children has gone worldwide, all because of Malala Yousafzai. In 2012, at the age of 15, the human rights activist rose to prominence when an Islamist extremist shot her in the head. Yousafzai recovered—and refused to be silenced. Two years later, she was awarded the Nobel Peace Prize, making her the youngest laureate in history.

With a focus on access to free quality education, her Malala Fund has already made strides in eight countries, and it's just the beginning. "With more than 130 million girls out of school today, there is more work to be done," says Yousafzai, shown speaking here at a 2016 conference in London. "Together, we can create a world where all girls can learn and lead."

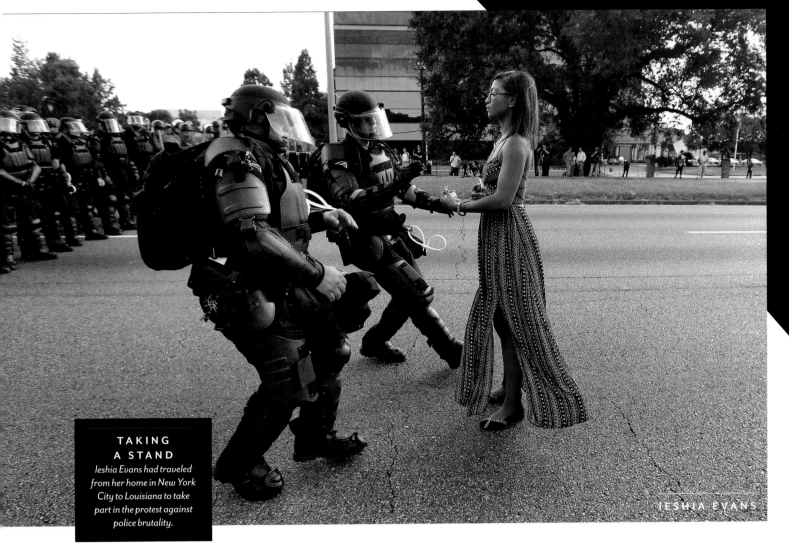

IESHIA EVANS

"People are suffering. People are dying. Entire ecosystems are collapsing."

GRETA THUNBERG

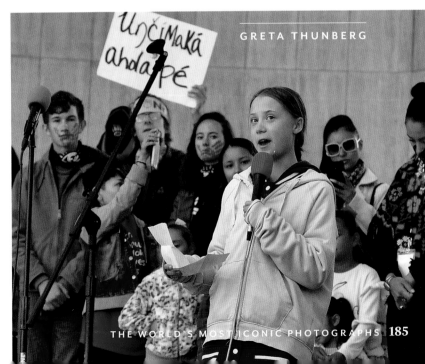

GRETA THUNBERG

2019 >> GRETA THUNBERG

The climate crisis has one of its loudest and youngest advocates in Greta Thunberg. In 2019, the Swedish environmentalist, then 16, sailed to North America to address the United Nations in an emotional speech that remains iconic. "We are in the beginning of a mass extinction, and all you can talk about is money and fairy tales of eternal economic growth," criticized Thunberg. "How dare you!"

SPECIAL THANKS TO CONTRIBUTING WRITER

Alexis Rotnicki

CREDITS

CENTENNIAL BOOKS

An Imprint of
Centennial Media, LLC
1111 Brickell Avenue, 10th Floor
Miami, FL 33131, U.S.A.

ISBN 978-1-955703-00-0

Distributed by
Simon & Schuster, Inc.
1230 Avenue of the Americas
New York, NY 10020, U.S.A.

For information about custom editions, special sales and premium and corporate purchases,
please contact Centennial Media at contact@centennialmedia.com.

Manufactured in Singapore

© 2022 by Centennial Media, LLC

10 9 8 7 6 5 4 3 2 1

PUBLISHERS & CO-FOUNDERS Ben Harris, Sebastian Raatz
EDITORIAL DIRECTOR Annabel Vered
CREATIVE DIRECTOR Jessica Power
EXECUTIVE EDITOR Janet Giovanelli
FEATURES EDITOR Alyssa Shaffer
DEPUTY EDITORS Ron Kelly, Anne Marie O'Connor
MANAGING EDITOR Lisa Chambers
DESIGN DIRECTOR Martin Elfers
SENIOR ART DIRECTOR Pino Impastato
ART DIRECTORS Olga Jakim, Jaclyn Loney, Natali Suasnavas, Joseph Ulatowski
COPY/PRODUCTION Patty Carroll, Angela Taormina
RESEARCH EDITOR Christine Coppa
SENIOR PHOTO EDITOR Jenny Veiga
PRODUCTION MANAGER Paul Rodina
PRODUCTION ASSISTANT Alyssa Swiderski
EDITORIAL ASSISTANT Tiana Schippa
SALES & MARKETING Jeremy Nurnberg